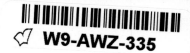
Leica

LEICA M
PHOTOGRAPHY

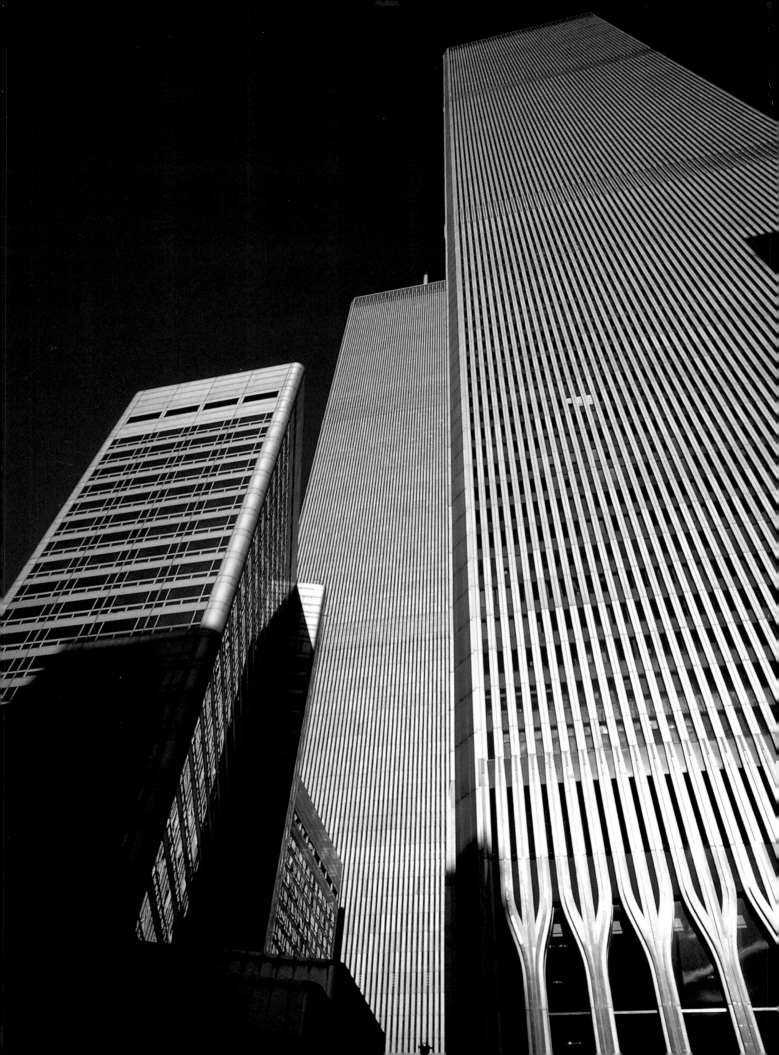

Leica

LEICA M
PHOTOGRAPHY

BRIAN BOWER

David & Charles

A DAVID & CHARLES BOOK

First published 1995
First paperback edition 1998
Reprinted 1999

A catalogue record for this book is available from the
British Library.

ISBN (hardback) 0 7153 0318 X
ISBN (paperback) 0 7153 0842 4

Designed by Paul Cooper
Printed by C. S. Graphics Pte Ltd
for David & Charles
Brunel House, Newton Abbot, Devon

All photographs by Brian Bower FRPS unless otherwise stated.

(Page 2)
THE PORT AUTHORITY
BUILDING,
MANHATTAN
A clear November day
crisply highlights the detail
of the 'Twin Towers'.

Leica M6 21/2.8 Elmarit,
Kodachrome 25 Professional,
1/125 sec, f5.6.

CONTENTS

FOREWORD

My first Leica, purchased in 1967, was an M2. The body was an ex-demonstration item and cost me £90! At the same time I bought a new 50mm f2 Summicron and a new 35mm f2.8 Summaron, together with a secondhand 90mm Elmarit. The versatility of that outfit and the quality of the results were a revelation and the realization that, from that point, I had no excuses on the equipment front, inspired a considerable improvement in my photography. There was real pressure to live up to the Leica reputation – after all, I had exactly the same camera as many of the 'greats'.

I loved that M2. I still have it and still use it from time to time although most of my photography now is with the M6. From the many Leica enthusiasts I come into contact with, I know that numerous photographers happily use the older models and get first class results. That special Leica feel – a superb precision instrument, a real pleasure to handle and demanding to be used to make great photographs – is always there. My hope is that those who have kept their older Leicas, and those whose first step on the Leica ladder is an older secondhand model, will find this book as interesting and useful as the owner of the current M6.

BRIAN BOWER

LEICA M2 OUTFIT
My very first outfit, referred to in the foreword, photographed very recently. The M2 body was purchased as demonstration soiled, the 50/2 Summicron and the 35/2.8 Summaron were new and the 90/2.8 Elmarit, a screw-mount version used with a bayonet adapter, was bought secondhand. Photographed by daylight indoors.

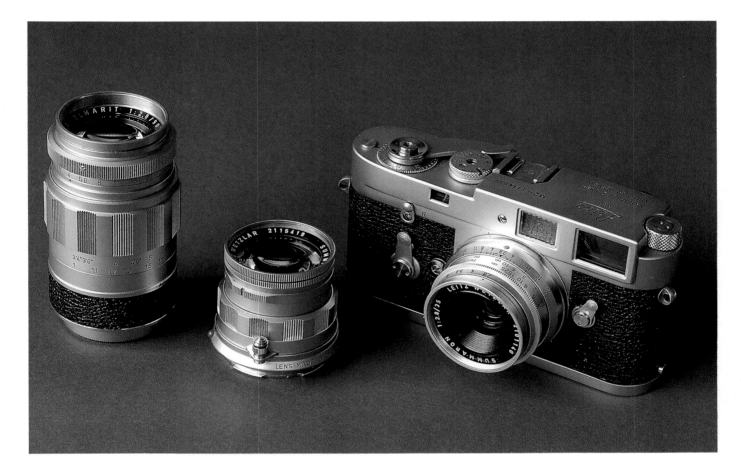

ZION, UTAH, USA
A splash of sunshine
with strong sidelighting
emphasizes the colours
and amazingly eroded
rock formations in this
photogenic area.

Leica M6, 35/1.4 Summilux
Aspherical, Kodachrome 25
Professional, 1/125 sec, f5.6.

CHAPTER 1

THE LEICA M PHILOSOPHY

The rangefinder style is different. It goes back to the basics of recording directly what the eye sees and the heart feels. The photographer is involved with his subject and the camera is merely a device for capturing a moment in time.

The reflex camera, on the other hand, encourages a more considered approach. The image is precisely framed and carefully composed on the focusing screen, rather than in the flesh with a frame around it. The photographer is slightly remote from the event, rather than being a part of it, and sees the subject two-dimensionally with the in-focus and out-of-focus effects clearly apparent.

In some respects the rangefinder camera is more demanding. The photographer has to have an understanding of how the three-dimensional reality before him will translate into a two-dimensional image. He has to have an instinctive feel for the depth-of-field a particular lens and f stop setting will provide. The advantage of the rangefinder is that the camera really does become an extension of the eye, and the mind. It is almost like capturing an image by blinking, although in reality a great plus with the range viewfinder is that you do not lose the image at the critical moment of exposure. It frames and captures the reality the photographer sees and senses.

The rangefinder M is a particularly outstanding instrument for use with wide-angle lenses and for low light photography in terms of viewfinder image size and focusing accuracy. An exceptionally smooth and quiet shutter, and its compact, unobtrusive size also contribute to the camera's strengths in the fields of discreet imagery and photojournalism.

More particularly the M is ergonomically near-perfect. The design started out right and has been honed and refined over a period of forty years. It is a real photographer's camera, and has a purist concentration on the essentials approach; that certainly demands more of the photographer but also puts him in charge. It looks and feels the true precision instrument that it is and it is a delight to use. Its own optical and mechanical perfection encourage an equally high standard from the photographer, and the pleasure of using it makes you want to get out and take pictures. For all its elegance, it is extremely robust and reliable.

The Leica M has limitations and weak spots, of course. It is not the camera for close-up or long-lens work or for sophisticated flash techniques. It does demand much more in technical know-how and visualization but it responds with results as near perfect as those you can achieve with a 35mm camera.

IN THE LOUVRE
M cameras are very quiet and very discreet, and the lens quality and rangefinder focusing accuracy in low light conditions is remarkable. The M6 has reliable and convenient through-the-lens metering to add to these attributes, allowing me, in this case, to work unnoticed by the painter and his companion.

Leica M6, 50/1.4 Summilux, Kodachrome 200 Professional, 1/30 sec, f2.

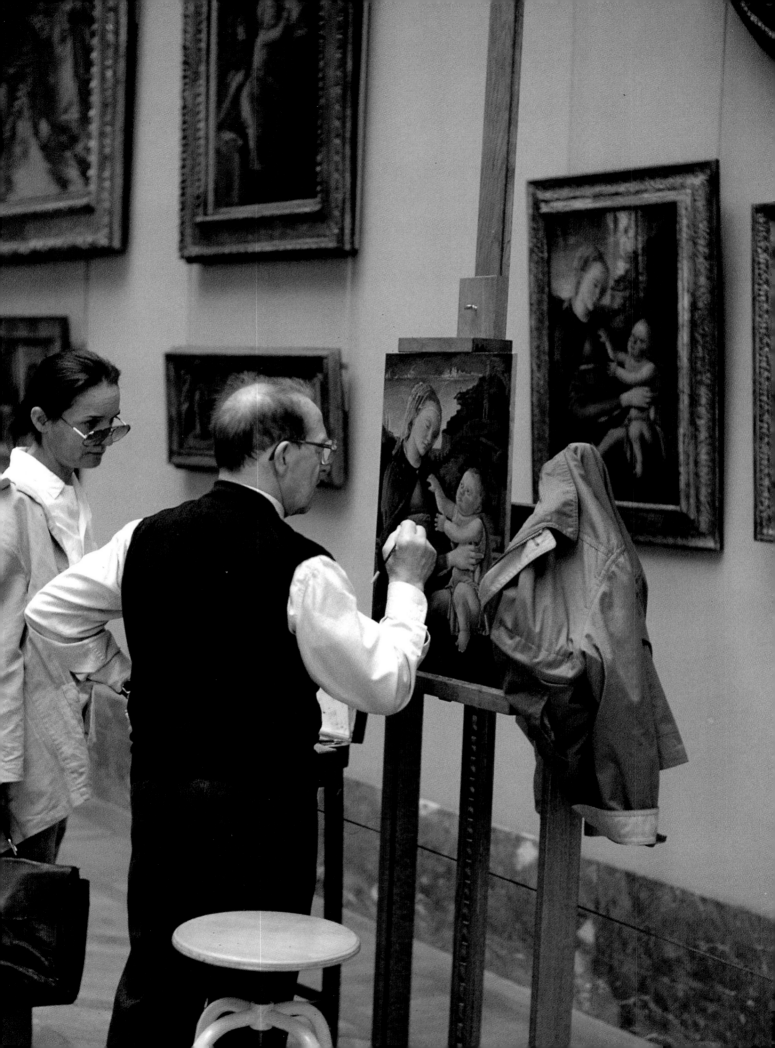

BARNACK'S CAMERA

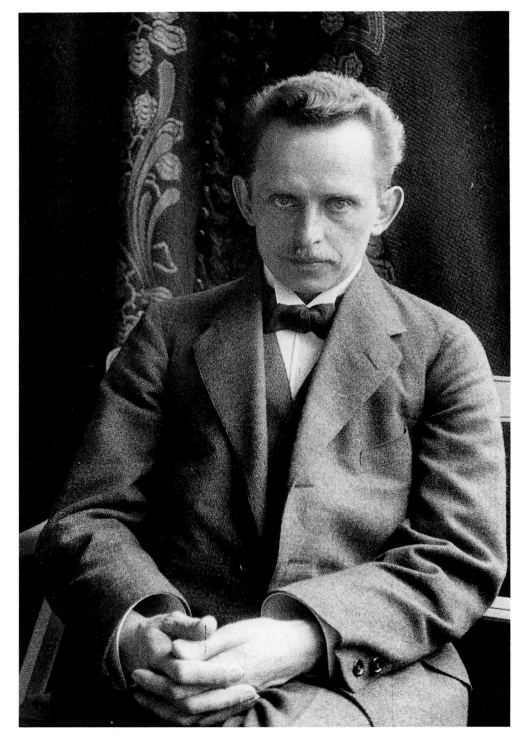

'I have decided – we shall risk it.' With these words Ernst Leitz II closed a long and strongly argued meeting of senior managers of the Leitz company at Wetzlar, near Frankfurt in Germany.

The year was 1924; the decision he made was truly historic. As events later proved, it was the moment that created the 35mm camera industry.

The meeting had been called to discuss the possibility of producing and marketing a miniature still camera, developed by one of the company's master technicians, Oskar Barnack. The camera was not new. Barnack's first prototype had been built eleven years earlier in 1913, partly for tests in connection with a 35mm motion picture camera which he was then developing, but also for use as a personal camera. He was in fact a keen amateur photographer but his frail health made transporting a large plate camera a serious burden and, from 1914 onwards, he used his new miniature camera extensively to facilitate his photographic activities.

DEVELOPMENT

Barnack had been impressed by the quality of image obtained on the large cinema screen from the tiny 18 × 24mm frame of the cine camera. Using the same perforated cine film but doubling the frame size to 36 × 24mm he discovered that, with care in processing, he was able to produce a satisfactory 10 × 8in enlargement from his negatives. The practicality of the miniature camera concept, along with the format of all future generations of 35mm camera, was established.

Over the following ten years, Barnack together with his friend and colleague Dr Max Berek, who contributed his skills in optical design, painstakingly improved this camera. At first his efforts were primarily for his own interest and satisfaction, and no commercial application was contemplated. However, after the 1914–18 war ended, business slackened and Ernst Leitz was busy looking for new products to maintain employment for the highly skilled technicians at his microscope works. Barnack's camera was considered a possibility and in 1923 and 1924 a pilot batch of thirty-one was manufactured and circulated to obtain reactions from prominent photographers and members of the photographic trade.

Reactions on the whole were not favourable. Apart from genuine technical misgivings, there were many vested interests in the photo industry who did not welcome such novel concepts. The meeting at Wetzlar was fairly evenly divided on the merits of the project. As lunch time approached and the argument

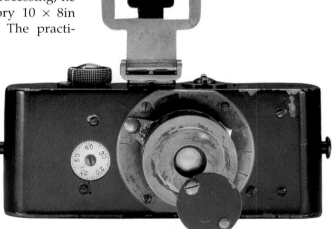

UR LEICA
Barnack's original prototype, now in the Leica Museum at Solms.

Photo Leica Archiv

OSKAR BARNACK
Barnack made this self-portrait with the first prototype – the UR Leica – in 1913. He used the ordinary cine film then available. The quality is remarkable.

Photo Leica Archiv

FLOODS, WETZLAR
Another of Barnack's pictures made with the UR Leica. The photojournalistic style so appropriate to 35mm photography is already apparent.

Photo Leica Archiv

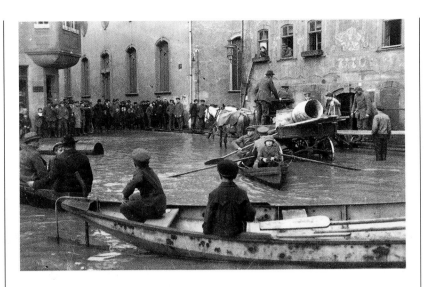

LEICA I AND LEICA II
The Leica I (USA Model A) in the upper photo had no rangefinder and the lenses were not interchangeable. A separate rangefinder shown here with the camera, allowed for accurate setting of the focus distance and was available as an accessory. Barnack's objective was to build this into the camera and automatically couple it to the focusing of the interchangeable lenses without increasing the size of the camera. How well he succeeded is shown in the lower picture of the Leica II (USA Model D).

continued, Ernst Leitz exercised his proprietorial prerogative and made his historic decision. Thus, at the 1925 Leipzig Trade Fair, the Leica (LEItz CAmera) as it was called was introduced to the public. With typical understatement it was described as 'the smallest camera with a focal plane shutter'.

It is worth remembering that at this time a typical small camera was 9 × 12cm (3½ × 4½in) format and the Leica with a film size of 1½ × 1in truly was miniature.

Right from the start the Leica was adopted by a complete new generation of photographers, especially those who recognized its potential in the field of documentary and journalistic photography. Cartier Bresson's 'decisive moments', Robert Capa's war pictures, Peter Stackpole's documentation of the construction of the Golden Gate Bridge, Kertesz's Paris, and the Farm Securities Administration documentation of America during the Depression years are some of the best known examples of the new style. Photography shifted gear and discovered what many considered to be its true vocation. Significantly, this period saw the birth of *Life* magazine, *Picture Post* and others, all of which relied heavily on the photo essays produced by this new generation of photographers. Alfred Eisenstaedt, doyen of *Life* photographers, was among the earliest Leica enthusiasts.

Technically the first major development of the Leica came in 1930 with the introduction of interchangeable lenses. A 35mm wide-angle and a 135mm long-focus lens complemented the standard 50mm Elmar.

The next great step forward was accomplished in 1932 when a coupled rangefinder was incorporated. To assist accurate focusing, separate rangefinders had been available from the start, but they clearly lacked convenience. Barnack insisted that the overall dimensions of his camera should not be affected by building in the rangefinder. How admirably he succeeded in his objective is apparent when one compares the Standard Model and its attached rangefinder, with the fully coupled Leica II. Not so readily apparent is the high precision engineering required to

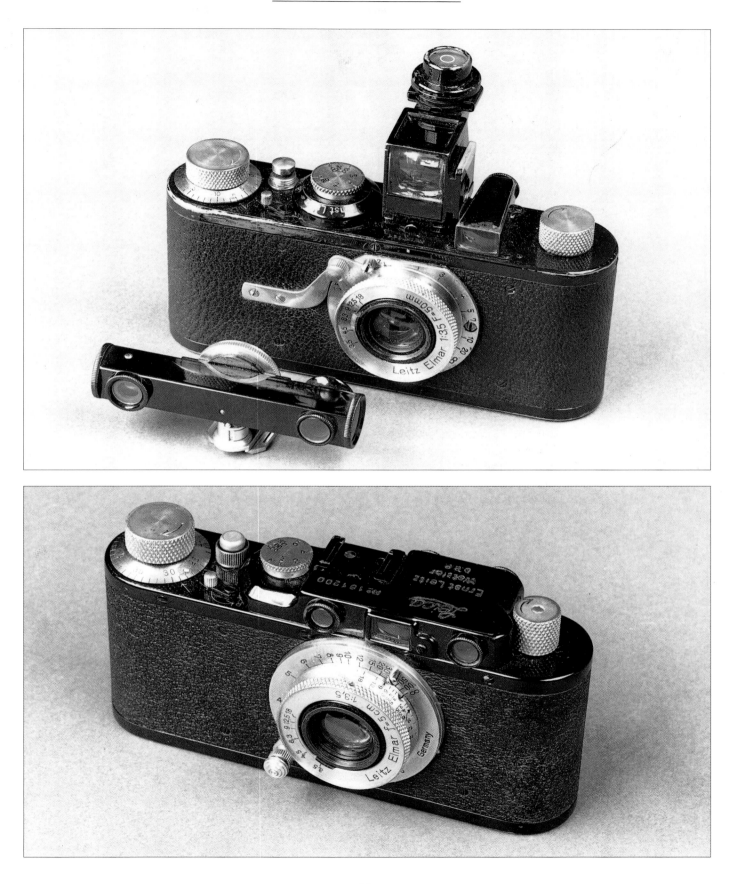

ensure accurate coupling of the rangefinder with the longer focal length lenses.

ACCESSORIES

Although the lenses were the cornerstones of the development of the Leica, Barnack's inventive genius extended much further. During the ten years following its introduction, he masterminded a fantastic range of accessories to create truly the first camera system. Precision enlargers were obviously essential if the 35mm format was to compete with larger cameras. In addition, projectors, close-up devices, copy stands, special viewfinders, all suited the Leica for a tremendous variety of roles. By 1936 the range of ten interchangeable lenses covered focal lengths from 28mm to 400mm. The speed of the standard lens had risen from the original f/3.5, first to f/2.5 (the Hektor, reputedly named after Max Berek's dog!) then f/2 (the Summar) and later the f/1.5 Xenon. For use with the long-focus lenses and for precise close-up work, Barnack produced a reflex housing. This accessory made the Leica the first-ever 35mm single lens reflex when it was introduced in 1933.

COMPETITION

By the mid-1930s much of the prejudice against the 'miniature' format had been overcome, the 35mm camera bandwagon was really rolling and Leitz had competition. The film manufacturers were producing special emulsions in standard cassettes for 35mm still cameras so that the enthusiast no longer had to load his own cassettes from bulk cine film.

Most of the leading camera manufacturers, such as Zeiss and Voigtlander, together with Kodak and Agfa, were now producing '35s'. Zeiss introduced a top line model, the Contax, that gave the Leica its first real competition. Once this arrived the battle was on with a vengeance, each side constantly trying to score technical points off the other.

Zeiss were at a serious disadvantage as the Leitz patents forced them into finding some very complicated engineering solutions to problems that Barnack had solved very elegantly, and simply (in the shutter mechanism for instance). There is no doubt, however, that the later Contax II and the even more luxurious Contax III, with built-in exposure meter, were important rivals, especially as Zeiss came up with some very fast, top class lenses such as the 5cm f/1.5 Sonnar and the 8.5cm f/2 Sonnar.

AFTER BARNACK

Following Barnack's death in 1936, development of the Leica slowed. Three years later, the outbreak of World War II had a devastating effect on the overseas markets for Leica and totally changed the technical and production demands on the Leitz company facilities.

Despite this, during this period, two significant improvements were made: the much closer placing of the separate rangefinder and viewfinder eyepieces, seen in the IIIb of 1938 (a considerable

convenience for the photographer), and the switch to a die-cast metal body with its one-piece top plate, seen in the IIIc of 1940. This latter change was important in facilitating consistent high precision production, thereby reducing the time and cost involved in careful individual assembly and adjustment of each camera.

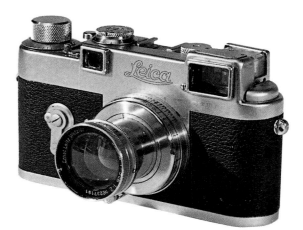

Some interesting new lenses came along. The 50mm f2 Summitar was a significant improvement over its predecessor, the Summar, and, outdoing the highly respected 85mm f2 Sonnar produced by Zeiss for the Contax, Leica came along with the stunning 85mm f1.5 Summarex (again, the 'rex' part of the name, reputedly, came from one of Max Berek's dogs). Two other fast lenses were the 50mm f1.5 Xenon of 1936, which included some features derived from the English Taylor, Taylor, Hobson company designs, and its much improved successor the f1.5 Summarit of 1949.

POST WAR

After the war Leica first concentrated their efforts on rebuilding production of the IIIc and re-establishing markets, so it was not until 1951 that a refined IIIc with sophisticated built-in, adjustable flash synchronization came along as the 'f' series camera. By now Japanese manufacturers, who at first had been little more than copyists of the Leica and Contax, were beginning to move ahead with their own advances in camera and lens design. The Korean war had introduced these to many American newspaper and magazine photographers and Canon and Nikon posed a real threat to the Leica's pre-eminence in the rangefinder field.

Leica had not been idle, however. For many years they had been working on a completely new design incorporating many improvements, to overcome the perceived deficiencies of the classic screw-mount models. In fact work had already started in Barnack's time on an early prototype known as the Leica IV.

LEICA IIId
The IIId is a rare variant of the 1940 IIIc. The wartime C series introduced important engineering improvements, including a die-cast chassis that facilitated precision production methods.

Photo Leica Archiv

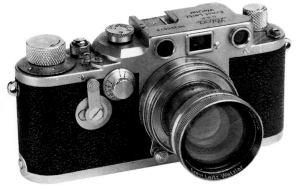

LEICA IV
The model IV was a development prototype produced at Wetzlar under Oskar Barnack's direction in 1936. It was very much the forerunner of the classic M3, although the war and other events conspired to prevent the introduction of this classic Leica until 1954.

Photo Leica Archiv

THE 1950s

The new design was introduced in 1954. It was the M3, which together with its descendants through to the current M6 was to become the dominant rangefinder camera. The story of the M cameras follows below but the screw series had many aficionados and continued in production for several more years, first as the 'f' series, with detailed improvements, and then, in a final blaze of glory, with the collectors' favourite the IIIg of 1956. This model incorporated enhancements that owed something to the M3 – the higher

magnification, bright-line finder with frames for 50mm and 90mm lenses for instance. The IIIg was an excellent design, beautifully made and finished, and a fitting end to the line of screw-mount Leicas.

The first M, the M3 of 1954, incorporated a number of major advances compared with the earlier Leicas. The main ones were:

☐ A quick-change bayonet lens mount
☐ An almost life-size viewfinder that incorporated bright-line frames for 50mm, 90mm and 135mm lenses – automatically activated when each lens was fitted
☐ A super-precise, long base rangefinder, combined with the viewfinder, that worked with both coincident and split images
☐ A single shutter speed dial with automatic flash synchronization (ie no requirement to set the delay as on the IIIf)
☐ A lever-wind film advance with a frame counter that automatically set itself to minus two frames when the film was changed

As might be expected with a completely new model, some detail improvements were soon incorporated. In particular the two strokes of the lever required to advance each frame was reduced

LEICA LITERATURE
Leica literature from the 1930s. The camera was very well marketed with good catalogues and brochures, and explanatory technical leaflets, designed to sell the merits of the Leica and the 35mm system concept of lenses and accessories to fit the camera for many

purposes. The introduction of Kodachrome gave a tremendous boost, and the illustration on page 16 includes part of a picture from one of the very first books based on 35mm colour transparencies, Anton Baumann's *Das Farbige Leicabuch*.

Leica M6, 50/2.8 Elmar, 16526 Copier, Fuji Provia, 1/15 sec, f11.

to one, and a facility was introduced so that by pushing a small lever on the front of the camera the bright-line frames for the 50mm, 90mm or 135mm lenses could be seen in the viewfinder. This was a great help to previewing and deciding the most appropriate lens for a particular subject.

Although at first there was a little reaction to the increased size of the M3 compared with the earlier screw-mount cameras, the overwhelming advantages of the new camera quickly won over working photographers. Leica also kept faith with users of earlier models by making available adapters so that their screw-fit lenses could be connected to the new M bayonet lens-mount coupling and could be used accurately with the rangefinder and would activate the correct bright-line viewing frame.

At first a separate viewfinder was needed for the 35mm lenses but subsequently Leica incorporated an optical correcting viewfinder with the lens. This automatically adapted the 50mm bright-line frame to the wider angle of view.

THE 1960s AND 1970s

The 35mm lens is the basic tool of the photojournalist and when Leica brought out the somewhat cheaper M2 in 1958, not only were the very complex optics of the M3 rangefinder system

redesigned and simplified, but the viewfinder frames provided were for 35mm, 50mm and 90mm focal lengths rather than the 50mm, 90mm and 135mm of the M3.

The penalty for incorporating the wide-angle viewfinder frame was lower finder magnification and, therefore, a less effective base length for the viewfinder, but the wisdom of the M2 design change became apparent when, as time went on, the 'economy' model began to be the preferred choice of the professionals. It is significant that, although the basic M3 chassis has endured right through to the current M6, it is the M2-type range-/viewfinder that has been the basis for all subsequent M models. With the M4, M5 and M4-2, a 135mm frame was incorporated within the 35mm one, and later the M4-P and M6 also paired a 28mm with the 90mm and a 75mm with the 50mm frames.

After the M2, the next development of the M series was the M4. This 1967 camera incorporated into the basic M2 design the self-resetting frame counter of the M3, together with a new, easy loading system for the film and a much easier to use, quicker operating, rewind knob, which had to be placed at a slightly awkward looking 45° angle to fit within the camera's unaltered, very compact dimensions. The M4 was the classic development of the original classic design, so much so that for all its detail improvements the current M6 is still basically the 1967 M4 with a built-in meter.

The M5 of 1972 was different. This camera also had a superbly sensitive built-in meter with the cell located on an arm that swung out of the way when the shutter was released. Unfortunately the weight and dimensions of this camera were greater than the M4, making it unattractive to the majority of Leica 'M' users in spite of many other useful features, including shutter speed information in the viewfinder and a hot shoe for flash synchronization.

Unlike the introduction of the M3, existing users could not be won over and Leica eventually reverted to improvements of the earlier M4 design. First they brought out the M4-2, in 1977. This was an M4 with provision for a new compact lightweight motor winder, and was followed by the M4-P in 1978 – an M4-2 with extra bright-line frames for the 28mm and the new 75mm f1.4 lenses. These two cameras were developed and made at the Leica factory in Canada, as were most of the M lenses in production by this time.

RETURN TO WETZLAR

The current M6 was introduced in 1984. The outstanding feature of this development of the M series is the particularly neatly executed built-in metering system, which measures off a white spot on the first curtain of the focal plane shutter. This elegant solution, along with its diode indicators in the viewfinder, has the robustness and reliability appropriate to the M series and has been an important factor in winning back many friends for the Leica rangefinder system. With the M6, production reverted to Germany, first at Wetzlar and then at a new factory at Solms just

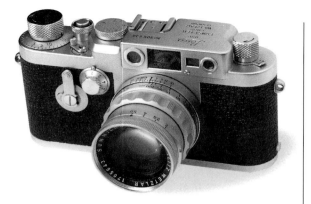

LEICA IIIG
The IIIg was the ultimate Leica for screw-mount lenses. Camera and lenses were beautifully built and finished and are much prized by collectors. The finder and bright-line frames for 50mm and 90mm lenses and the flash synchronization were considerably simplified.

LEICA M3
This was the first M camera and set totally new standards when it appeared in 1954. The first models did not have the lever on the left for previewing the bright-line frames and required two strokes of the lever wind to advance the film.

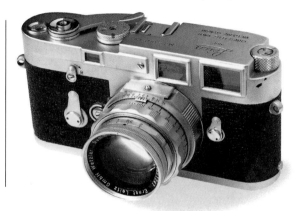

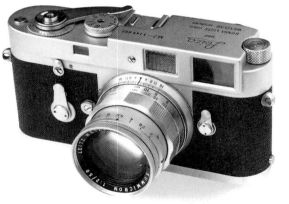

LEICA M2
Originally introduced in 1958 as an economy companion to the M3, the M2 eventually became the more popular of the two cameras, as the bright-line frames for 35mm, 50mm and 90mm lenses were often more convenient than the 50mm, 90mm and 135mm ones of the M3.

LEICA M4
The M4, available from 1967, was an excellent combination of the best features of the M3 and M2, with a new quick-loading system for the film and an unusual tilted rewind crank.

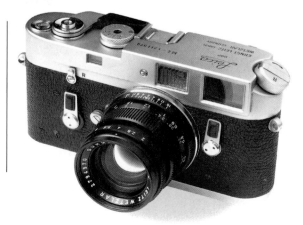

outside Wetzlar. The M6 and its outstanding lens line are discussed in detail in later chapters of this book.

OTHER M MODELS

The above brief history outlines the development of the primary M models. As the table on page 60 indicates, there have been derivatives for special purposes, notably the MP and the Mot cameras (prior to the standard provision for using a motor winder that came with M4-2) together with the simplified M1, MD and MDa cameras, which were variations of the then current M but without rangefinder or viewfinder. These cameras were intended for use in scientific or technical applications. Apart from the 'work' cameras, the M series is especially rich in minor variations and special models, making it a particularly happy hunting ground for the many appreciative Leica collectors.

RETROSPECT

Barnack died in January 1936, some eleven years after the commercial introduction of his camera. Just before his death, however, there occurred two events which, in retrospect, can be seen to have been major influences on the long-term development of the 35mm camera. One was the marketing of Kodachrome colour film, representing the culmination of the research and enthusiasm of two American amateurs – the musicians Mannes and Godowsky. The other was the introduction of the Kine Exakta, the first 35mm camera designed from the outset as an interchangeable lens single lens reflex, taking Barnack's add-on reflex housing a logical step forward. This camera heralded the mainstream of 35mm camera development.

Barnack was a very remarkable man. Not only did he establish the basic format and concept of the 35mm system, but it is fascinating to see how many of his ideas have lived on or been re-introduced many years later. A typical example is the modern autowinder – remember that Barnack developed a winder for the Leica sixty years ago, and it didn't suffer from battery problems, either, because it was clockwork driven!

In a world of 35mm photography that consists overwhelmingly of Japanese manufactured, auto-exposure, automatic focusing, single lens reflexes and 'point and shoot' compacts, it is encouraging to see that the quality coupled rangefinder species with which the format originated, is not only alive and well in the Leica M6 but its merits are being increasingly appreciated by professional and advanced amateur photographers.

Barnack's creative engineering genius was responsible for the concept of the 35mm system camera and his place in the history of photography is secure. It should never be forgotten, however, that the man who made it all possible by shouldering a very considerable financial risk and making it commercially viable was Ernst Leitz II. 'I have decided – we shall risk it' he said in 1924 and photography moved into a new era – technical and aesthetic.

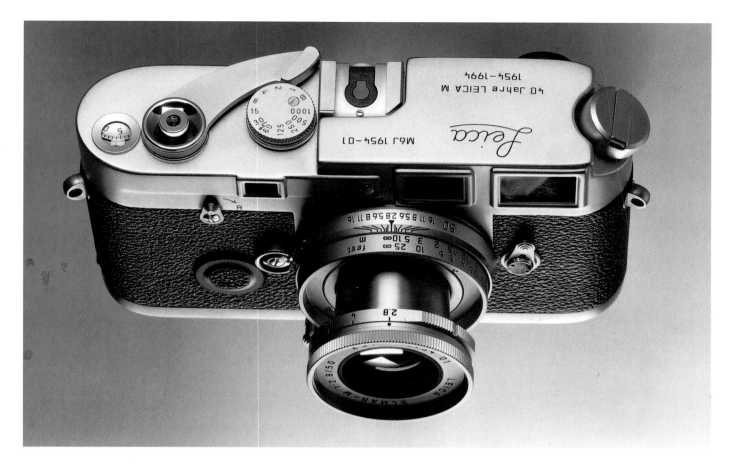

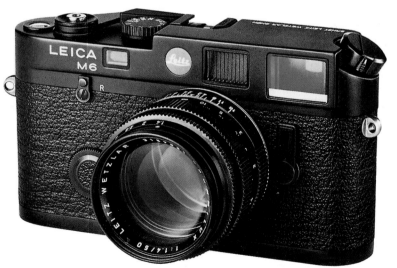

LEICA M6J
This special model was produced in 1994 to celebrate the 40th anniversary of the M Leica. It combines features of the M3 and the M6 and was issued with a redesigned version of the 50mm f2.8 Elmar.

Photo Leica Archiv

LEICA M6
The M6 represents the most up-to-date development of Barnack's camera. It is available in black chrome, silver chrome, or titanium finish.

Photo Leica Archiv

THE LEICA M6 CAMERA

The current M6 is a highly refined development of the M4 line. The original M4 was a classic amalgam of the best features of the M2 and the original M camera, the M3, together with its own highly effective improvements to film loading and rewind. The M6 retains the M4-P multi-frame range-/viewfinder for lenses up to 135mm focal length and its provision for fitting a three-frames-per-second motor drive. The camera is fully manually operated – no autofocus, no autoexposure and the focal plane shutter is mechanically, not electronically controlled. Power is used only to supply the exposure meter so the camera will continue to function reliably whether the batteries are dead or alive.

THE RANGE-/VIEWFINDER

The viewfinder and the combined rangefinder of the M6 is a masterpiece of optical and mechanical design and construction. The basic system harks back to the M2 of 1958 but with many detail

Leica M6

Photo Leica Archiv

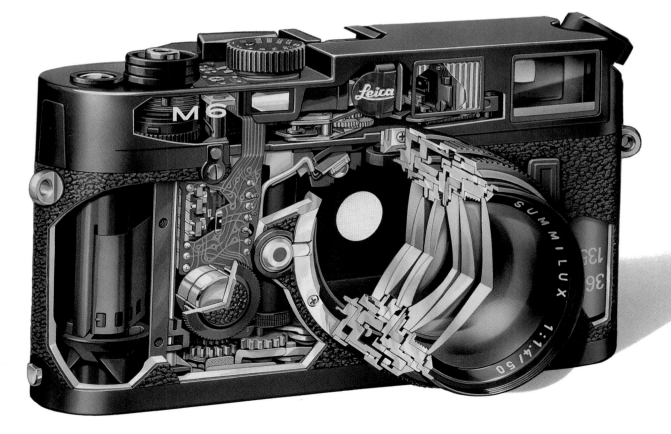

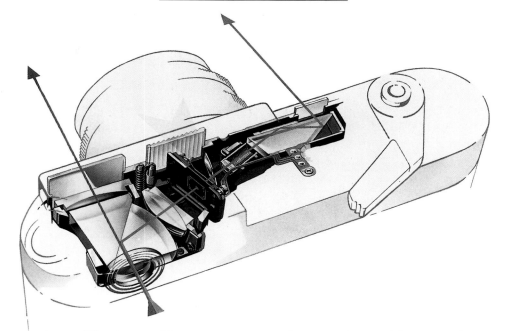

modifications and improvements over the years. Some of the parts are tiny and the precision required in manufacture and assembly is very demanding, yet the whole is amazingly reliable and robust.

The viewfinder automatically shows a bright luminous frame outlining the field of view of the lens in use. In the centre of the viewfinder is the rangefinder patch, the edges of which are so clearly defined that focusing can be carried out by the coincident method, ie superimposing two images, or the split image method, whereby a clear vertical line is chosen so that the image in the rangefinder patch is aligned with that outside. At the same time that the lens is focused, the bright-line frame moves slightly to compensate for parallax. This is the difference in view between the finder and the lens axes, normally minimal, but which can become important at closer distances.

The physical base length of the rangefinder is 68.5mm, so that with the finder magnification of 0.72 × the effective base length is 49.3mm. There are frames for six focal lengths: 28mm, 35mm, 50mm, 75mm, 90mm and 135mm, which appear in pairs – 28 + 90, 35 + 135 and 50 + 75. These combinations have been chosen to avoid the possibility of confusion. The appropriate frames come up when a lens is fitted to the body and they can also be previewed by moving the lever on the left front of the camera. Thus the most appropriate lens can be selected before actually fitting it.

For those who are used to reflex camera viewing there are two particular advantages of the direct viewfinder system – you do not lose the image at the moment of exposure (so you know if your flash went off or somebody blinked and you can follow through accurately when panning a shot), and with all but the 28mm frame, you can actually see what is happening just outside the field of view which is a great help in anticipating events. With distant scenes the image outlined by the frame is slightly smaller than you actually get on the film but the difference is practically eliminated at nearer distances because the angle of view of a lens

Leica M6 rangefinder system, schematic illustration.

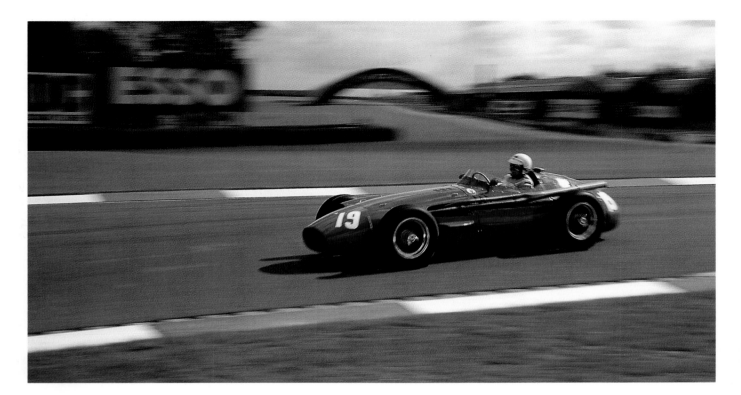

(Previous page)
FERN PASS, AUSTRIA
The widest angle lens for
the M6 is the 21mm.
Although this couples
with the rangefinder for
focusing, viewing is
through a separate
viewfinder. With such a
wide-angle lens, care is
needed to keep the
subject level in the frame
and to avoid
unnecessary tilting of
the camera.

Leica M6, 21/2.8 Elmarit,
Kodachrome 25 Professional,
1/125 sec, f5.6.

narrows the closer you focus. The most difficult thing to get used to is the fact that everything in the viewfinder is sharp. In-focus and out-of-focus areas, so obvious on a reflex screen, are not apparent. Only experience and judicious use of the depth-of-field scale on each lens will teach you how to judge this.

THE BUILT-IN METERING SYSTEM

The built-in TTL (through-the-lens) exposure meter is the outstanding improvement of the M6. Incorporating a robust reliable metering system into the compact M body, which had virtually no space to spare, required great technical ingenuity. The solution is especially elegant. A small lens mounted in the body, just clear of the incoming light rays from the lens, reads off a white spot on the front shutter curtain. The light reading is fed to two LEDS (light-emitting diodes). These are activated by a light pressure on the shutter release and adjusted by altering the shutter speed or aperture until both glow with equal brightness – indicating correct exposure. There are no moving parts and no mechanical coupling to the lens as there is no need for an automatic diaphragm in a rangefinder camera, so that the whole system is accurate, reliable and shockproof. It is quite remarkable how much more convenient the M6 is to use compared with the earlier Ms that are used with a separate meter or even the well proven MR meter that couples to the shutter speed dial.

CONSTRUCTION

A minor difference with the M6 compared with earlier Ms is that the top plate to the body is made from a zinc alloy rather than

VINTAGE RACING
CAR
This picture of a Ferrari
was taken during a
vintage meet at
Donnington. One of the
advantages of the M
camera is that you have
continuous vision of the
subject – a great help
when 'panning' the
motion as here.

Leica M4, 50/2 Summicron,
Kodachrome 25 Professional,
1/60 sec, f8.

brass. The metal is very slightly thicker which means that one or two earlier accessories either will not fit or need special care when attaching them to the M6. In the most recent M6 production the baseplate latch has also been changed and will no longer operate the old Leica N cassettes. These could be used to load 35mm film from bulk rolls and incorporated a scratch-avoiding, light-trapping system that was opened by the key which locked the baseplate.

LENS FITTING

The M6 accepts all Leica M bayonet lenses and all Leica screw-mount lenses when fitted with a bayonet adapter. It should be noted, however, that although they can be fitted and used on the camera, certain lenses obscure the meter cell and will give incorrect readings (see chapter 8, Earlier Rangefinder Lenses, pages 67–73). It accepts the discontinued Visoflex III reflex housing so that the lenses designed for this accessory can also be fitted, thereby allowing long-telephoto and close-up photography, albeit significantly less conveniently than with a Leica R single lens reflex camera.

M6 FILM LOADING

As with all Leica rangefinder cameras, the M6 is loaded from the bottom after removing the camera baseplate. The quick-load system which involves slotting the film leader into a three-prong take-up spool (as shown on the bottom of the shutter housing when the baseplate is off) was introduced with the M4 and on the whole has proved to be quick and reliable. In recent years, however, occasional misloads seem to be more frequent than in my early days with the M4. There are two likely reasons for this. One is simply that very occasionally the film cassette has been very tightly crimped in manufacture and there is considerable initial resistance, preventing the film pulling out easily and smoothly. The cure is to pull the film out an extra half inch or so before loading it into the camera and then if necessary to wind it back a little. This eliminates that initial resistance so the film will wind on instead of slipping out of the take-up spool prongs.

Schematic of the Leica M6 metering system.

The white spot on the M6 focal plane shutter curtain from which the meter reads.

Photos Leica Archiv

27

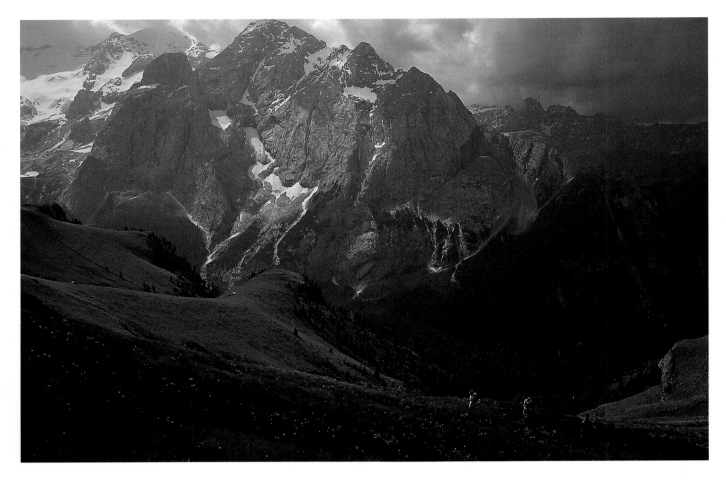

MARMOLADA,
DOLOMITES, ITALY
The widest angle lens for
which a bright-line frame
is provided in the M6
range viewfinder is the
28mm. The 21mm
requires a separate
viewfinder. The '28' is an
excellent general
purpose wide-angle lens
and the current design is
an outstanding
performer.

Leica M6 28/2.8 Elmarit,
Kodachrome 25 Professional,
1/125 sec, f5.6.

DELTA AIRLINES
TRISTAR
The longest focal length
that is provided for in
the M6 rangefinder
system is 135mm. The f4
Tele-Elmar is a compact
'135' with almost 'apo'
performance, as this shot
at full aperture on a slow
high-quality film
demonstrates.

Leica M6, 135/4 Tele-Elmar,
Kodachrome 25 Professional,
1/500 sec, f4.

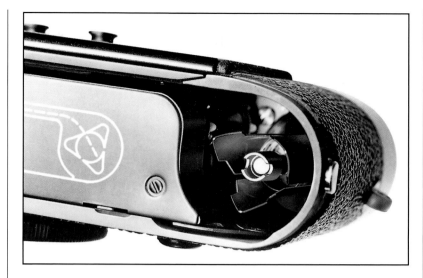

The second cause is related to the fact that the half-depth leader section on 35mm film is much shorter than it used to be. The longer leader is absolutely essential with screw-mount Leicas (see p 63) and, although not essential, it also helped ensure that the film fed accurately into its track in the M4 and later M cameras. There is always a slight kink in new film where it has been lying against the cassette mouth in the film container. This kink, which used to be in the half-depth leader section, is now the full width of the film and sometimes prevents the film slotting easily into its track as it is pushed into place when the baseplate is attached. Sometimes the film even gets caught up with the shutter curtains, which could be quite disastrous. The trick is just to ease the film up so that it is definitely lying correctly in the track before closing the back flap and replacing the baseplate.

Finally, always, but always, check that the rewind knob is rotating as you wind on (after first taking up any slack in the film). This should be standard practice with all cameras and has certainly saved me some potentially very embarrassing situations!

CURRENT LEICA M LENSES

Leica lenses have always been the standard by which all other lenses for 35mm cameras are judged. Max Berek's Elmax and Elmar lenses for the very first Leicas in 1924 and 1925 achieved the remarkable quality that made the new, tiny negative format viable and ever since Leica have been at the forefront. Leica lenses are especially renowned for the results they deliver with colour film. It is difficult to define the special quality they have; it is not just sharpness and contrast but also a purity and clear differentiation of colour that sets them apart.

With the growth of the versatile single lens reflex systems and in particular Leica's own redoubtable R line of cameras, the range of lenses needed for the M cameras has reduced. Lenses with focal lengths from 21mm to 135mm couple with the rangefinder. Compared with the single lens reflex this range may seem somewhat restrictive but in practice it is only in specialized areas of wildlife or sports photography, demanding very long lenses, or with critical close-up photography, that the M user is inhibited. The M can in fact be adapted for this kind of work with the (discontinued) Visoflex add-on reflex housing and its lenses, described on pages 74–81, but this is a rather clumsy solution when compared with a modern SLR such as the R7.

For general purpose photography, the present M range of lenses is more than adequate and the considerable advantages of

A compact and versatile M outfit. M6 body with 35mm f2 Summicron, a 50mm f1.4 Summilux and 90mm f2 Summicron.

COLLE SAN LUCIA, DOLOMITES, ITALY This series of pictures shows the different angle of view of the range of M6 lenses. They also demonstrate the consistency of colour balance of the various lenses. All were taken on Kodachrome 25 Professional film.

Leica M6, 21/2.8 Elmarit, 1/125 sec f5.6.

Leica M6, 28/2.8 Elmarit, 1/125 sec f5.6.

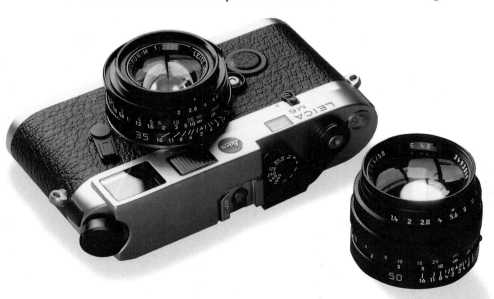

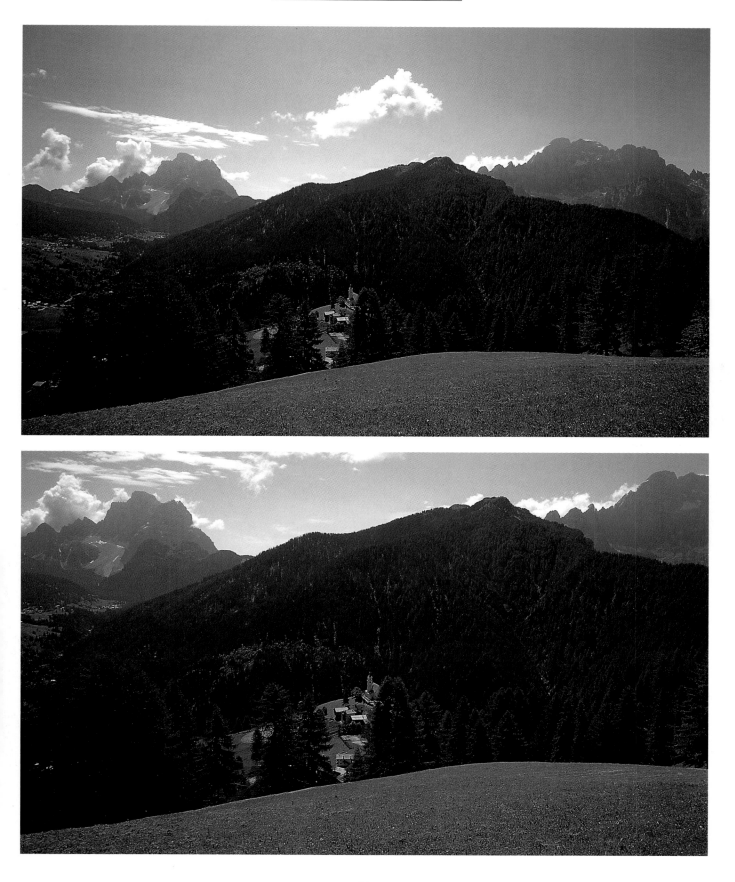

the rangefinder camera are supported by outstandingly good optics. In particular Leica have developed some very fast, top quality lenses for the M. The 50mm f1 Noctilux and the 35mm f1.4 Aspheric Summilux are remarkable examples of the lensmaker's art, designed to exploit the M cameras' abilities in 'available darkness'. The 35mm f2 Summicron is a classic design in an incredibly compact package, complementing the compact dimensions of the M camera.

Compared with a single lens reflex, the rangefinder system offers significant advantages to the lens designer. Optically he is free of the need to produce lenses with sufficient back-focus to ensure that the rear element is clear of the reflex camera's instant return mirror. With ultra-wide-angle lenses this constraint imposed by an SLR can be quite serious. As an example, the 21mm f3.4 Super Angulon for the M cameras, introduced as long ago as 1960 and itself superseded in 1980 by the 21mm f2.8 Elmarit M, will still equal or better any SLR equivalent.

Mechanically the M lens is free of the cams and levers needed for the fully automatic diaphragms and full aperture metering systems in the SLR lens. In design terms the essential rangefinder cam is relatively simple to incorporate although it does require extreme precision in the manufacture, assembly and final adjustment of the lens. The rangefinder lenses can therefore be made very robust and relatively compact. The reliability factor achieved with quality manufacturing is easily judged by the number of M lenses from the 1960s and 1970s that are still in regular use, and the fact that lenses from way back in the 1930s will still couple accurately with a modern M6 rangefinder and deliver very acceptable results.

The M6 viewfinder has bright-line viewing frames for 28mm, 35mm, 50mm, 75mm, 90mm and 135mm focal lengths. For the 21mm lens, a separate viewfinder is fitted to the accessory shoe. The viewfinder magnification is a constant 0.72 × life-size. Compared with a typical SLR this means that the M viewfinder image is about the same size when a 50mm lens is fitted, larger when wide-angle lenses are fitted, and smaller with the longer focal lengths. The frames for the different focal lengths can be previewed by moving the lever on the front left of the camera, thereby allowing the most suitable lens to be chosen easily.

THE STANDARD LENSES

The 'standard' focal length of 50mm is a good general purpose lens as it equates with the angle of view of the human eye. There are four 50mm lenses available for the M6. Each has advantages and disadvantages and no particular one can be described as the best as this depends very much on the needs of the individual photographer.

50mm f2.8 ELMAR

First introduced to accompany the special edition M6J, this lens is the latest, recomputed, re-engineered version of the Max Berek's

Leica M6, 35/2 Summicron, 1/125 sec f5.6.

Leica M6, 50/2 Summicron, 1/250 sec f4.

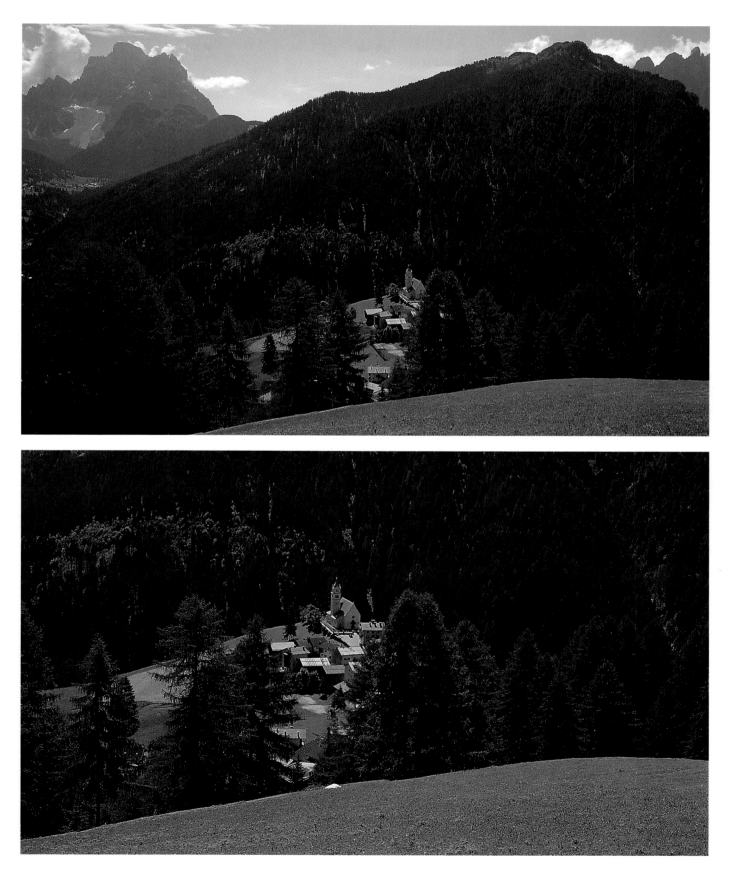

classic Leica rangefinder lens. The collapsible design provides an amazingly compact camera/lens combination. Performance is very good and fully maintained in the close-up range. The Elmar is available in black or chrome finish.

50mm f2 SUMMICRON

When the first 50mm Summicron was introduced for the Leica IIIf in 1953 it was a sensation. It incorporated new types of optical glass and the design set new standards for lenses for 35mm cameras. Since then there have been three redesigns of this lens for the rangefinder Leicas. The first was in 1958, when a completely revised optical design, but still retaining seven elements, was incorporated in a rigid, rather than a collapsible mount; the second was in 1968, when new glass types allowed a six element design with closer focusing (0.7m instead of 1m) and better correction in the near range. The third, in 1978, was designed and first produced by Leica Canada. It also has six elements but with even more advanced glass types and is of lighter construction than its predecessor. The lens was modified to incorporate a built-in lens hood in 1994 but the optical design remains unchanged. Each of these four Summicrons has become the standard for judging all other contemporary 50mm lenses for 35mm cameras.

Not surprisingly the Summicron is the most popular standard lens. The maximum aperture of f2 is entirely adequate for most needs. It focuses closer than the Summilux or the Noctilux 0.7m (28in), instead of 1m (40in), and it is smaller, lighter and cheaper. Partly because of its more modest maximum aperture, a higher degree of correction for the various optical aberrations has also been achieved. In absolute technical performance this is the best of the three lenses and if this is the only factor to be taken into account this lens must be the first choice. It is available in silver chrome as well as the standard black finish. The chrome lens is heavier as the finish requires that the lens mount is made from brass instead of light alloy.

50mm f1.4 SUMMILUX

Although a relatively old design, the Summilux seems to have been 'tweaked' over the years; the coatings in particular have been improved, giving very good colour rendering. This lens has always been particularly reliable when shooting against the light, with great freedom from reflections and flare. Performance at f1.4 is remarkably good. A careful comparison would show the Summicron to have better edge definition at f2 and f2.8 but from f4 to f16 you would have great difficulty in distinguishing between them on any normal subject. The Summilux is slightly bulkier and noticeably heavier than the Summicron but is still quite compact and fits easily into an outfit case. It is comfortable to handle and the less steep focusing helix can sometimes make for greater accuracy. The latest version, introduced in 1995, focuses to 0.7m, has a built-in collapsible lens-hood, takes an E46 filter and is available in black or titanium finish.

Leica M6, 90/2.8 Elmarit, 1/250 sec f4.

Leica M6, 135/4 Tele-Elmar, 1/250 sec f4.

34

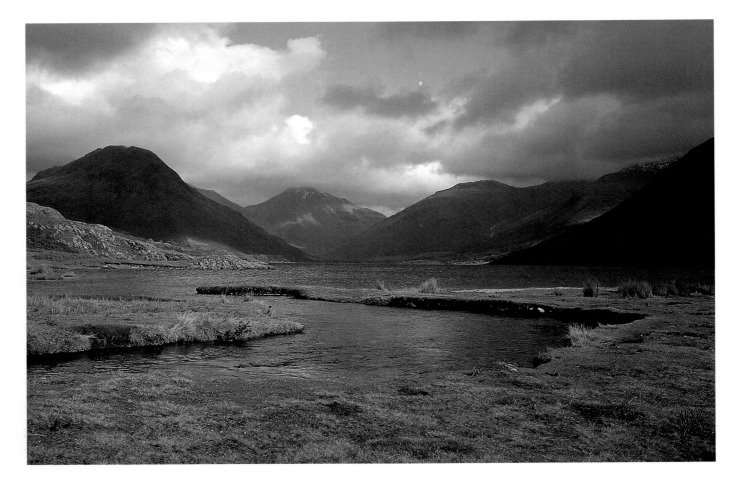

50mm f1 NOCTILUX

The Noctilux is a technical *tour de force*. Image quality at f1 is very good over most of the field and remarkably free from reflections and flare caused by bright lights in the picture area. Although the design has naturally been optimized for low light photography at the wider apertures, the lens still performs very well indeed for more usual photographic applications in good light at smaller stops. All lenses are subject to vignetting (darkening in the corners) at wider apertures and wide angles. Open up any f2 lens to its maximum aperture and photograph an even tone, such as a white wall or blue sky, and this will be apparent. Not surprisingly, at the Noctilux's f1 maximum this vignetting is more obvious, but in practice this is rarely a problem with the kind of pictures taken in very low light. The lens is big and heavy as well as extremely expensive but if you habitually work in poor light the performance is astonishing with outstanding differentiation of tonal values and colour. The current lens, introduced in 1994, has a redesigned mount incorporating a built-in lens hood but the optical design is identical to its predecessor.

THE WIDE-ANGLE LENSES

The 35mm focal length is a classic lens for the street photographer or photojournalist as well as for much travel photography. In

36

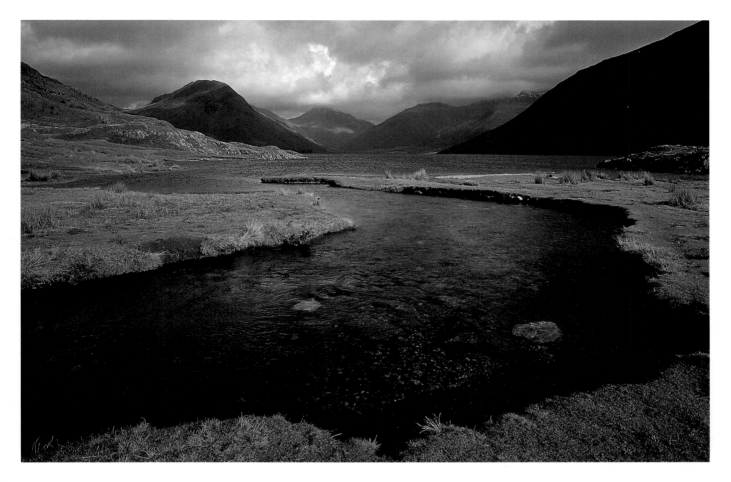

practice many such photographers look upon the 35mm as their standard lens. This was why, eventually, the later M2 viewfinder, which incorporated a 35mm frame as standard, overtook the M3 and became the basis for subsequent M cameras. More recently the 28mm has become very popular and Leica 'stretched' the finder to include this frame as well. The 21mm lens is more specialized in its application so the need to use a separate viewfinder for this focal length is less inconvenient than might be expected. The 28mm and more particularly the 21mm can provide dramatic perspective effects and great depth-of-field so that dominant foregrounds can be set against detailed, still sharp, backgrounds.

21mm f2.8 ELMARIT

This lens was introduced in 1980. The slightly increased back focus, as compared with its predecessor the f3.4 Super Angulon, means that the rear of the lens does not project so far into the camera body and therefore allows metering with the M6 and also with the much earlier M5. Performance is excellent even at full aperture, but stopping down to f5.6 or smaller will reduce the inevitable vignetting of such a wide-angle lens and also achieve best possible definition on subjects that have critical detail at the extreme edges of the image. The lens is relatively free from

Leica M6, 21/2.8 Elmarit, Kodachrome 25 Professional, 1/125 sec f5.6.

reflections which is useful as, when shooting against the light, the sun is quite likely to be included in the picture area. Distortion is minimal, remarkable in such a wide-angle lens.

28mm f2.8 ELMARIT

A new design introduced in 1993, this latest version is noticeably more compact than its predecessor. First class performance at full aperture improves slightly on stopping down to f4/f5.6. As with the 21mm version, reflections from bright light sources in the picture area have been virtually eliminated and the lens can be used confidently against the light. For practical purposes distortion is non-existent. This is a highly desirable lens.

35mm f2 SUMMICRON

The first 35mm Summicron was introduced in 1958. The current model is the fourth design, dating from 1980 although, again, I get the impression that it has been 'tweaked' since then. Very light, very compact, with a dinky but very effective rectangular lens hood, it is a very useful general purpose lens of excellent performance. Care is sometimes needed to avoid reflections at certain angles when shooting into the light. Some vignetting is apparent at full aperture or with subjects of an even tone but this is minimal for a wide-angle lens of this speed, and quickly improves on stopping down. Available in silver chrome as well as the standard black finish.

35mm f1.4 SUMMILUX ASPH

This lens, introduced at Photokina 1994, matches the exceptional performance of the earlier limited-production Aspherical Summilux. By using new production techniques to mould a single aspheric surface the cost has been reduced to more acceptable levels. Edge definition and contrast at wide apertures are outstanding. The lens is much heavier and significantly bulkier than the 35mm Summicron, even more so when each is fitted with its lens hood. It is expensive too, but if you want outstanding performance at f1.4, this is your lens.

THE TELEPHOTO LENSES

Strictly the word 'telephoto' means a lens with shorter back-focus than its focal length, but the term is now frequently used to include any lens with a focal length longer than standard.

Leica provide three focal lengths in the range of longer lenses for the M series – these are 75mm, 90mm and 135mm, with a choice of maximum aperture for 90mm and 135mm. All but the 75mm are of true telephoto construction, enabling the design to be kept very compact. Apart from the obvious advantage of allowing less accessible subjects to be photographed, the benefits of a medium telephoto such as the 75mm or 90mm are that they encourage selectivity of subject matter and, because of the reduced depth-of-field available, allow differential focusing so that a sharp main subject is separated from an out-of-focus background. The 135mm focal length is a very useful longer

TUG, HULL DOCKS
Some of the most interesting pictures present themselves in very low light conditions. The M6 and its fast lenses are ideal for these situations.

Leica M6, 50/1.4 Summilux, Kodachrome 200 Professional, 1/60 sec, f1.4.

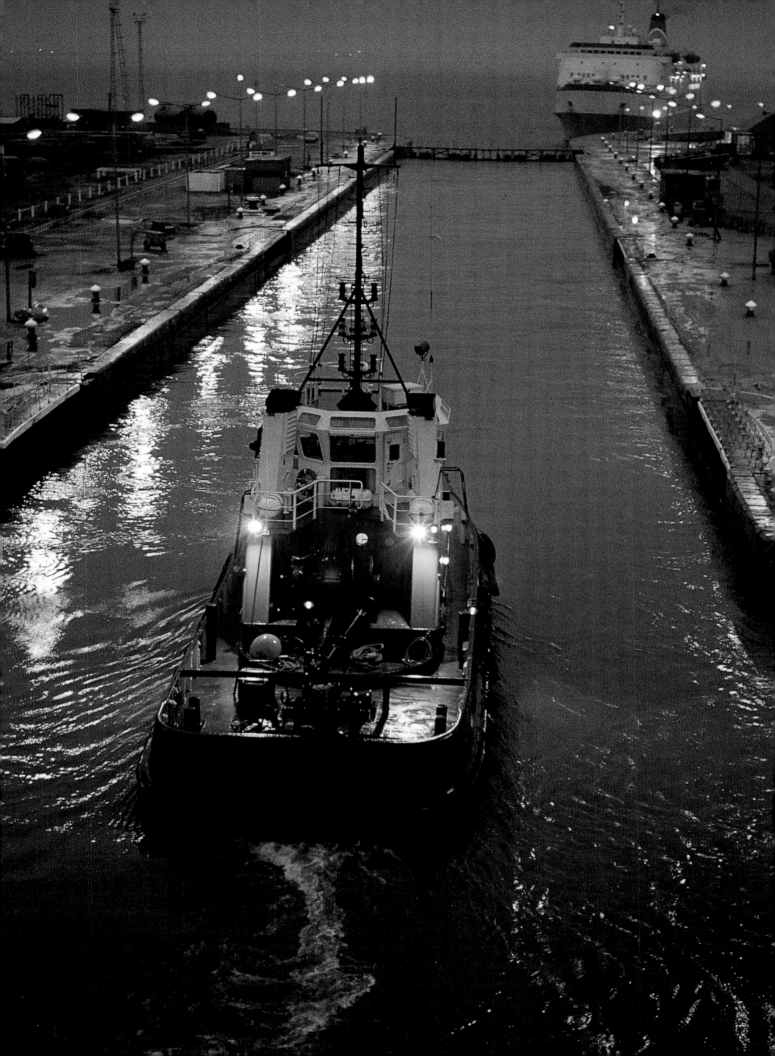

telephoto for travel, landscape and some general purpose sports and action photography, but those specializing in wildlife and sports photography will probably also wish to have longer focal lengths available via the Visoflex housing or an SLR system.

75mm f1.4 SUMMILUX

When a longer focal length with an f1.4 maximum aperture was required this was the longest that could be accommodated without seriously obscuring the viewfinder. This is a first class lens, particularly free from reflections. It has good performance when wide open at f1.4 which becomes excellent at f4 and smaller stops.

90mm f2 SUMMICRON

A superb lens and very compact considering its speed. The performance at f2 is very good and when stopped down one or two stops it is excellent. It is relatively free from reflections and the vignetting at full aperture is minimal. If absolute best performance is required in the near range (below about 2.5m/8ft) it is necessary to stop down to f4 or smaller – but this is perfectionism! As well as the standard black finish, there is a silver chrome version. Again this is heavier due to the use of brass instead of light alloy for the mount.

90mm f2.8 ELMARIT

The same optical design as the 90mm f2.8 Elmarit R. A well tried lens of excellent performance at all apertures. A little more compact than the 90mm Summicron but not markedly so. Its performance in the near range is a little better than the Summicron. This lens is very keenly priced; this, plus top optical performance make it a very good buy.

135mm f2.8 ELMARIT

Another lens optically identical to the R series equivalent. In order to ensure accurate rangefinder focusing at f2.8 an optical attachment that magnifies the view-/rangefinder image 1.5 times is built onto the lens. It gives a very good performance, even wide open, but this lens is very bulky especially by Leica M standards.

135mm f4 TELE-ELMAR

The latest versions of this lens have a redesigned mount incorporating a built-in lens hood. This is an important practical convenience. Those who still use a Visoflex should note, however, that it is no longer possible to remove the lens head and use it in the Universal focusing mount or Bellows II.

Performance of the Tele-Elmar is outstanding even at full aperture. In my opinion this lens is virtually apochromatic standard and there need be no hesitation in using it wide open at f4 whenever necessary.

MEMORIAL DAY PARADE, FLEMINGTON, NEW JERSEY
The dynamic perspective and amazing depth-of-field of the ultra-wide 21mm focal length allied to the quiet, unobtrusive Leica M, provide an ideal combination for grab-shots and candids. Shooting against the light gave strong shapes and colours to the composition.
Leica M6, 21/2.8 Elmarit, Kodachrome 25 Professional, 1/125 sec, f5.6.

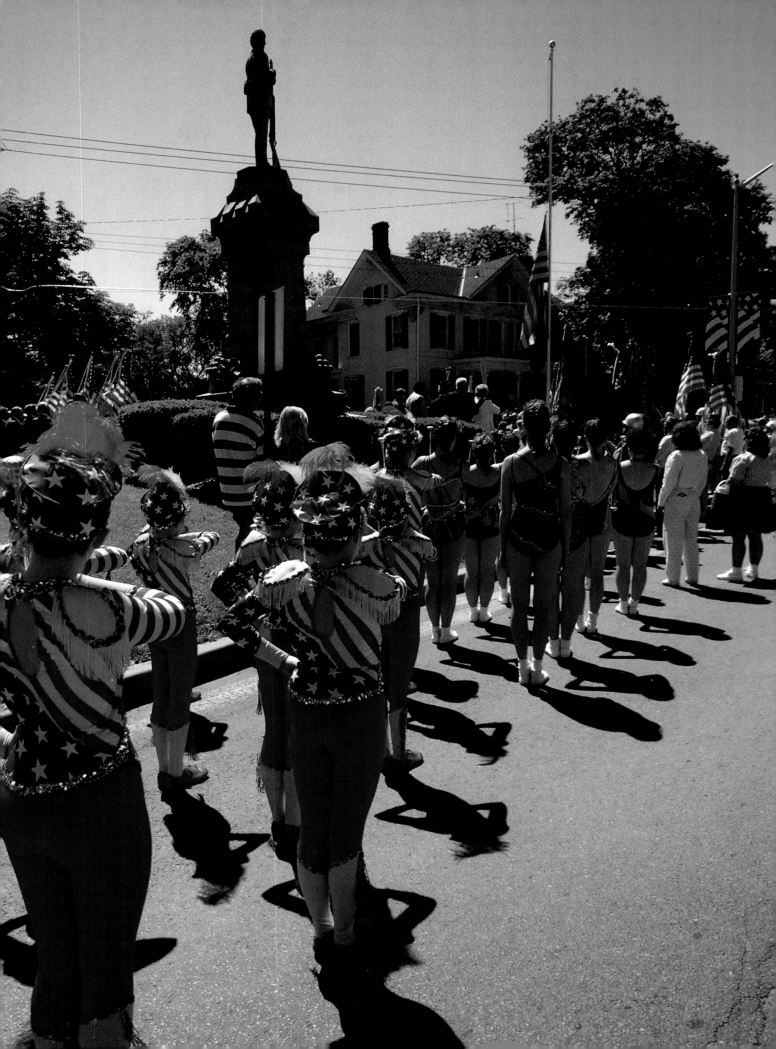

TABLE 1:
CURRENT LEICA M LENSES

Lens	Speed focal length mm	Angle of view	Lens elements groups	Smallest aperture	Focusing range in mm	Smallest object field in mm	Recommended filter size	Length in mm	Largest Ø in mm	Weight in g	Order no
ELMARIT-M	1:2.8/21	92°	8/6	16	∞ - 0.7	705×1,058	E60	46.5	62	290	11 134
ELMARIT-M	1:2.8/28	76°	8/7	22	∞ - 0.7	533×800	E46	48	53	260	11 809
SUMMILUX-M ASPH.	1:1.4/35	64°	9/5	16	∞ - 0.7	420×630	E46	44.5	53	300	11 874
SUMMICRON-M	1:2/35	64°	7/5	16	∞ - 0.7	430×640	E39	26	52	160	11 310
SUMMICRON-M silver chrome	1:2/35	64°	7/5	16	∞ - 0.7	430×640	E39	26	52	250	11 311
NOCTILUX-M	1:1/50	45°	7/6	16	∞ - 1.0	410×620	E60	62	69	630	11 822
SUMMILUX-M	1:1.4/50	45°	7/5	16	∞ - 0.7	277×416	E46	46.7	54.5	275	11 868
SUMMILUX-M titanium	1:1.4/50	45°	7/5	16	∞ - 0.7	277×416	E46	46.7	54.5	380	11 869
SUMMICRON-M	1:2/50	45°	6/4	16	∞ - 0.7	277×416	E39	42	52	225	11 826
SUMMICRON-M silver chrome	1:2/50	45°	6/4	16	∞ - 0.7	277×416	E39	42	52	295	11 816
ELMAR-M	1:2.8/50	45°	4/3	16	∞ - 0.7	274×411	E39	21.6	52	200	11 824
ELMAR-M silver chrome	1:2.8/50	45°	4/3	16	∞ - 0.7	274×411	E39	21.6	52	200	11 823
SUMMILUX-M	1:1.4/75	31°	7/5	16	∞ - 0.75	192×288	E60	80	68	600	11 815
SUMMICRON-M	1:2/90	27°	5/4	16	∞ - 1.0	220×330	E55	77	62.5	475	11 136
SUMMICRON-M silver chrome	1:2/90	27°	5/4	16	∞ - 1.0	220×330	E55	77	62.5	690	11 137
ELMARIT-M	1:2.8/90	27°	4/4	22	∞ - 1.0	220×330	E46	76	56.5	410	11 807
ELMARIT-M	1:2.8/135	18°	5/4	32	∞ - 1.5	220×330	E55	114	66	780	11 829
TELE-ELMAR-M	1:4/135	18°	5/3	22	∞ - 1.5	220×330	E46	107	57.5	550	11 861

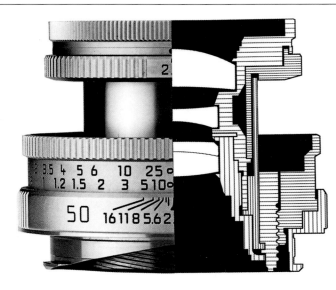

The new version of the Elmar 50mm f2.8 first introduced with the M6J.

Photo Leica Archiv

CROSS-SECTION DIAGRAMS OF CURRENT LEICA M LENSES

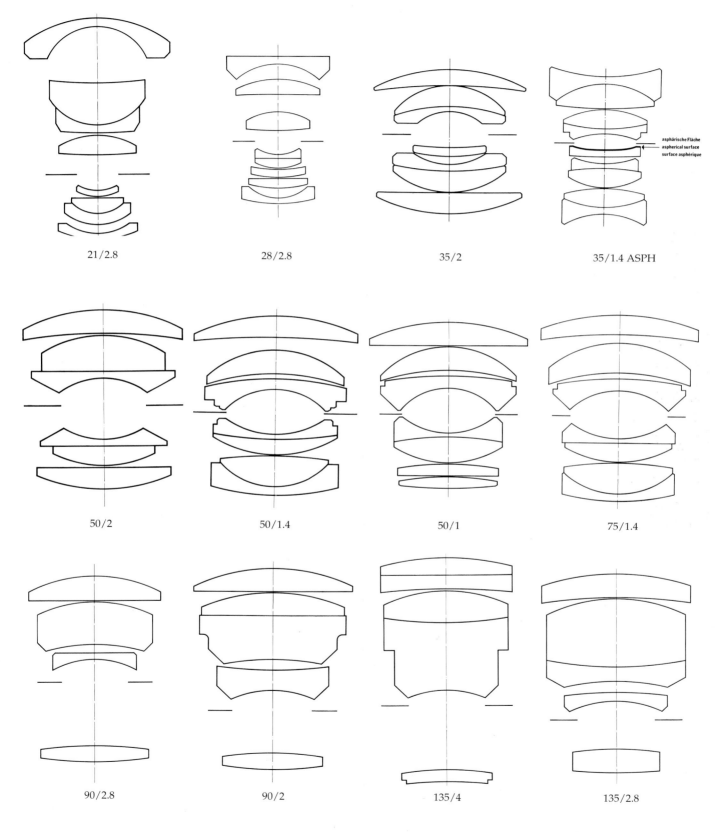

21/2.8 28/2.8 35/2 35/1.4 ASPH

asphärische Fläche
aspherical surface
surface asphérique

50/2 50/1.4 50/1 75/1.4

90/2.8 90/2 135/4 135/2.8

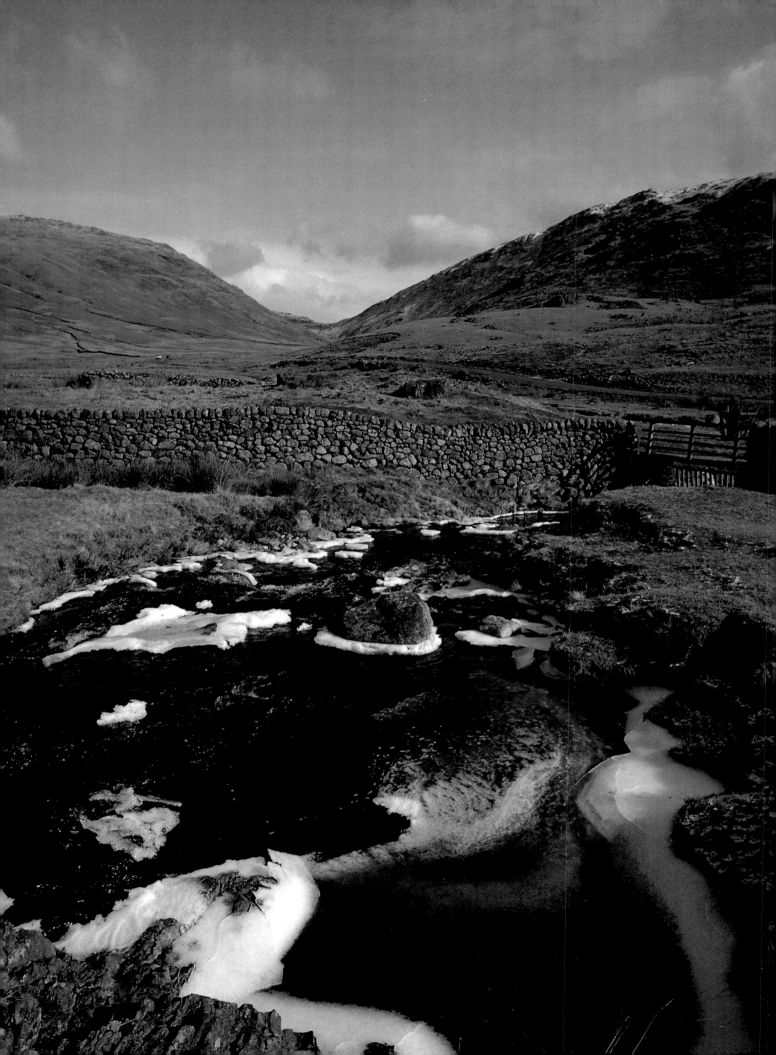

CHOOSING LENSES

LAKELAND STREAM
Enormous depth-of-field available with a 21mm lens allows images that are sharp from detailed close-up foregrounds through to the far distance. Accurate measurement with the rangefinder allows the near and far distances to be established and careful use of the depth-of-field scale will ensure sharpness throughout.

Leica M6 21/2.8 Elmarit,
Kodachrome 25 Professional,
1/60 sec, f8/11.

Every photographer has different interests and priorities and the Leica M user, more than most, is likely to be experienced in photography and have clear ideas on his favourite subjects. These suggestions for choosing lenses are based on practical experience over a fairly long period but they are personal and should be considered no more than a starting point for further consideration.

WEIGHT

One of the great attractions of an M is its compactness and light weight. Unless you really do need them, there is no point in encumbering yourself with bulky, heavyweight lenses such as the 50mm f1 Noctilux or the 135mm f2.8 Elmarit. Nor is there a need to carry the full range of focal lengths. In fact, for more strenuous hiking and walking activities a 35mm Summicron and a 90mm Elmarit (or even better, a late model 90mm Tele-Elmarit) are my choice to cover almost all requirements and still be very light and easy to carry. If need be, a 50mm Summicron does not add too much extra weight and the whole outfit is still eminently pocketable.

The lightweight lenses of the current range are the 35mm f2 Summicron, the 50mm f2 Summicron and the 90mm f2.8 Elmarit. As well as being the lightest in their focal length range they are also the least expensive and of the highest optical quality. An M6 together with these three lenses will cover a high proportion of general photographic needs and, correctly handled, produce images of outstanding quality.

The 90mm f2.8 Tele-Elmarit, now discontinued, is an extremely compact lens ideal for hikers and climbers especially in combination with a 35mm f2 Summicron.

Photo Leica Archiv

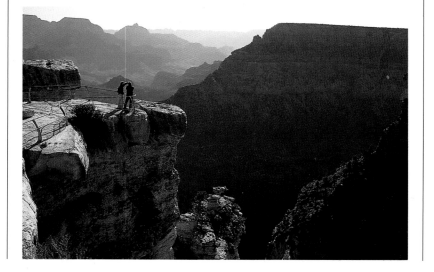

GRAND CANYON
An early morning view from the South Rim. The low light and the remaining traces of mist give depth to the picture and the figures help the sense of scale.

Leica M4, 35/2 Summicron,
Kodachrome 25 Professional,
1/125 sec, f5.6.

SPEED

The M6 is undoubtedly the camera for 'available light'. For this reason the higher speed lenses have a particular attraction. Nevertheless in my experience of general photography there is only an occasional need for anything faster than f2 so the only 'super speed' lens that I regularly carry is the 50mm f1.4 Summilux. My other most used 'fast' lenses are the 35mm and 90mm Summicrons. In other focal lengths the 21mm and 28mm f2.8 Elmarits are both top performers, and in reasonable light the lens speed is perfectly adequate even for Kodachrome 25. The normal exposure for an ISO 25 film in good sunlight allows 1/500 sec at f4 so that action photography is practical even with the 135mm f4 Tele-Elmar.

ESSENTIALS

The majority of regular M Leica users will tell you that they would be lost without a 35mm lens. My own favourite in this focal length is the f2 Summicron. It is light, compact and plenty fast enough for most needs. The most useful companion to this lens is a 90mm. Again my preference is the Summicron, which is not that much bigger and heavier than the Elmarit. With the longer focal length the extra stop is a help, allowing faster shutter speeds even at lower light levels, thereby preventing camera shake when using the slower colour transparency films.

For me these two lenses are the absolute essentials. Normally I like to have with me my 21mm Elmarit and also one of the 50mm lenses. As indicated my usual preference at 50mm is the Summilux so that I have at least one f1.4 lens with me; however, when travelling light or perhaps needing closer focusing capability or the ability to use the polarizer, I choose the Summicron.

On a major photo trip I also take the 28mm Elmarit and 135mm Tele-Elmar along but these are used much less frequently than the other lenses and are really there 'just in case'!

CONCLUSION

As stated at the start, my comments and choices of lenses are personal. All the current M lenses are first class so whatever choice you make will not prejudice performance and I urge you not to be in too much of a hurry to buy extra lenses until you have really decided where your main interests lie. Plan your acquisitions so that you have a basic 'core' outfit which you are comfortable with, and supplement this with other lenses when the necessity arises.

KEEPING IT SHARP

Whichever Leica lenses you choose they will be capable of producing images of the highest quality. Maximum aperture whether it is f1 or f4 is entirely usable whenever necessary. Most Leica lenses are at their optimum by f4 or f5.6, and further stopping down is only required to increase depth-of-field.

SAILPLANE
Different focal lengths allow subtle changes in the appearance of a subject. In these two shots, one with a 28mm the other a 90mm lens, the aircraft is kept the same size in the picture, but notice the effect on the background.

Leica M6 28/2.8 Elmarit, Kodachrome 25 Professional, 1/125 sec, f5.6/8.

Leica M6, 90/2 Summicron, Kodachrome 25 Professional, 1/250 sec, f4/5.6.

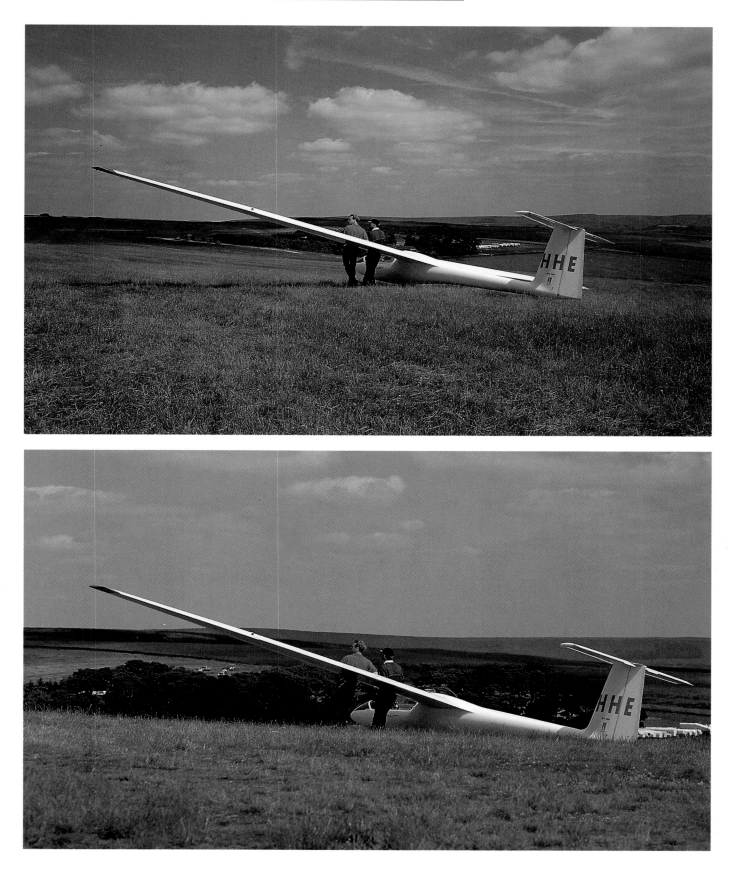

EDWIN APPLETON,
HON FRPS

The Noctilux lens is an optical *tour de force*, as can be seen in this shot taken by daylight indoors. The quality at its full aperture of f1 is remarkable. The minimal depth-of-field available at this aperture is also obvious.

Leica M4, 50/1 Noctilux, Kodachrome 25, 1/60 sec, f1.

Ensuring that you achieve the best results a lens is capable of requires a reasonable amount of care but this will be repaid handsomely. The essential elements are: accurate focusing with adequate depth-of-field; avoidance of camera shake and subject movement; the right film correctly exposed; and appropriate lighting.

Rangefinder focusing is extremely positive and less demanding of perfect eyesight than reflex viewing. Nevertheless for critical work you should ensure that you can see the rangefinder images absolutely clearly. This may mean wearing glasses or having a correction lens fitted to the camera eyepiece. Leica stock dioptre correction lenses but for more complicated prescriptions, such as astigmatism, they provide a suitable mount into which your optician can fit an appropriate correction lens.

Depth-of-field requirements can be established easily with the rangefinder. Focus on the nearest and farthest parts of the subject that need to be sharp, check the relevant distance readings on the lens scale, and then choose a stop that encompasses the two distances on the depth-of-field scale. For instance if you are photographing a landscape with a 35mm lens and require everything sharp – from a foreground at 5 metres through to infinity – the depth-of-field scale will show that by setting the lens to 10 metres both distances will be adequately sharp if you stop down to f4. Always remember, however, that depth-of-field only indicates a theoretical degree of acceptable unsharpness, and only the focused point is perfectly sharp. For this reason and to be sure of high quality, I always try to use one stop smaller than the scale would demand, so that in the example above I would use the same 10-metre focus setting but stop down to f5.6.

Amazing lens speed and remarkable performance are combined in the 50mm f1 Noctilux.

In my experience camera shake is the biggest single cause of unsharp pictures. Many photographers are wildly optimistic about their ability to hold a camera/lens combination steady. To be reasonably certain of a perfectly sharp result my rule of thumb for minimum shutter speeds with the different focal length Leica M lenses are:

lens	shutter speed
21/28mm	1/60 sec
35mm	1/125 sec
50/75mm	1/250 sec
90/135mm	1/500 sec

This is not to say that I would not use slower speeds if circumstances demand. A less-than-perfect shot of an interesting or unrepeatable subject is better than no shot at all. It is entirely possible with the smooth, vibration-free M camera to get acceptable results hand-held even at 1/8 or 1/15 sec. By careful wedging of the camera or support of the body on a wall or fence, the odds can be significantly improved. The techno-perfectionist would say, 'use a tripod'. To me this defeats the very special nature of Leica M photography and the only time I use the tripod is for critical close-up work with the Visoflex. However, I often carry the little table tripod on my travels and resort to this when the light levels get too impossible; but this is a last resort. Always remember that your Leica lenses really do perform at wide apertures so use what you have paid for!

A shutter speed of 1/250 sec or 1/500 sec will stop most normal subject movement – people walking, branches waving, cars at a distance – but fast or close action will often need your highest shutter speed of 1/1,000 sec. This can apply irrespective

A comprehensive M6 outfit. Two bodies, one with the 35mm Summicron and one with the 50mm Summilux, a 21mm Elmarit with special viewfinder, a 135mm Tele-Elmar and a 28mm Elmarit coupled back to back with the 90mm Summicron. Note that care is needed when using the coupling ring as the projecting rear elements of some lenses can be damaged if its 'partner' is not chosen carefully.

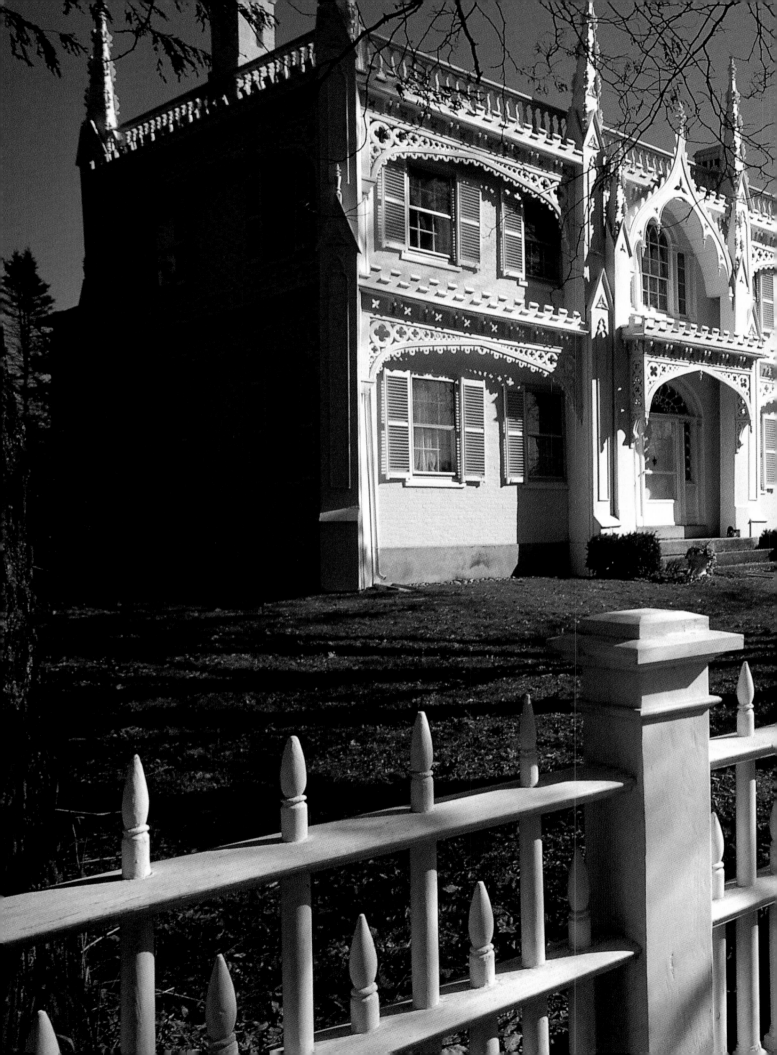

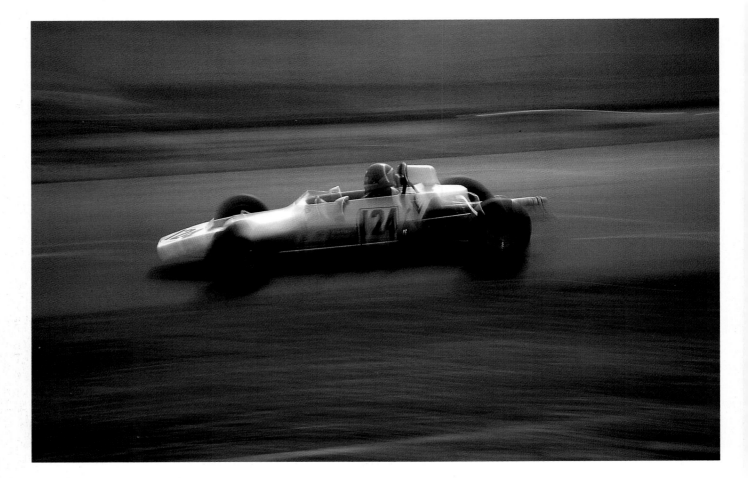

(Previous page)
THE WEDDING CAKE
HOUSE,
KENNEBUNKPORT
When a Maine sea
captain had to go to sea
almost immediately after
his wedding he
promised his bride a
house like a wedding
cake. The low sun of an
autumn morning gives
this highly photogenic
building an almost three-
dimensional effect,
highlighted by the steep
perspective achieved
with the 21mm lens.

Leica M6 21/2.8 Elmarit,
Kodachrome 25 Professional,
1/125 sec, f5.6.

of lens focal length. For instance working close to a fence when photographing horses at a show-jumping event you may be using a 35mm lens, nevertheless you will still need 1/500 sec or even 1/1,000 sec to eliminate movement blur just as much as if you were working with a telephoto lens from a greater distance. Sometimes, however, deliberate blur, say with a panned shot of movement, can be effectively impressionistic.

Later chapters deal with choice of film and exposure. Generally the slowest films are the sharpest and if you really want to see what your Leica lenses can do these are the ones to use. There are many instances however where subject and lighting impose other constraints. Fortunately the quality of many of the faster films has improved remarkably so that this is now much less of a concern. Correct exposure is vital to sharpness. Overexposure and underexposure can both kill detail.

Lighting can also make a very big difference to the apparent sharpness of a subject. Strong cross-lighting emphasizes shape and texture, backlighting heightens contrast and gives sparkle and strong outlines to a subject. Gentle lighting, mist, veiled sunlight, dull days or low light soften the subject details, and often it is these subjects that are most demanding of lens quality if detail is to be preserved. This is when you will really appreciate your Leica M lenses.

AT SPEED
'Panning' with the subject
at very slow shutter
speeds can produce
attractive impressionistic
results. The effect is
somewhat unpredictable
and the most interesting
results are often with
standard or wide-angle
lenses – it is worth
experimenting.

Leica M4, 50/2 Summicron,
Kodachrome 25, 1/15 sec, f16.

LOBSTER POTS, MAINE
Strong side-lighting
enhances the shapes and
texture of a subject and
can add to the impression
of sharpness.

Leica M6 90/2 Summicron,
Kodachrome 25 Professional,
1/250 sec, f4/5.6.

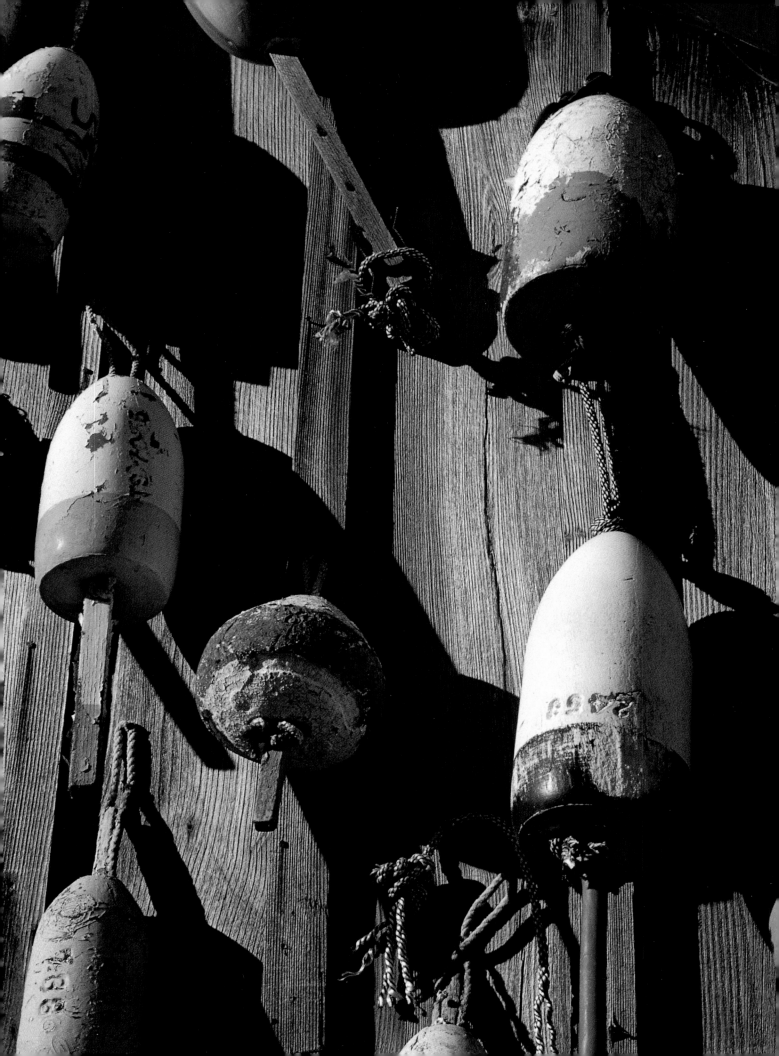

EARLIER LEICA M CAMERAS

LEICA M3, M2, M1, MD, MP

The M3, the first Leica M camera, was introduced in 1954; the M2 was introduced in 1958. Both were then produced concurrently until they were superseded by the M4 in 1967. Handling of the two models is very similar, the main differences being that the M3 viewfinder has frames for 50mm, 90mm and 135mm lenses while the M2 has 35mm, 50mm and 90mm frames. The M2 finder has lower magnification of 0.72 × compared with the M3's 0.91 × and therefore has an effective base length of 49.9mm, the same as the M6, as against the 62.1mm of the M3. The M3 is therefore the best rangefinder model for very fast lenses and for 135mm lenses.

The M3 has a self-resetting frame counter while the M2, like the older screw-lens-mount Leicas, has to be reset manually when a film is changed.

Neither camera has the quick-load device for film. Film is

The very first Leica M, the M3 of 1954, shown with the M6J special model produced to commemorate its 40th anniversary in 1994.

Photo Leica Archiv

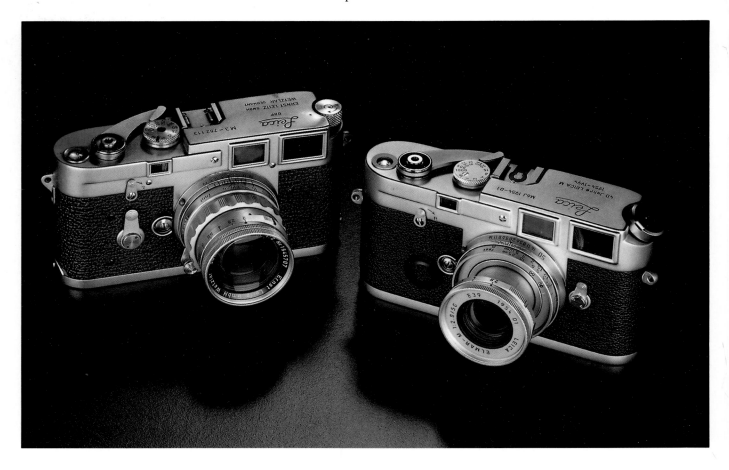

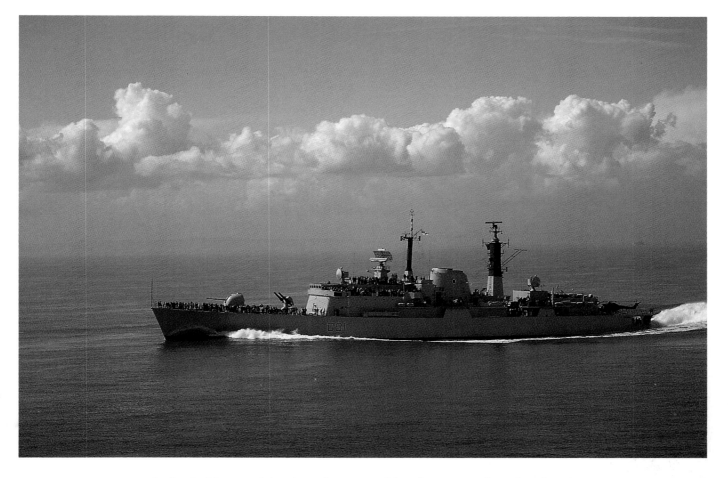

loaded by attaching it to the removable take-up spool, under the spring clip, emulsion side out. With film attached, the cassette and take-up spool are then inserted into the camera from the base, ensuring that both go fully home and that the film is correctly located in the film track. The baseplate is attached, making sure that the back flap is closed and held by the base, and two blank frames are fired off. The M3's counter will now be at '0', ready to wind on to number '1'; the M2 should be manually set to '0'. Film is rewound for unloading by moving the small lever on the front of the camera to 'R', pulling up the rewind knob to engage the rewind action, and rewinding in the normal way.

Early M2 models have no delayed action and have a button rather than a lever for the rewind setting. Early M3s have no preview lever for the viewfinder frames and for a period two strokes of the film wind lever were required to advance the film. Very early models were fitted with a glass pressure plate.

A useful feature found on both the M2 and the M3 is a pair of cut-outs one above and one below the rangefinder patch. These indicate the depth-of-field available at f5.6 (lower) or f16 (upper) with a standard 50mm lens. If the rangefinder images of part of the subject are not separated by more than the width of the cut-out, that part of the subject is within the depth-of-field for the relevant stop.

HMS *NOTTINGHAM* AT SPEED

HMS *Nottingham* was escorting the aircraft carrier HMS *Ark Royal* from whose flight deck this picture was taken. The camera was an M4-P, the immediate predecessor of the M6.

Leica M4-P, 135/4 Tele-Elmar, Kodachrome 64 Professional, 1/500 sec, f5.6.

The Leica M1 is an M2 with no rangefinder, and viewing frames for 35mm and 50mm lenses only. The camera was primarily used for scientific purposes and in the later version, the MD, the viewfinder was eliminated altogether; but a special baseplate allowed a strip with relevant information for each picture to be inserted into the film plane so that the information was recorded on the film.

Now very much a collectors' item, the MP was an intermediate model between the M3 and the M2. It was produced in very limited numbers for photojournalists and had the quick-wind Leicavit system built into the baseplate.

LEICA M5

The M5 was the first attempt by Leica to incorporate TTL metering into an M series camera. The operation of the metering system is covered in chapter 12: Correct Exposure, page 116; in most other respects the handling is very similar to the M4. An extra-large shutter speed dial slightly overhangs the front of the camera to facilitate adjustment without removing the camera from the eye. Shutter speeds set are displayed in the finder. Loading the film is carried out as shown by the diagram on the camera base when the baseplate is removed. Compared with the M4 the only difference is in the shape of the prongs on the take-up spool and the incorporation of a centre post. Don't forget that after you load a film you must set the film speed with the dial on the top of the camera.

With the M5 the film rewind system is a major difference. The rewind knob is located on the base of the camera but otherwise operates normally. The baseplate is unlatched and removed in the same way as other M Leicas.

LEICA CL

This camera was an effort by Leitz to produce a compact more economically priced rangefinder Leica. Although the lens mount is the standard Leica M and it is possible to fit certain 50mm and 90mm M lenses, the CL has its own special lenses – a 40mm f2 Summicron and a 90mm f4 Elmar. The finder incorporates bright-line frames for 40mm, 50mm and 90mm lenses. At 31.5mm the rangefinder base length is much reduced. With only 0.6 × viewfinder magnification it becomes an effective 18.9mm. Therefore its accuracy is inadequate for f2 or faster 50mm lenses and for 90mm lenses faster than f4.

The camera was built for Leica by Minolta and marketed in Japan as the 'Leitz Minolta'. Minolta on their own initiative later brought out a much improved version, the CLE, with a longer base rangefinder, automatic exposure, TTL flash, and a viewfinder with frames for their own compact 28mm f2.8 lens as well as the 40mm f2 and 90mm f4 lenses based on the original Leica designs for the CL. Unlike the CL lenses, the rangefinder camming is accurate enough so that the 28mm and 90mm lenses can be considered for the M bodies. However, on the M4-P and M6 the 28mm brings up the 35mm and not the 28mm frame so that a separate finder is required.

SUNRISE, GRAND CANYON
Early birds get the best pictures at Grand Canyon just as anywhere else. This shot was taken on my very first trip to the American West. Getting the right exposure was tricky.

Leica M4, 50/1.4 Summilux, Kodachrome 25, 1/125 sec, f5.6.

The Leica MP, a rare special version of the M3 with Leicavit base.

Photo Leica Archiv

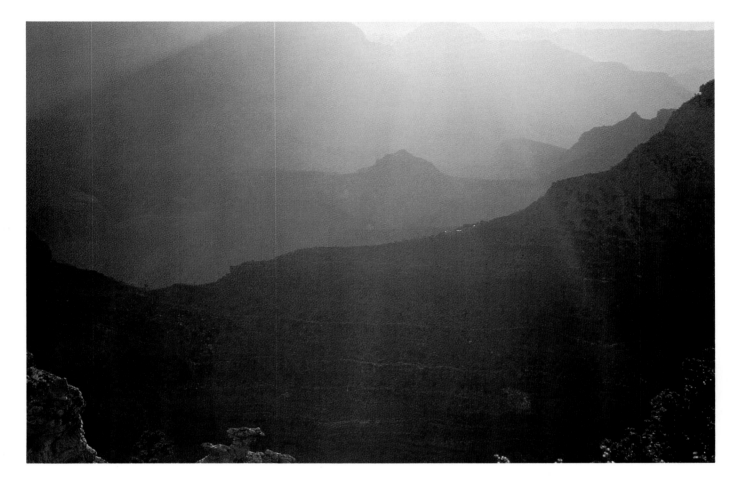

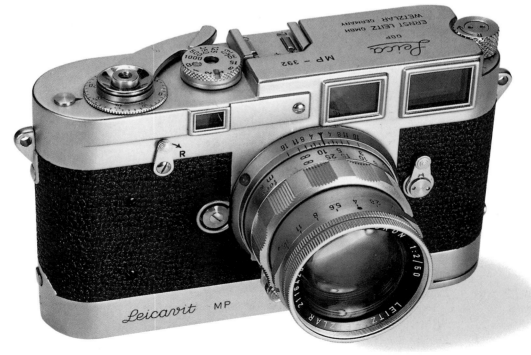

M4, M4-2, M4-P, MDA, MD-2

The M4 is basically an M6 with no built-in meter, no provision for motor-drive, no flash hot shoe and without the bright-line frames for the 28mm and 75mm lenses. Like the 21mm, a separate accessory viewfinder is required for the 28mm lens and is still available. Unfortunately, there is no such accessory finder for the 75mm lens although it is possible to have the rangefinder system modified to the M6/M4-P type. The M4 does have a delayed action release operated by a lever on the front of the camera below the shutter release.

A Canadian-built development of the M4, the M4-2 gained the motor-drive facility and the hot shoe for flash but, in the process of modifying the film advance system for the motor-drive, it was not possible to retain the delayed action. The separate flash socket for flash bulbs was also eliminated. Handling, film loading and unloading and so on, of the M4 and M4-2 and the M4-P are all the same as the M6, with full lens and accessory capability.

Without the contacts and the connections for the motor-drive and exposure meter, the shutter release on the M4 is very light and smooth. There is a significant difference in travel due to the need in the M6 for an extra pressure point as the exposure meter is activated. You need to be prepared for this if you work with both an M4 and an M6.

The M4-P was a further development of the M4-2. Apart from the fact that it does not have the built-in meter the M4-P is identical in handling to the M6. It has the same viewing frames for lenses from 28mm to 135mm, the same film-loading system, and it accepts all the same lenses and accessories. Early body top plates were brass while late model M4-Ps have slightly thicker zinc alloy top plates, similar to those of the M6, and will not therefore accept the 50mm close-focus Summicron. Motor-drive capability is the same as the M6. For exposure metering the Leicameter MR couples with the shutter speed dial – see chapter 12: Correct Exposure, page 117.

The Leica MDa and the MD-2 are non-rangefinder versions of the Leica M4 and M4-2 for technical and scientific applications. They are the equivalent models to the MD which was produced alongside the M2 (see above).

THE M6-J

This special model was produced in 1994 to celebrate forty years of Leica M. Only 1,640 were produced – forty for each year of M camera production, each specially numbered. Apart from the film rewind crank the top plate (in brass) is identical with the M3. Internally the mechanisms, including the metering, are those of the M6 except that the range-/viewfinder has a magnification of 0.85 × instead of 0.72 × and only has frames for 35mm, 50mm, 90mm and 135mm lenses. The camera was supplied complete with a recomputed 50mm Elmar f2.8 lens in a presentation case. Interestingly the higher magnification finder, with its greater effective rangefinder base length, has aroused considerable interest as it is much more convenient and accurate when using

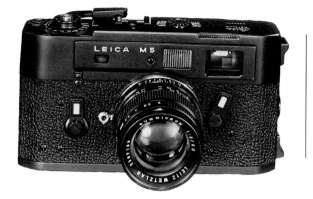

The M5 was the first Leica with TTL metering and the specially developed black chrome finish. It was bigger and heavier than the preceding M4 which limited its success.

Photo Leica Archiv

In an effort to capture a lower price market segment Leica introduced the CL, a compact camera with TTL metering similar to the M5. It had its own 40mm f2 and 90mm f4 lenses with M bayonet and had a viewfinder frame to enable it to accept the 50mm M lenses. The body was made in Japan by Minolta.

Photo Leica Archiv

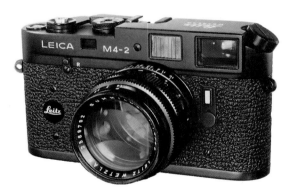

When M4 and M5 production ceased at Wetzlar, Leica's Canadian plant took on the job of producing M cameras and introduced the M4-2. This is basically an M4 with provision for a compact motor-drive and hot shoe electronic flash synchronization. There was no self-timer.

Photo Leica Archiv

Further development in Canada led to the M4-P, an M4-2 with added viewfinder frames for the 28mm lenses and the newly introduced 75mm f1.4 Summilux.

Photo Leica Archiv

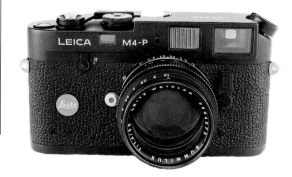

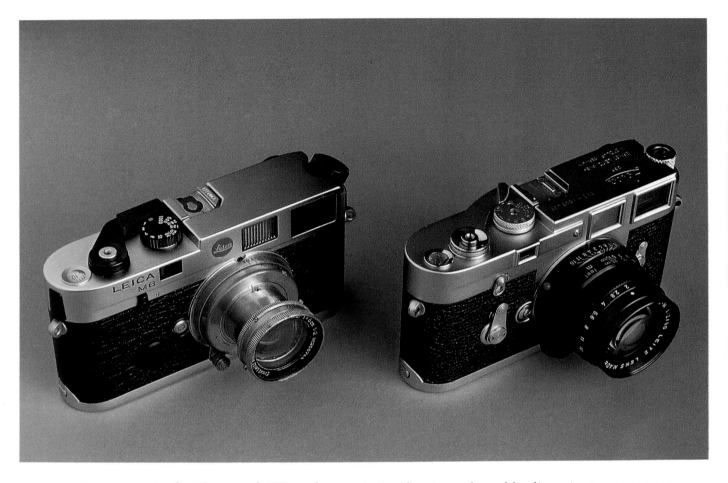

LEICA M6 AND LEICA M3

Leica rangefinder lens compatibility is excellent and even the earliest rangefinder lenses can be used on the M cameras. The Summar on the M6 is a 1934 model while the 1965 M3 is fitted with a 1993 Summicron.

the 90mm and 135mm lenses. A significant number of leading photographers have asked Leica to consider fitting this viewfinder system in a standard M6 body as a regular alternative to the normal viewfinder. Leica are said to be seriously considering this possibility.

PARIS, PLACE DU TERTRE

Taken in 1968 with my first Leica. The wide aperture needed because of the overcast day was useful to keep the distracting background out of focus.

Leica M2, 50/2 Summicron, Kodachrome II, 1/60 sec, f2.8.

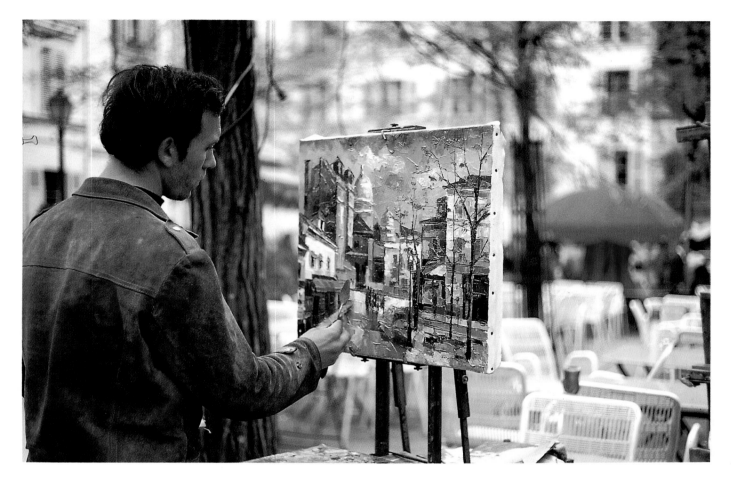

TABLE 2:
LEICA M CAMERAS

Model	Available	Viewfinder Frames	Comment
LEICA M3	1954–1967	50 90 135	
LEICA MP	1956–1957	50 90 135	SPECIAL MODEL
LEICA M2	1958–1967	35 50 90	*
LEICA M1	1959–1964	35 50	NO RANGEFINDER
LEICA MD	1963–1966	NO FINDER	NO RANGEFINDER
LEICA M4	1967–1975	35 50 90 135	*
LEICA MDa	1966–1976	NO FINDER	NO RANGEFINDER
LEICA M5	1971–1975	35 50 90 135	
LEICA CL	1973–1976	40 50 90	
LEICA M4-2	1978–1980	35 50 90 135	
LEICA MD-2	1977–1987	NO FINDER	NO RANGEFINDER
LEICA M4-P	1981–1987	28 35 50 75 90 135	
LEICA M6	1984–	28 35 50 75 90 135	
LEICA M6-J	1994–	35 50 90 135	SPECIAL MODEL

*Motorized versions of these models were manufactured in very limited numbers.

LEICA SCREW-MOUNT RANGEFINDER CAMERAS

The Leica fascination is such that many Leica M users are also interested in the older screw-mount rangefinder models. For the sake of completeness the following brief description of the various models and their operation has been included.

Although many improvements were incorporated between the making of first rangefinder Leica, the Leica II (USA Model D) of 1932, and the very last, the IIIg of 1957, handling of all these models is very similar. The handling of the IIIf is described below. Further notes explain the differences relevant to the other models.

LEICA IIIF/IIF/IF 1950 – 1957

This was the first Leica with built-in flash synchronization. Early models had a black synchronization setting dial, later models with slightly different shutter speeds had a red synchronizing dial. Models built from 1954 were fitted with a delayed-action mechanism. The adjustable flash synchronization was necessary to accommodate the many different types of flash bulb, with different

A late model IIIf with delayed action and a 50mm f2 Summicron. The other lenses are an 85mm f1.5 Summarex, a 28mm f5.6 Summaron and late model 50mm f3.5 Elmar with red focusing scale.

The film-loading diagram on the inside base of a Leica IIIf which also shows the length and shape of film leader tongue required for a screw-mount camera.

firing delays, that were on the market at that time. Leica If and IIf models have no slow speeds and no delayed-action mechanism and the If has no rangefinder system.

SHUTTER SETTINGS

The shutter speeds are set on two dials, the slow speeds on a dial on the front of the camera, the faster speeds, from 1/20, 1/25 or 1/30, according to the model, on the dial on the top of the camera. The camera has to be wound on before setting the shutter speed and the slowest speed on the top dial must be set for the slow speed dial to be effective. The top dial rotates as the shutter operates and must not be obstructed in any way.

The flash synchronization setting dial is below the main shutter speed dial. For electronic flash the settings are:

Black setting dial		Red setting dial	
shutter speed	contact number	shutter speed	contact number
1/30sec	2	1/50sec	20
T, 1sec – 1/20sec	2	T, 1 – 1/25sec	0
B	6	B	2

FILM LOADING

As with the M series, loading is from the base of the camera but there is no flap on the camera back to facilitate accurate alignment of the film in its track and loading must be carried out very carefully. A full-length loading tongue is a necessity. All modern films have a shortened tongue and must be modified. The easiest way to do this is with a Leica film trimming template, code ABLON, if you can find one at a dealer; otherwise follow the diagram inside the camera – see above.

Remove the take-up spool from the camera, push the end of the film tongue into the spring clip with the emulsion side out, pull out 10cm (4in) of film – no more – and then insert the film cassette and take-up spool into the camera. Make sure that both are snugly down, and ensure that the sprockets are engaged with the film perforations, remove any slack in the film by gently winding the rewind knob and then refit the baseplate. If this does not go on easily remove it and check that cassette, take-up spool and film are correctly inserted.

Next check that the A – R lever has been set back to 'A' after rewinding the previous film. Wind on and fire off two blank frames and then set the frame counter to '0'. Take up any slack with the rewind knob and check that it rotates as you wind on to frame number '1'. If it does not, or if you experience any difficulty such as a very stiff winding action, do not force anything but start the whole process over again. A few lost frames of film are

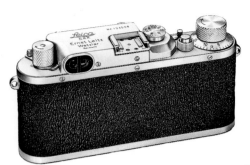

3969

The twin eyepiece of the 1938 Leica IIIb brought the separate viewfinder and rangefinder optics much closer together.

Photo Leica Archiv

nothing compared with a hopelessly jammed camera! Unloading is much simpler. Simply set the A – R lever to R, and rewind with the rewind knob until you feel the film pull out of the take-up spool.

FOCUSING

The two eyepieces are twinned very closely for easy viewing by just moving the eye. One is for the viewfinder and the other for the rangefinder. Although it has a shorter base (39mm) the rangefinder is magnified 1.5 × so that the effective base length is 58.5mm. The rangefinder eyepiece has a dioptre adjustment operated by a lever under the rewind knob. It is however, of the coincident type only, there is no split image facility as there is on the M models. The viewfinder image is quite small and for the 50mm lens only, so many photographers often prefer to use one of the many types of accessory finder that Leica have produced over the years. This will be necessary anyway if you wish to use wide-angle or telephoto lenses. If you are not too much of a purist and want a universal finder for regular use, the Russian copy of the old Contax finder made for the Fed and Zorki cameras is very good and relatively cheap!

LEICA IIIG 1957 – 1960

This was the last of the screw-mount cameras and, compared with the IIIf, incorporates a number of improvements inspired by the M3. The viewfinder is larger and has permanently visible bright-line frames for 50mm and 90mm lenses. Flash synchronization is considerably simplified. As the body is taller than the IIIf and earlier cameras, a number of accessories, such as the close-up devices NOOKY, SOOKY, etc, cannot be used. For this purpose the IIIg has its own device ADVOO. Camera handling is similar to the Leica IIIf. The Ig is equivalent to the 1f with no rangefinder.

LEICA IIID/IIIC/IIC/IC 1940 – 1950

These are identical in operation to the Leica 'f' series except that there is no built-in synchronization. The Leica IIId is a rare version of the IIIc with a delayed-action mechanism.

LEICA IIIB/IIIA/III/II/I 1932 – 1939

The main differences between these cameras and the later 'c', 'f' and 'g' series is that the body is about 3mm shorter. This is because there was a change in construction from a metal-pressing to a die-cast body. Some baseplate fitting accessories, eg the MOOLY clockwork motors or Leicavit rapid winders, are not interchangeable between models.

The Leica IIIb of 1938 was the first model with the convenient twinned eyepiece. The Leica IIIa (1935) incorporated a 1/1,000 sec top shutter speed compared with the 1/500 sec of the III (1933) and the II. As with equivalent later models, the II has no slow speeds and the I has no coupled rangefinder. The II also does not have the 1.5 × magnification or the dioptre correction for the

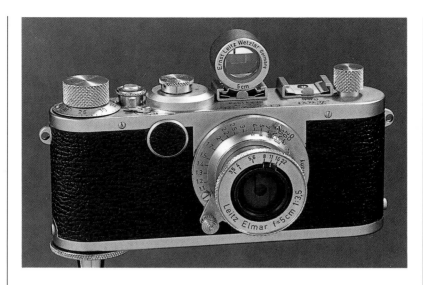

In common with all the
I models the Ic lacked
the rangefinder and had
no slow speed dial.

Photo Leica Archiv

rangefinder. The dioptre correction on the III and IIIa is achieved via a small lever behind the eyepiece rather than under the rewind knob.

Operation is still essentially the same as the IIIf, etc, and all the screw lenses are fully interchangeable between models.

GENERAL

The above short descriptions cover the commonly used models with the screw-lens mount. There were many specials, the Leica 250 reporter and the Leica 72 half-frame camera for instance, but these are now firmly in the hands of collectors and unlikely to be used for regular photography.

From a user point of view the IIIg is the most convenient of the screw Leicas, although undoubtedly now the most expensive to acquire. On a more economical note the IIIf, especially a late model with delayed action, is still likely to be found in very good order and would make a practical, high-performance 'compact'. Equipped with one of the collapsible 50mm lenses or a 35mm Summaron it fits easily into the pocket and is very light and extremely quiet in operation.

One of the rarest models is the Leica 72 which took 'half frame' (24 × 18mm) pictures. Production was mainly from the Leitz Canadian factory in Midland Ontario as this example.

Photo Leica Archiv

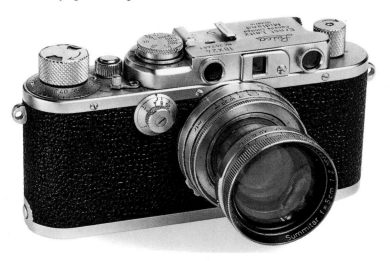

TABLE 3:
MAIN LEICA SCREW–MOUNT MODELS

Model	Available	Rangefinder	Speeds	Flash syncro	Interchangeable lens
LEICA 1 (USA MODEL A)	1925–1932	NO	1/20 – 1/500	NO	NO
COMPUR LEICA (USA MODEL B)	1926–1931	NO	1 – 1/300	NO	NO
LEICA 1 INTERCHANGEABLE (USA MODEL C)	1931–1932	NO	1/20 – 1/500	NO	YES BUT NON–STANDARD
LEICA 1 STANDARD (USA MODEL E)	1932–1947	NO	1/20 – 1/500	NO	YES
LEICA II (USA MODEL D)	1932–1947	YES	1/20 – 1/500	NO	YES
LEICA III (USA MODEL F)	1933–1942	YES	1 – 1/500	NO	YES
LEICA IIIa (USA MODEL G)	1935–1938	YES	1 – 1/1,000	NO	YES
LEICA IIIb	1938–1945	YES	1 – 1/1,000	NO	YES
LEICA IIIc	1940–1951	YES	1 – 1/1,000	NO	YES
LEICA IIc	1948–1951	YES	1/30 – 1/500	NO	YES
LEICA Ic	1949–1952	YES	1/30 – 1/500	NO	YES
LEICA IIIf BLACK SYNCHRO DIAL	1950–1952	YES	1 – 1/1,000	YES	YES
LEICA IIf BLACK SYNCHRO DIAL	1950–1952	YES	1/30 – 1/500	YES	YES
LEICA If BLACK SYNCHRO DIAL	1950–1952	NO	1/30 – 1/500	YES	YES
LEICA IIIf RED SYNCHRO DIAL	1952–1954	YES	1 – 1/1,000	YES	YES
LEICA IIf RED SYNCHRO DIAL	1952–1957	YES	1/25 – 1/1,000	YES	YES
LEICA If RED SYNCHRO DIAL	1952–1957	NO	1/25 – 1/1,000	YES	YES
LEICA IIIf RED SYNCHRO DIAL AND DELAYED ACTION	1954–1957	YES	1 – 1/1,000	YES	YES
LEICA IIIg	1957–1960	YES	1 – 1/1,000	YES	YES
LEICA Ig	1957–1960	NO	1 – 1/1,000	YES	YES

EARLIER RANGEFINDER LENSES

M LENSES

Table 4 lists all the discontinued lenses made for the M series of cameras since the introduction of the M3 in 1954. Any one of these lenses in good condition would give a first class account of itself. Some in fact would give even the current designs a close run. Lenses that are worth a special mention are the 21mm f3.4 Super Angulon, any of the 35mm Summicrons, the 50mm f2.8 Elmar, the rigid 50mm Summicron, particularly the 1969/79 model, the 90mm Summicron and the later model 90mm Tele-Elmarit. The 135mm f4 Elmar is bulkier but almost as good in performance as its successor, the remarkable 135mm Tele-Elmar.

Two of the lenses listed are special limited-edition designs – the 35mm f1.4 Summilux Aspherical, the immediate predecessor of the current 35mm f1.4 Summilux ASPH, and the 50mm f2.8 Elmar, specially produced for the M6-J. The original aspherical design incorporated two aspheric surfaces compared with the single one of the latest design. The plan was to produce two thousand of these but it is believed that due to the very complex

A group of older model Leica M lenses. Left to right – 90mm f2.8 Tele-Elmarit, 35mm f2 Summicron with M3 ocular, 90mm f4 Elmar in collapsible mount, 90mm f2 Summicron, 21mm f3.4 Super Angulon, 50mm f2 Summicron, 35mm f2.8 Summaron and the 50mm f2.8 Elmar.

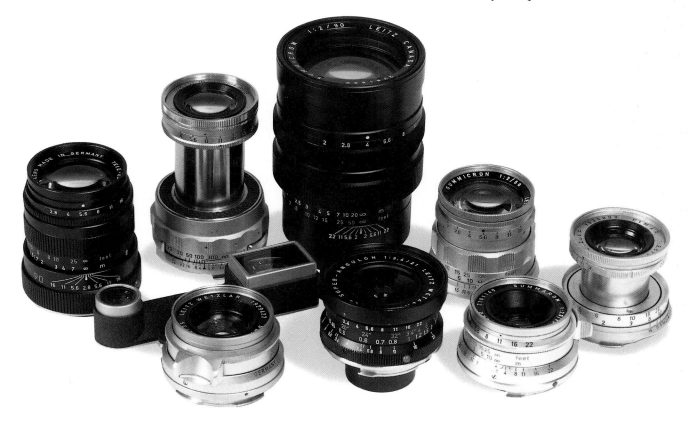

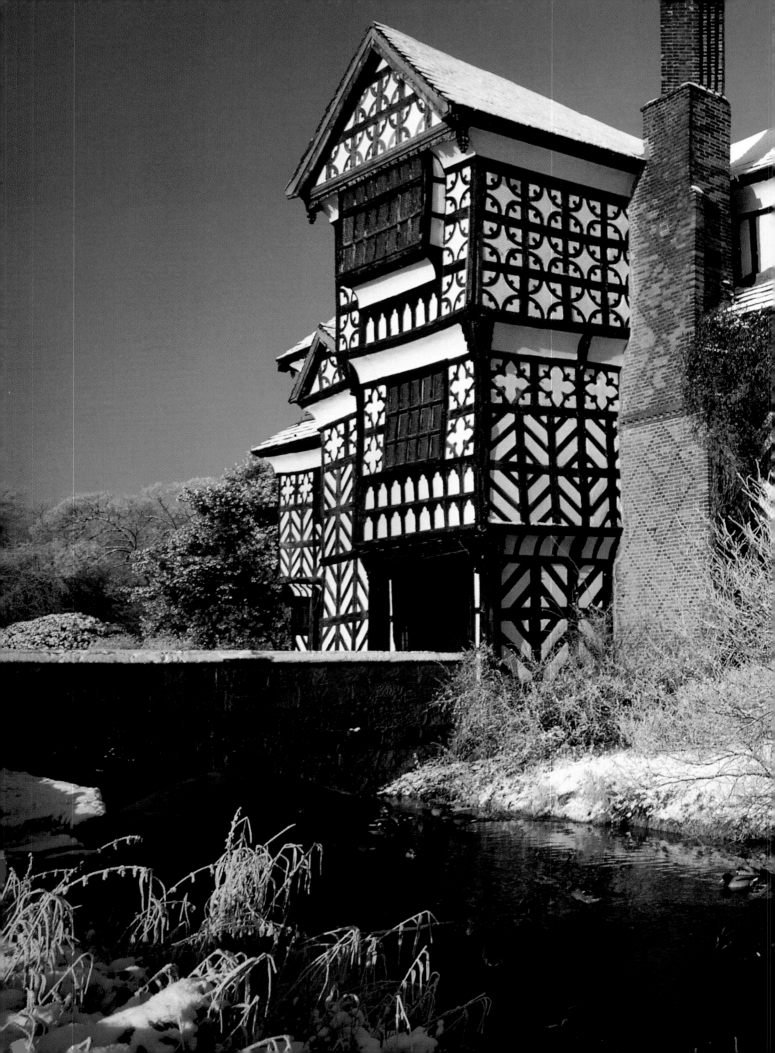

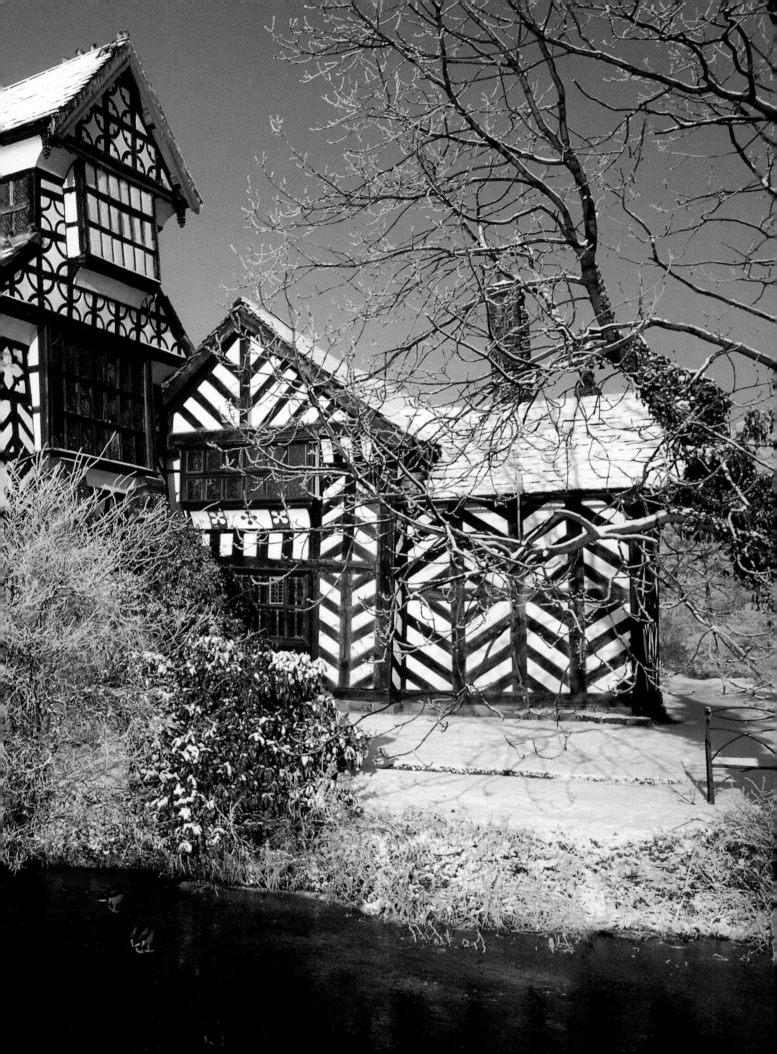

processes involved, less than this number were eventually manufactured.

The special Elmar for the M6-J was recomputed optically and redesigned mechanically as compared with the earlier 50mm f2.8 design. The newer lens is 20g lighter, focuses to 0.7m instead of 1.0m and has a non-rotating focusing mount. To match the M6-J requirement 1,640 were produced. Leica have now commenced further production as a compact lens for the regular M6.

Both these lenses are superb performers capable of producing outstanding image quality. It should be noted also that the 50mm Noctilux f1 (code 11821) and the 50mm f2 Summicrons (codes 11819 and 11825), included in the listing are all optically identical with the current lenses with identical performance characteristics.

Leica has improved lens coatings over the years so with a lens that has had a long production run look for one with as high a serial number as possible. Approximate datings for serial numbers are:

numbers	dates
500,000	1939
1,000,000	1952
1,500,000	1957
2,000,000	1964
2,500,000	1971
3,000,000	1979
3,500,000	1990
3,650,000	1995

Early 50mm and 90mm Elmars tend to have a somewhat cool rendering and benefit from a skylight filter rather than a UVa filter. When shooting in open shade or dull light an 81B is worth trying.

All the lenses listed can be fitted to any Leica M apart from the M5 or CL. Some of the lenses that have projecting rear elements will not meter on the M6; these same lenses must not be used on the Leica M5 or CL as they will foul the meter arm. Collapsible lenses must not be collapsed on the M5 or CL for the same reason, and it is safest therefore not to use them. See the notes to Table 4.

SCREW-MOUNT LENSES

With one or two exceptions concerning the Leica M5 and the Leica CL, any interchangeable screw-mount lenses can, with the appropriate adapter, be fitted to any Leica M camera and will couple accurately with the rangefinder. However, the 21mm f4 will not meter correctly with the M6. This lens should not, due to its projecting rear elements, be fitted to the Leica M5 or the CL and there are dangers in fitting any of the collapsible lenses to these two cameras – see notes above.

Apart from the mount, the very late screw-thread lenses were identical with the equivalent M lenses, and similar recommendations apply. The last screw-mount lenses were made in 1964 so finding even a late one in top condition is likely to be more difficult, and in any case, you are competing with the collectors. Apart from age deterioration, earlier uncoated lenses have less contrast and will be more susceptible to flare and these, and some earlier coated lenses, may have a somewhat variable colour rendering as it was not until the 1960s that Leica introduced their patented 'absorban' cement layer that greatly facilitated efforts to achieve consistent colour transmission in the full range of lenses.

Two lenses that should be mentioned as they never had an M bayonet equivalent are the 90mm Thambar, an early lens specially designed to give lovely soft-focus effects for portraiture, and the 85mm f1.5 Summarex, a remarkable achievement in its day and still a pretty good performer even by current standards.

Table 5, overleaf, lists all the screw-thread lenses from 1930 onwards. Rangefinder coupling for all lenses was introduced from 1932 along with the Leica II (Model D in USA) so you may just come across an earlier uncoupled lens. If you do it could be extremely valuable to a collector!

Four screw-mount rangefinder lenses shown with the appropriate adapters to enable use on M Leicas. Left to right – 35mm f3.5 Summaron, 50mm f1.5 Summarit, 28mm f5.6 Summaron, 90mm f4 Elmar. Note that contrary to the engraving on the adapter rings, the 28mm lens requires the 90mm adapter to display the correct frame on the M6 and M4-P.

TABLE 4:
EARLIER M LENSES

Lens	Speed/ Focal Length (mm)	Elements/ Groups	Angle of View	Smallest Aperture	Focusing Range (m)	Filter	Date	Weight (gm)	Code	Comment
HOLOGON	f8/15	3/3	110°	8	INF – 0.2*	Special	1973–1976	120	11003	(X)
SUPER ANGULON	f4/21	9/4	92°	22	INF – 0.4*	E39	1958–1963	250	11102	(X)
SUPER ANGULON	f3.4/21	8/4	92°	22	INF – 0.4*	E48/S7	1963–1980	300	11103	(X)
ELMARIT	f2.8/28	9/6	76°	22	INF – 0.7	E48/S7	1965–1969	225	11801	(X)
ELMARIT	f2.8/28	8/6	76°	22	INF – 0.7	E48/S7	1969–1980	225	11801	(A)
ELMARIT	f2.8/28	8/6	76°	22	INF – 0.7	E49	1980–1993	240	11804	
SUMMARON	f3.5/35	6/4	64°	22	INF – 1	E39	1956–1958	220	11107	For M3
SUMMARON	f3.5/35	6/4	64°	22	INF – 1	E39	1958–1959	135	11305	
SUMMARON	f2.8/35	6/4	64°	22	INF – 0.65	E39	1958–1973	220	11106	For M3
SUMMARON	f2.8/35	6/4	64°	22	INF – 0.7	E39	1958–1973	135	11306	
SUMMICRON	f2/35	8/6	64°	16	INF – 0.65	E39	1958–1973	250	11104	BLACK FOR M3
SUMMICRON	f2/35	8/6	64°	16	INF – 0.65	E39	1958–1973	250	11108	CHROME FOR M3
SUMMICRON	f2/35	8/6	64°	16	INF – 0.7	E39	1958–1969	150	11307	BLACK
SUMMICRON	f2/35	8/6	64°	16	INF – 0.7	E39	1958–1969	150	11308	CHROME
SUMMICRON	f2/35	6/4	64°	16	INF – 0.7	S7	1969–1973	170	11309	
SUMMICRON	f2/35	6/4	64°	16	INF – 0.7	E39/S7	1973–1980	170	11309	(B)
SUMMILUX	f1.4/35	7/5	64°	16	INF – 1.0	S7	1961–1994	195	11870	
SUMMILUX	f1.4/35	7/5	64°	16	INF – 1.0	S7	1992–1994	195	11860	TITANIUM
SUMMILUX	f1.4/35	7/5	64°	16	INF – 0.65	E41	1960–1974	325	11871	FOR M3
SUMMILUX	f1.4/35	9/5	64°	16	INF – 0.7	E46	1990–1994	300	11873	(G)
ELMAR	f3.5/50	4/3	45°	22	INF – 1	E39	1954–1962	210	11110	(Y)
ELMAR	f2.8/50	4/3	45°	22	INF – 1	E39	1958–1966	220	11112	(Y)
ELMAR	f2.8/50	4/3	45°	16	INF – 0.7	E39	1994	200	12549	(Y) (J)
SUMMICRON	f2/50	7/6	45°	16	INF – 1	E39	1954–1957	220	11116	(Y)
SUMMICRON	f2/50	7/6	45°	16	INF – 1	E39	1957–1969	285	11117	BLACK (C)
SUMMICRON	f2/50	7/6	45°	16	INF – 1	E39	1957–1969	285	11818	CHROME (C)
SUMMICRON CF	f2/50	7/6	45°	16	INF – 0.5	E39	1956–1968	400	11918	(D)
SUMMICRON	f2/50	6/5	45°	16	INF – 0.7	E39	1969–1979	260	11817	
SUMMICRON	f2/50	6/4	45°	16	INF – 0.7	E39	1993–1994	225	11825	CHROME
SUMMICRON	f2/50	6/4	45°	16	INF – 0.7	E39	1980–1994	295	11819	BLACK
SUMMARIT	f1.5/50	7/5	45°	16	INF – 1	E41	1954–1960	320	11120	
SUMMILUX	f1.4/50	7/5	45°	16	INF – 1	E43	1959–1995	325	11114	(E)
NOCTILUX	f1.2/50	6/4	45°	16	INF – 1	S7	1966–1975	515	11820	
NOCTILUX	f1/50	7/6	45°	16	INF – 1	E60	1976–1994	630	11821	(H)
SUMMICRON	f2/90	6/5	27°	22	INF – 1	E48	1957–1979	660	11123	
ELMARIT	f2.8/90	5/3	27°	22	INF – 1	E39	1959–1974	330	11129	
TELE–ELMARIT	f2.8/90	5/5	27°	16	INF – 1	E39	1964–1974	355	11800	
TELE–ELMARIT	f2.8/90	4/4	27°	16	INF – 1	E39	1974–1990	225	11800	
ELMAR	f4/90	4/3	27°	32	INF – 1	E39	1954–1963	240	11130	
ELMAR	f4/90	4/3	27°	32	INF – 1	E39	1954–1968	300	11131	(Y)
ELMAR	f4/90	3/3	27°	32	INF – 1	E39	1964–1968	220	11830	
HEKTOR	f4.5/135	4/3	18°	32	INF – 1.5	E39	1954–1960	560	11135	
ELMAR	f4/135	4/4	18°	22	INF – 1.5	E39	1960–1965	550	11850	
TELE–ELMAR	f4/135	5/3	18°	22	INF – 1.5	E39	1965–1994	510	11851	
ELMARIT	f2.8/135	5/4	18°	32	INF – 1.5	S7	1963–1975	730	11829	(F)

(A) NEW DESIGN FROM 2314921
(B) NEW DESIGN FROM 2461001
(C) RIGID MOUNT – REVISED OPTICAL DESIGN
(D) RIGID MOUNT – SPECIAL CLOSE-FOCUS VERSION
(E) TO 1844000 EARLIER OPTICAL DESIGN
(F) OLDER OPTICAL DESIGN TO 2656666
(G) LIMITED EDITION WITH TWO ASPHERICAL SURFACES
(H) LENSES TO 2919656 FILTER SIZE E58
(J) LIMITED EDITION FOR M6J
(X) WILL NOT METER WITH LEICA M6, DO NOT USE ON LEICA M5 OR LEICA CL
(Y) COLLAPSIBLE MOUNT – DO NOT USE ON LEICA M5 OR LEICA CL

*RANGEFINDER FOCUSING TO 0.7 M

TABLE 5:
SCREW-MOUNT RANGEFINDER LENSES

Lens	Speed/ Focal Length (mm)	Elements/ Groups	Angle of of View	Smallest Aperture	Focusing Range (m)	Filter	Date	Code	Comment
SUPER ANGULON	f4/21	9/4	92°	22	INF – 0.4	E39	1958–1962	SUOON	
HEKTOR	f6.3/28	5/3	76°	25	INF – 1.0	A36	1935–1953	HOOPY	
SUMMARON	f5.6/28	6/4	76°	22	INF – 1.0	A36	1955–1963	SNOOX	
ELMAR	f3.5/35	4/3	64°	18	INF – 1.0	A36	1931–1949	EKURZ	
SUMMARON	f3.5/35	6/4	64°	22	INF – 1.0	A36	1950–1956	SOONC	
SUMMARON	f3.5/35	6/4	64°	22	INF – 1.0	E39	1956–1960	SOONC	(A)
SUMMARON	f2.8/35	6/4	64°	22	INF – 1.0	E39	1958–1963	SIMOO	
SUMMICRON	f2/35	8/6	64°	16	INF – 1.0	E39	1958–1963	SAWOO	
ELMAX	f3.5/50	5/3	45°	18	INF – 1.0	A36	1924–1925	–	(B)
ELMAR	f3.5/50	4/3	45°	18	INF – 1.0	A36	1926–1962	ELMAR	(C)
ELMAR	f2.8/50	4/3	45°	16	INF – 1.0	E39	1957–1962	ELMOO	
HEKTOR	f2.5/50	6/3	45°	18	INF – 1.0	A36	1930–1939	HEKTOR	
SUMMAR	f2/50	6/4	45°	12.5	INF – 1.0	A36	1933–1940	SUMAR	
SUMMITAR	f2/50	7/4	45°	16	INF – 1.0	E36.5	1939–1940	SOORE	
SUMMICRON	f2/50	7/6	45°	16	INF – 1.0	E39	1953–1960	SOOIC	(D)
SUMMICRON	f2/50	7/6	45°	16	INF – 1.0	E39	1960–1962	SOSTA	(E)
XENON	f1.5/50	7/5	45°	9	INF – 1.0	Special	1936–1949	XEMOO	
SUMMARIT	f1.5/50	7/5	45°	16	INF – 1.0	E41	1949–1960	SOOIA	
SUMMILUX	f1.4/50	7/5	45°	16	INF – 1.0	E43	1960–1963	SOWGE	
HEKTOR	f1.9/73	6/3	34°	25	INF – 1.5	Special	1932–1942	HEGRA	
SUMMAREX	f1.5/85	7/5	28°	16	INF – 1.5	E58	1943–1960	SOOCX	
ELMAR	f4/90	4/3	27°	32	INF – 1.0	A36	1931–1963	ELANG	(F)
ELMAR	f4/90	3/3	27°	32	INF – 1.0	E39	1963–1964	11730	
ELMARIT	f2.8/90	5/3	27°	22	INF – 1.0	E39	1959–1963	ELRIT	
THAMBAR	f2.2/90	4/3	27°	25	INF – 1.0	E48	1935–1941	TOODY	(G)
SUMMICRON	f2/90	6/5	27°	22	INF – 1.0	E48	1957–1958	SOOZI	
SUMMICRON	f2/90	6/5	27°	22	INF – 1.0	E48	1959–1962	SEOOF	(H)
ELMAR	f6.3/105	4/3	23°	36	INF – 3.0	A36	1932–1937	ELZEN	
ELMAR	f4.5/135	4/3	18°	36	INF – 1.5	A36	1931–1933	EFERN	
HEKTOR	f4.5/135	4/3	18°	36	INF – 1.5	A36	1933–1960	HEFAR	(F)
ELMAR	f4/135	4/4	18°	32	INF – 1.5	E39	1960–1964	11750	

(A) New style mount from 1423141.
(B) Also known as Anastigmat.
(C) Many minor variations of mount.
(D) Collapsible mount.
(E) Rigid mount new optical design.
(F) Later lenses, E39 filter, many mount variations.
(G) Special soft-focus lens for portraiture.
(H) Built-in lens hood.

CHAPTER 9

THE VISOFLEX AND LENSES

The first reflex housing enabling the rangefinder Leica to operate as a single lens reflex was the PLOOT of 1935. As we have seen earlier, this made the Leica the very first single lens reflex camera. The PLOOT and its successors – the Visoflex I (1951–1963), the Visoflex II (1959–1963) and the Visoflex III (1963–1983) – enable the Leica rangefinder camera to be adapted for close-up and long-lens photography.

It has to be said immediately that set against the convenience and sophistication of a modern reflex camera such as the Leica R, even a very late model Visoflex III is clumsy and slow in use. Nevertheless for occasional requirements, particularly with static subjects when it is possible to work off a tripod, it is a fully viable accessory. More particularly it allows the use of many excellent Leica lenses including, via adapters, the lens heads of a number of fairly recent rangefinder mount lenses.

The Visoflex III was the last and not surprisingly the most convenient in use. It was only made in M bayonet mount but it does fit all M camera bodies, accepts all Visoflex lenses, and takes both a vertical and a 90° pentaprism-type finder. It is bayonetted

An M6 with Visoflex III, Bellows II, horizontal magnifier (fitted), vertical rangefinder, 65mm f3.5 Elmar on the bellows unit, and at left the 200mm f4 Telyt complete with the 16466 (OUBI0) adapter for fitting direct onto the Visoflex III.

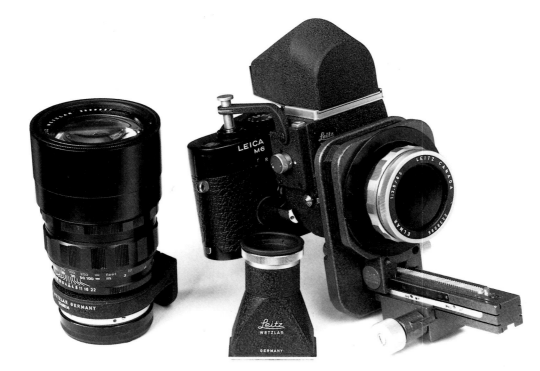

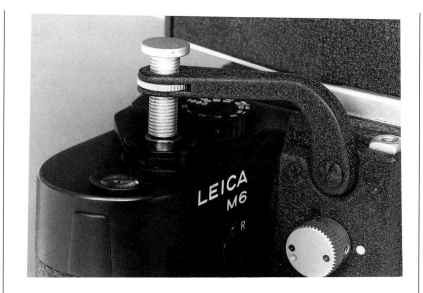

The gap between the Visoflex release arm and the shutter release button on the M camera should be at least 1mm to ensure that the reflex mirror is released before the shutter fires.

onto or off the camera body without having to move the shutter release lever or remove the magnifier. There are three settings for the mirror release, adjusted by a small knurled knob on the right-hand side:

Yellow dot The mirror springs up an instant before the shutter fires. This is the normal setting for hand-held use.

Black dot The mirror moves up slowly out of the light path as the release arm is depressed. This reduces noise and the possibility of camera shake.

Red dot When set to this position the mirror is locked in the 'up' position. This setting is made after focusing and eliminates any possibility of vibration.

In the case of the yellow and black dot settings, when the release arm of the Visoflex is allowed to rise after the exposure, the mirror automatically returns to the viewing position. Also in the case of both these settings, if a cable release is used the slow-rise mirror mode operates.

Before using the Visoflex III (also the II) it is important to set the adjusting screw on the release arm so that the mirror is raised just before the shutter is fired. The gap between the adjusting screw and the shutter release button should be 1mm. Check that all is well by listening and ensuring that you hear the mirror releasing fractionally before the shutter goes.

The Visoflex II is a little less sophisticated but still entirely practical in use and also accepts all Visoflex lenses. There is no instant-return mirror and after each exposure you have to reset the mirror via a small lever on the right-hand side. The housing has to be bayonetted onto or off the camera like a lens which means that the 90° magnifier has to be removed each time. The shutter release lever also has to be moved out of the way by

pulling it outwards slightly and swinging it out of the way to the right.

Because of the different body heights and position of the shutter button, the screw-mount version of the Visoflex II has a different release arm which is not suitable for the M cameras. In its standard version the arm is for use on the Leica IIIg. It is important to know that the release arm adjusting screw requires a small extension piece to enable the release arm to work with the Leica IIIf and earlier models which have a lower body.

The PLOOT and the Visoflex I were much less convenient. The camera shutter and the mirror were operated by a twin cable release. This was satisfactory for tripod use but not so practical for hand-held photography. Some later lenses will not fit – see Table 6, page 81.

It is possible, with any of the reflex housings, to achieve through-the-lens exposure metering with an M6 or an M5. It is first necessary to raise the mirror – use the black dot setting on the Visoflex III – then take the first pressure on the shutter release to illuminate the diodes on the M6, and then look through the camera's viewfinder to match the diodes, or line up the needle in the case of the M5. Some dexterity and determination is required but TTL metering is a boon for close-ups as it automatically takes care of any exposure increase required at the higher magnifications.

Table 6, page 81, lists all the lenses produced specifically for the various Visoflex models. In addition, some rangefinder lenses in the longer focal lengths used to have removable lens heads that could be fitted into special short focusing mounts for use on the reflex housings.

Bellows units were also available, Bellows I for the Visoflex I and Bellows II for Visoflex II and III. These are ideal for close-up work and allow a variety of lenses to be used, including some that provide very high magnifications.

The lens I consider to be most useful on the Visoflex is the 65mm Elmar. Essentially, this is a macro lens of excellent quality providing – on Visoflex II and III – focusing from infinity to 0.33m in the universal focusing mount, and infinity to 1.4 × magnification with the Bellows II. There are two versions of this lens: the earlier has a chrome mount, the later is black. The later lens has a little more contrast but in practice the difference is marginal and either is recommended.

Both lenses have click-stopped pre-set aperture rings so that the aperture to be used can be set before the lens is stopped down by turning a separate, free-moving ring, after focusing is completed at full aperture.

The 65mm Elmar will cover pretty well all your close-up and general requirements with a Visoflex. If you want to try some long-lens work, beyond the capability of your 135mm rangefinder

VISOFLEX CLOSE-UPS
For convenient close-up photography a Visoflex plus Bellows II unit is extremely versatile. The 65mm f3.5 Elmar allows focusing from infinity to 1.4 times life-size. The illustrations here show the set-up for photographing by daylight indoors and shots of the flower at two different reproduction ratios.

Leica M6, 50/2 Summicron, Kodachrome 200 Professional, 1/60, sec f8.

Leica M6, Visoflex III, 65/3.5 Elmar, Kodachrome 25 Professional, 1/2 sec, f16.

Leica M6 Visoflex III, 65/3.5 Elmar, Kodachrome 25 Professional, 1/8 sec, f16.

AER LINGUS
BOEING 737
The 400mm f6.8 is a
classic long-focus lens,
very easy to handle and
of excellent optical
performance. With the
quality of modern fast
films, the f6.8 maximum
aperture is not inhibiting
and the required high
shutter speeds are
possible in good light.

Leica M6, Visoflex III, 400/6.8
Telyt, Kodachrome 200
Professional, 1/1,000 sec, f8.

GANNETS, BASS ROCK
On my more recent trips to Bass Rock I have appreciated the advantages of the Leica R system for bird photography. Nevertheless, this shot, taken on my very first visit, shows that the M plus Visoflex can get equally good results albeit much less conveniently.

Leica M4, Visoflex III, 200/4 Telyt, Kodachrome 64, 1/500 sec, f5.6.

lenses, my recommendation is to look for a 200mm f4 Telyt or the 400mm f6.8 Telyt. Both are first class lenses and, most importantly, both handle well on the Visoflex. The 200mm, like the 65mm, has a pre-set aperture ring. The 400mm f6.8 is a classic lens. Although it is a simple two-element design, performance at full aperture is good, and only half a stop down, at f8, it is excellent.

Another lens that was only made for the Visoflex and that portraitists might like to try (if they can find one!) is the 125mm f2.5 Hektor. At or near full aperture the residual aberrations and the narrow depth-of-field combine to produce a very attractive result. Don't forget that if you do buy this lens (or the 200mm Telyt) you will need adapter 16466 (OUBI0) to fit it to the Visoflex II or III.

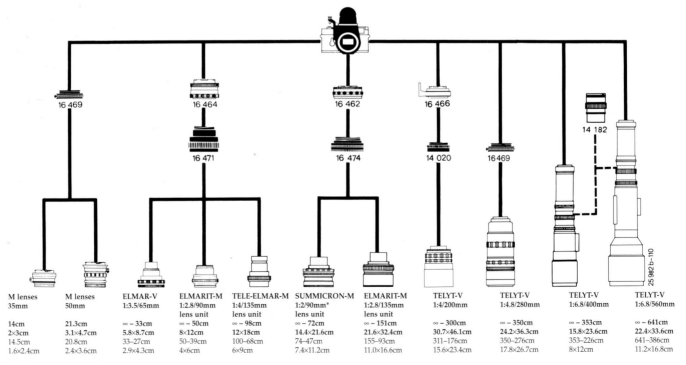

M lenses 35mm	M lenses 50mm	ELMAR-V 1:3.5/65mm	ELMARIT-M 1:2.8/90mm lens unit	TELE-ELMAR-M 1:4/135mm lens unit	SUMMICRON-M 1:2/90mm* lens unit	ELMARIT-M 1:2.8/135mm lens unit	TELYT-V 1:4/200mm	TELYT-V 1:4.8/280mm	TELYT-V 1:6.8/400mm	TELYT-V 1:6.8/560mm
14cm	21.3cm	∞ – 33cm	∞ – 50cm	∞ – 98cm	∞ – 72cm	∞ – 151cm	∞ – 300cm	∞ – 350cm	∞ – 353cm	∞ – 641cm
2×3cm	3.1×4.7cm	5.8×8.7cm	8×12cm	12×18cm	14.4×21.6cm	21.6×32.4cm	30.7×46.1cm	24.2×36.3cm	15.8×23.6cm	22.4×33.6cm
14.5cm	20.8cm	33–27cm	50–39cm	100–68cm	74–47cm	155–93cm	311–176cm	350–276cm	353–226cm	641–386cm
1.6×2.4cm	2.4×3.6cm	2.9×4.3cm	4×6cm	6×9cm	7.4×11.2cm	11.0×16.6cm	15.6×23.4cm	17.8×26.7cm	8×12cm	11.2×16.8cm

Bold type = normal working range
Lean type = ring adapters required for the near-focusing and macro range
Format details = object size at minimum camera distance
* Up to No. 2 997 000

TABLE 6:
LENSES FOR THE VISOFLEX I II & III

Lens	Speed/Focal Length (mm)	Elements/ Groups	Angle of of View	Smallest Aperture	Focusing Range (m)	Filter Size	Date Available	Code	Comment
ELMAR	F3.5/65	4/3	36°	22	INF – 0.33	E41	1960–1969	11062	(A)
ELMAR	F3.5/65	4/3	36°	22	INF – 0.33	S6	1969–1984	11162	(A)
HEKTOR	F2.5/125	4/3	20°	22	INF – 1.2	E58	1954–1963	11032	(B) (E)
TELE ELMARIT	f2.8/180	5/3	14°	22	INF – 1.8	S7	1965	11910	(D) (E)
TELYT	f4.5/200	5/4	12°	36	INF – 3.0	E48	1935–1958	OTPLO	(B) (E)
TELYT	f4/200	4/4	12°	22	INF – 3.0	E58	1959–1984	11063	(B) (E)
TELYT	f4.8/280	4/4	8.5°	22	INF – 3.5	E58	1961	11902	(B) (E)
TELYT	f4.8/280	4/4	8.5°	22	INF – 3.5	E58	1961–1970	11912	(B) (E)
TELYT	f4.8/280	4/4	8.5°	22	INF – 3.5	S7	1970–1984	11914	(D) (E)
TELYT	f5/400	5/4	6°	36	INF – 8.0	E85	1936–1955	TLCOO	(B)
TELYT	f5/400	4/3	6°	32	INF – 8.0	E85	1956–1966	TLCOO	(B)
TELYT	f5.6/400	2/1	6°	32	INF – 3.6	S7 (C)	1966–1971	11866	(D) for use on Televit
TELYT	f6.8/400	2/1	6°	32	INF – 3.6	S7 (C)	1970–1984	11966	(D)
TELYT	f5.6/560	2/1	4.3°	32	INF – 6.6	S7 (C)	1966–1971	11867	(D) for use on Televit
TELYT	f6.8/560	2/1	4.3°	32	INF – 6.4	S7 (C)	1972–1984	11864	(D)

(A) For use in 16464 Universal focusing mount on Viso II/III. Can also be used on Focusing Bellows.
(B) Adapter 16466 required for use with Viso II/III.
(C) In Filter Slot.
(D) Not for use on Viso I.
(E) Lens head can be used on Focusing Bellows.
Note: Many earlier 90mm and 135mm rangefinder lenses have removable lens heads that will fit the Visoflex II/III via short-focusing mounts or the Focusing Bellows. Shorter focal lengths can be fitted direct or via an adapter but will only provide close-up focusing.

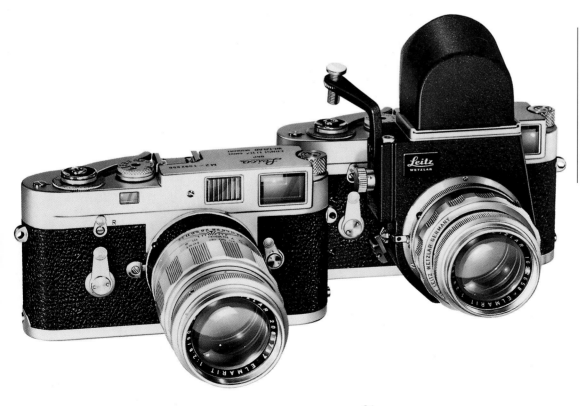

Many older Leica lenses have an optical unit that can be detached from the rangefinder barrel and fitted to a different focusing mount for the Visoflex. The 90mm f2.8 Elmarit is shown here in both mounts.

Photo Leica Archiv

CHAPTER 10

PRACTICAL ACCESSORIES

We have already seen that the strengths of the Leica M camera are in its simplicity, reliability and straightforward operation. In certain general areas of photography the M is unequalled but in many specialized areas the ubiquitous single lens reflex has to be acknowledged as the more versatile system.

Leica has recognized this over the years, and the range of accessories for the M system has been reduced to essentials at the same time as the R reflex system has been enhanced. There are, nevertheless, some older discontinued accessories that can be employed very effectively with the M6 so, in addition to the range presently available, some notes are included on those older items that will be found particularly useful. Also mentioned are a few items from other sources that supplement the Leica range.

TRIPODS

For general photography outside the studio a tripod is the antithesis of the 35mm rangefinder style which is based on a flexible, quick-reacting, involved approach. Only occasionally for indoor portraiture or other studio-style pictures or for night photography is a tripod essential. When you do need a tripod, first class quality and rigid construction are as important with a 35mm camera as any other format, so do not be tempted to go for a light, flimsy construction.

My choice of tripod is the Benbo, a somewhat idiosyncratic design which takes a bit of practice to learn how to handle but is incredibly versatile. I use it with the large Leica ball-and-socket head. There are other reliable makes, so it is worth spending a little time looking round and choosing carefully. A good tripod is an investment that will serve you for many, many years.

Normally the Benbo stays at home or in the car boot. What I do frequently carry on my travels, however, is the little Leica table tripod with the (discontinued) small Leica ball-and-socket head. This fits easily into the gadget bag or a pocket and, with a little ingenuity, a suitable position can be found on a wall, fence, or other support for those situations such as night shots or very low light levels indoors when hand-held exposures become impossible. The picture of the interior of St Mark's, Venice (opposite page) and the night scene of New York (page 125) are typical examples.

ST MARK'S CATHEDRAL, VENICE (INTERIOR)
The magnificent domed interior of St Mark's is very dimly lit. Even with Kodachrome 200, hand-held exposures were running at 1/30 sec with my 50mm Summilux wide open at f1.4. With the 21mm Elmarit needed for this view, the little table tripod was rested on a balcony wall, allowing me to expose for half a second at f5.6.

Leica M6, 21/2.8 Elmarit, Kodachrome 200 Professional, 1/2 sec, f5.6.

LEICA TABLE TRIPOD
A most useful accessory for the travelling photographer. The tripod when folded is very compact and fits easily into pocket or gadget bag. The now discontinued small ball-and-socket head illustrated is worth hunting for in second-hand shops in preference to the current larger model as it will keep weight and size to a minimum.

82

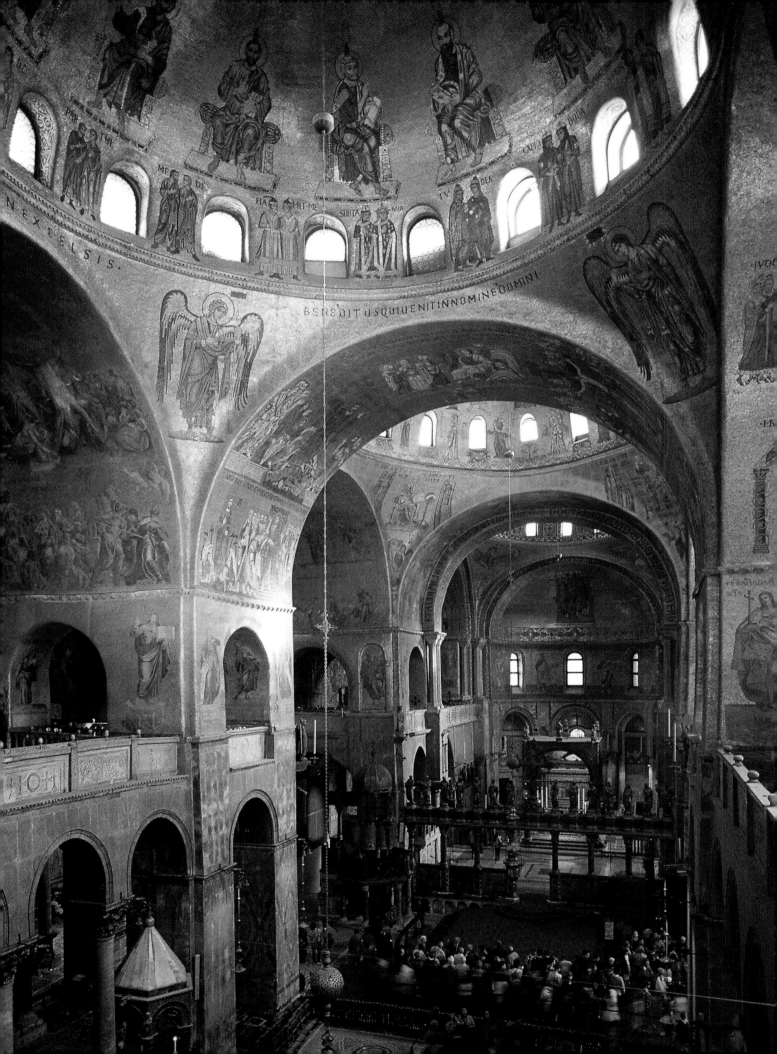

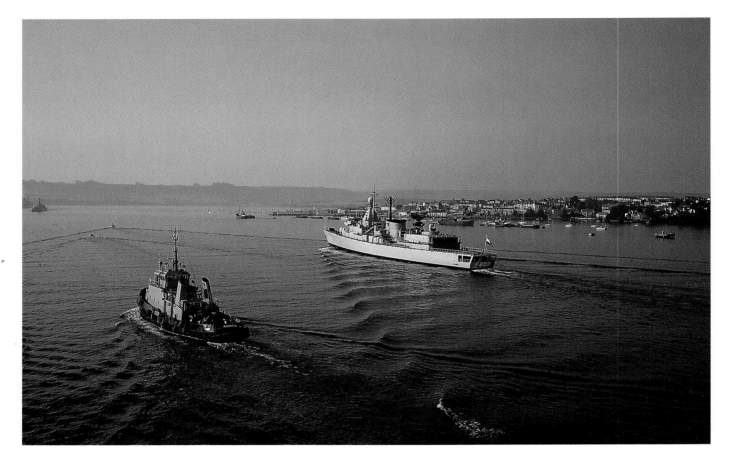

DEPARTING ON THE
MORNING TIDE
At one time it was
always advisable to use a
UV (ultraviolet) filter
when by the sea or at
high altitudes. Modern
lens coatings have
eliminated the need for
this but most
photographers keep a
UV or skylight filter
fitted to their valuable
lenses as protection from
rain, sea spray, dust and
sticky fingers.

Leica M6, 35/2 Summicron,
Kodachrome 25 Professional,
1/250 sec f4.

There are various mini tripods around but many are very flimsy. Other than the Leica the best one that I have tried is the Minolta TR1, a clone of the Leica but with a permanently attached ball and socket head.

FILTERS

Thankfully the lack of reflex viewing has spared the Leica M photographer from the perils of the so called 'creative' filter systems. Only the basic filters are likely to be needed but even so Leica's own range is very limited and it may be necessary to buy from other sources. The situation is not helped by the non-standard fittings that Leica M lenses employ – a legacy of the need to keep the lenses compact and to avoid obscuring the viewfinder.

The useful filters for colour photography are an ultraviolet (Leica UVa) or skylight (1A, 1B or KR1.5) (Wratten 1A), a polarizer (but see below) and an 81b or 81c. A UV filter is no longer strictly necessary as its function to filter out image-degrading ultraviolet has been superseded by modern lens coatings. In practice I always keep a UVa or skylight on any lenses to protect them from rain, snow, dust, finger marks and possible scratches. This is cheap insurance and I have never been able to see any deterioration in lens performance when a good quality filter is fitted.

POLARIZING FILTER
As you do not have through the lens viewing with a rangefinder camera the M polarizer for E39 filter size lenses has a special mount that allows the filter plus lenshood to be swung through 180° in front of the viewfinder. The filter is rotated for the effect desired and then swung back in front of the lens. It's easier than it sounds!

A skylight filter gives a slight warming effect which is useful in open shade or at higher altitudes. It does no harm in other situations and with some of the older Leica lenses – early coated 50mm and 90mm Elmars in particular – will counteract the rather cold rendering. The 81 series is a much stronger warming filter which is valuable on very dull days and for close-ups and portraits in open shade where the illumination primarily comes from a blue sky.

A polarizing filter is especially valuable with colour; not only can it be used to eliminate unwanted reflections from glass and many other surfaces, but it will help deepen blue skies and increase colour saturation in distant views. The difficulty is that with a rangefinder camera you are not viewing through the lens and therefore the effect of the polarizer cannot be seen. Leica have got around this problem with a polarizer in a special mount that swings up in front of the M viewfinder so that the correct rotation for the effect required can be seen and can then be swung back in front of the lens (see illustration). Unfortunately, this filter is only available in a clamp-on mount for E39 filter-mount lenses and comes complete with a lens hood suitable for lenses of 35mm or longer focal length.

Leica's own range of filters is now very limited and some of the sizes are rather uncommon. The makes listed below will be found to be satisfactory where Leica do not have a particular type in their catalogue:

Filter size	Suppliers		
E39	B&W	HOYA	TIFFEN
E46	B&W	HOYA	TIFFEN
E55	B&W	HOYA	TIFFEN
E60	B&W		
Series filters	B&W		

Filters worth having for black-and-white photography are a medium yellow (2x or 3x) and an orange (usually 5x). For use with black-and-white infrared film the deep red K25, rather than the full infrared filter, is recommended.

The medium yellow filter is a good general purpose one for landscapes and architectural views, giving very satisfactory normal rendering of sky and clouds. Orange will darken blue skies more and clouds will stand out very strongly. An even more exaggerated effect can be gained with the red filter.

MOTOR-DRIVES AND WINDERS

Leica did produce special 'Mot' versions of the M2 and the M4 to take a motor-drive. The motor with its battery pack was heavy and bulky and sufficiently few were sold to make both camera and motors collectors' items. With the M4-2, Leica introduced a much smaller, lighter, quieter motor-winder. The very first models (up to serial number 10349) were for single frame operation only with a maximum winding speed of two frames per second. Later versions including the winder M4-P and the winder M permitted continuous operation with a maximum speed of three frames per second. Compatibility between cameras and winders is not universal – see Appendix – so care is needed if you are buying secondhand.

The Leica winder is fitted to the base of the camera instead of the usual baseplate. It cannot therefore be attached or removed in mid-film. The main advantage of the winder is not so much for motorized sequences but for ensuring that the camera is always ready and does not have to be removed from the eye to wind on when things are happening quickly. The disadvantage is the weight and bulk which tend to detract from the essential compactness of the M camera. The winder does make camera handling with the Visoflex much easier, especially when using the

MOTOR WINDER
The M6 winder allows continuous shooting at up to three frames per second. It is remarkably quiet but does add bulk to the compact M.

86

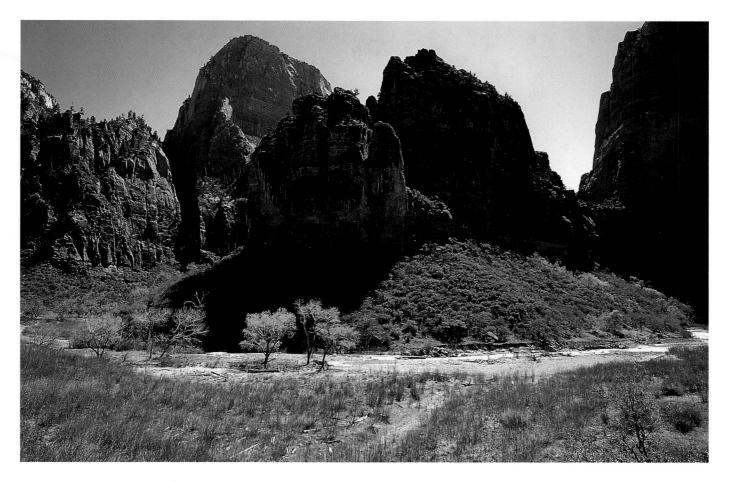

longer lenses. It is also noticeably quieter than the majority of SLR winders.

LENS HOODS

All Leica M lenses are supplied with a built-in lens hood or a convenient clip-on type. Those for the wide-angle lenses are rectangular in order to provide maximum efficiency in the short depth that is available. With present-day surface coatings the general need to shield a lens from stray non-image-forming light that could cause overall flare is not so critical. Much more important is the risk of reflections that can occur when a very bright light source, for example the sun, is in the field of view or just outside it. Where the light source is actually in the picture the lens hood cannot help. When it is just outside the picture area that is precisely when the hood will be of maximum benefit and when I always fit one if at all possible.

When the light source is in the picture area, it is always worth removing any filter as this is a common source of reflections or ghost images. It is also worth doing a little experimentation. Lenses can be much more prone to reflection problems with the sun at some angles than at others. It is also true to say that certain lenses are much less susceptible to reflections than others. If, like me, you often take pictures shooting into the light it is well worth

ZION, UTAH
When shooting against the light with the sun just outside the image area it is important to fit a lens hood.

Leica M6, 35/2 Summicron, Kodachrome 25 Professional, 1/250 sec, f4/5.6.

getting to know how each of your lenses behaves in such situations so that you can take steps to avoid any problems.

CLOSE-UP DEVICES

The largest image scale that can be obtained with a Leica M is 1:8 with the 75mm lens. The 90mm lenses give 1:9 and the 50mm Summicron 1:11.5. None of these is particularly close and if you are seriously interested in close-up photography, the M Leica is much less convenient than a modern SLR such as the Leica R. For relatively static subjects, however, the discontinued Visoflex housing which converts the M into a very basic SLR is also a capable solution (see chapter 9: The Visoflex and Lenses, page 74). More particularly there are a number of simple close-up devices that were once produced for the Leica M and which are very convenient for occasional copying or similar work.

One that I regularly use is the 16526 copying gauge known at

16526 COPYING STAND
Using different extension collars the stand will copy at A4, A5 or A6 sizes. It can be used with collapsible 50mm lenses. (Elmar or Summicron) or with the detachable lens unit of the earlier 50mm Summicrons, codes 11818, 11918 and 11817. The lens unit is used with the adapter 16508 shown in the picture.

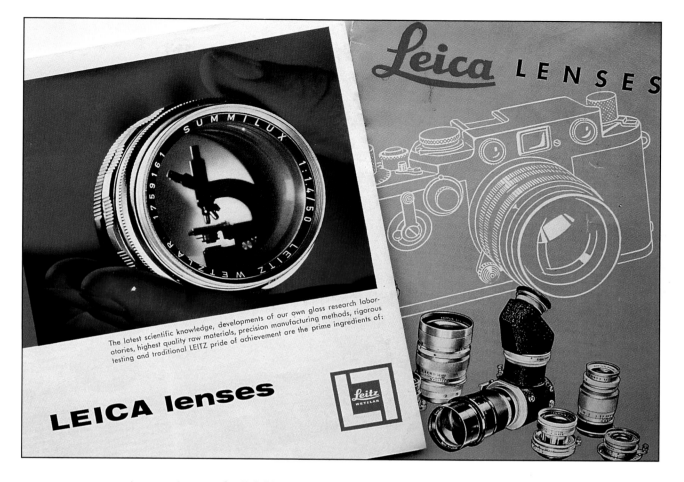

one time as the BOOWU-M. This is a set of four legs that can be set for A4, A5 or A6 size (approx). The legs are screwed into the appropriate attachment which fits into the camera like a lens and acts as an extension tube. The lens, a collapsible 50mm Elmar, a collapsible 50mm Summicron or the removable lens head of one of the earlier rigid 50mm Summicrons, fitted with adapter 16508, is fitted to the adapter. The legs outline the field of view of the lens and the plane of focus. It is best to stop down to at least f8 for flat copy or to f11 or f16 if there is any depth in the subject. There is no difficulty in metering with the M6 or the M5.

For even closer work the 16511 stand allows ratios of 1:3, 1:2, 1:1.5 and 1:1. The device consists of a stand with an adjustable column and extension tubes of various combinations with which to achieve the appropriate magnification. Masks set into the base outline the field of view for each combination. For focusing the camera is removed from the stand and a focusing tube with a ground glass screen is substituted. Any 50mm lens can be used but the Noctilux and Summilux are not recommended as they are not well corrected for the extreme close-up range. TTL metering is convenient with the M6 and the M5 and avoids the need for the exposure adjustment that is necessary at these higher image ratios when a separate meter is used. The adjustment for each combination is indicated on the stand.

LENS BROCHURE
An example of copying work with the set-up shown on the left.

Leica M6, 50/2.8 Elmar, Ektachrome Panther 100, 1/15 sec, f11.

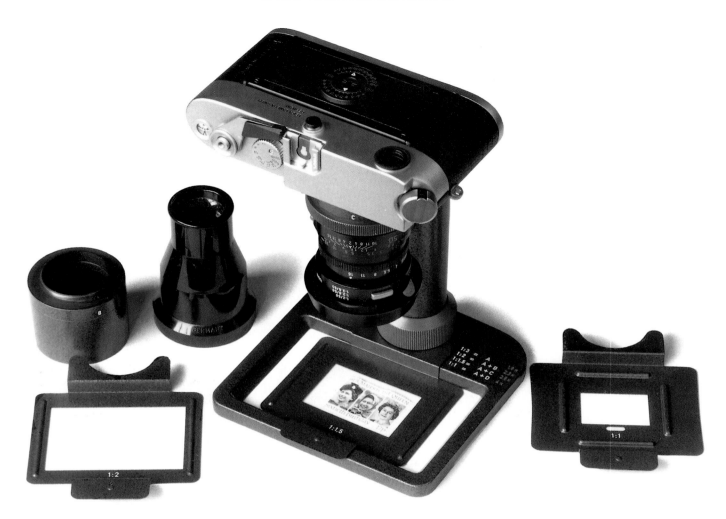

16511 COPY STAND
Used with a 50mm Summicron or Elmar lens this stand can be used to copy at ratios of 1:3, 1:2, 1:1.5 and 1:1. With a suitable lightbox transparencies can be copied.

FLASH GUNS

The M is the ultimate available light camera and using a flash gun, convenient though it may be, ignores the camera's potential for natural results in difficult lighting. It also has to be said that the fastest synch speed (1/50 sec) is very slow by modern standards and seriously inhibits some fill-in flash techniques.

Nevertheless if there is just not enough light for a subject, a good electronic flash gun is worth having around. I have two. The first is a tiny manual one, little bigger than a film box, that I keep in the gadget bag to provide a touch of fill-in flash to heavily shadowed areas (eg the face when shooting against the light). The other is a larger, computerized Bauer unit, which offers a good choice of f-stop settings and is also powerful enough for bounce flash in a normal room. It is also extremely valuable for fill-in light on more distant subjects such as an industrial scene. The object of fill-in flash is to put some light into heavily shadowed areas and it is important to avoid overpowering the natural lighting. Bounce flash gives a more natural effect than direct lighting. My Bauer gun actually allows some light to be bounced and some to be directed at the subject which is probably the best of both worlds.

GADGET BAGS

There are many excellent camera bags on the market and choice is very much a matter of how much equipment you wish or need to carry and how much rough and tumble you expect bag and contents to have to endure.

Leica's own soft leather cases are very elegant and carefully laid out internally for quite comprehensive outfits, accessories and film. They are smart, light and compact, and nice to carry around. They do not however take kindly to being tossed about in the back of a four-wheel drive, being stuffed under aircraft seats or suffering the many other indignities inflicted in the line of professional or serious amateur duty in all sorts of weather! For this you need a well made, very well padded bag, light enough not to become too much of a burden and soft enough to be carried without undue hurt. It also needs to have flexible internal partitioning and plenty of space for maps, passports, tickets and other non-photographic paraphernalia. Most of all the padding and stiffening needs to be up to the job of protecting your precious Leicas.

There is plenty of choice so do have a proper look at what is available at a good camera store, and do take along your preferred outfit to make sure that it fits, preferably with a little room to spare. My preference for the M is a Billingham '335'. Bags in the Billingham series are particularly well made from high quality materials, and are the choice of many professionals.

BILLINGHAM BAG
The English range of Billingham bags is particularly well made and not too obviously camera holdalls – an advantage from the security aspect.

CHAPTER 11

THE CHOICE OF FILM

Choosing the right film is important if you are to get the best from your Leica. Unfortunately any discussion of film choice is like trying to hit a moving target. The major manufacturers are constantly coming up with new films or improved versions of existing films. Competition is fierce and the beneficiaries are us the users, with the quality of all types of 35mm film, black-and-white, colour negative or colour transparency, already amazingly good and continuing to get better. No doubt by the time this book is published some of what is written will already be out of date but it is encouraging to see how the tried and tested favourites continue. This is because there is a constant process of minor improvements to a film or its processing, even when its basic characteristics are retained. Some of the changes are unseen and have more to do with facilitating quality control in manufacture or reducing sensitivity to processing variations than anything immediately obvious to the photographer, such as sharpness, grain or colour balance.

COLOUR NEGATIVE

With colour the first choice is between colour transparencies and colour negatives. If you are not looking to sell your work for quality publication – books, magazines, calendars and brochures etc – but mainly require prints for personal use or occasionally to enlarge for house décor or exhibition purposes, then negative film is the answer. It is less demanding in terms of exposure technique and it is easier and cheaper to get satisfactory prints both initially and when enlargements are needed.

A high proportion of press photography is now on colour negative rather than black-and-white film, too. This is the consequence of the much increased use of colour pictures in newspapers with advanced techniques using digitalized images for transmission and reproduction. The relatively tolerant exposure and processing demands of colour negatives, compared to those of transparency films, are more appropriate for press photography.

Overall the great majority of photographs are taken on colour negative and there is an excellent selection of first class films available from all the leading makers with constant improvements being announced.

Other than Kodak's remarkable Ektar 25, the slowest, and therefore the sharpest and finest grained negative films have a speed of around ISO 100. This is plenty fast enough for general photography and a film from this group is a good choice. There

COLOUR PRINT
Fuji Reala is a good general purpose professional print film. It has an extra emulsion layer that enables it to render fluorescent lighting without the typical green cast. This shot has a mixture of flash, daylight and fluorescents which the film has handled well.

Leica M6, 21mm Elmarit, Fuji Reala, 1/30 sec, f5.6.

are films in this group available from leading manufacturers such as Kodak, Fuji, Agfa and Konica and all will provide excellent enlargements from 35mm negatives. Kodak's Ektar 25 is much slower (ISO 25) but is by far the sharpest and finest grained of colour negative films. It is more critical in use, requiring accurate exposure and careful camera technique if its qualities are to be exploited. However, if you really want to see what your Leica is capable of, this is the film. Another film that needs special mention is Fuji Reala. This is one of the ISO 100 group and is designated a 'professional' film. In common with a number of the colour negative films primarily intended for professional studio use (Kodak Vericolor is another example) it is of lower contrast with less heavily saturated colours than the 'amateur' films. This can be helpful with pictures taken against the light where there are extremes of light and shade, and also in cases where subtle colours are important to the picture. Reala is also unique in its ability to render fluorescent lighting naturally. Normally this light comes out green with colour film and although it can be corrected with suitable filters there are problems with mixed lighting and Reala offers a much better solution. Fuji's newer Fujicolor Super G Plus has many of Reala's characteristics with less sensitivity to processing variations, and rather higher contrast.

The next group of films are those with a speed around ISO 200. Quality is still very good and these are a good choice for general purpose photography. Sharpness, grain and colour are not up

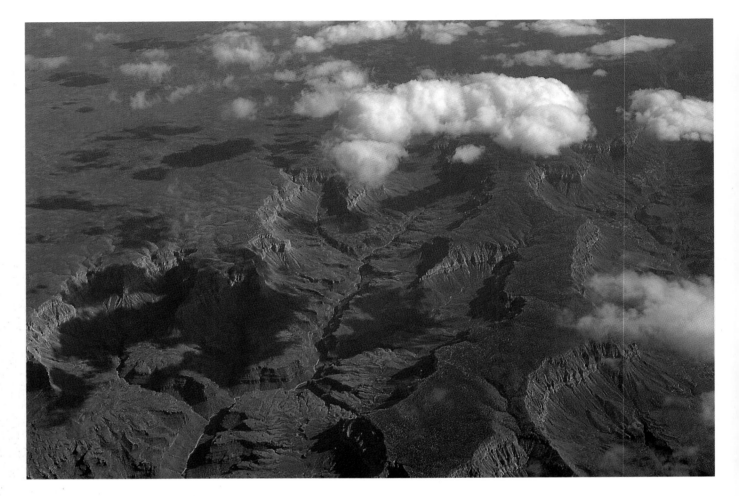

GRAND CANYON
(AERIAL VIEW)
Fuji Velvia has high
contrast and strong
colour saturation. This
can be an advantage for
distant views and high
altitude aerial shots
where haze often
interferes. This picture
was taken from a
scheduled flight
travelling to Las Vegas.

Leica M6, 35/2 Summicron, Fuji
Velvia, 1/250 sec, f8.

with the best of the ISO 100 group but unless you are looking for big enlargements the difference will not be obvious. Some of the best professional films are in this group and although the 'studio' films such as Vericolor III have been produced with medium format users in mind, their characteristics are often applicable to aspects of Leica M photography.

Even more relevant perhaps to the M Leica are those films specially designed for press use. The Kodak Ektapress series starts at ISO 160 and goes up to ISO 1600. There is also a new Ektapress which is so tolerant that it can be exposed at any speed between ISO 100 and ISO 1000 on the same film and with standard processing. This is an enormous benefit to the press photographer who never knows how lighting conditions may vary during an assignment.

Recent improvements in emulsion technology have benefited the less specialized faster films. The ISO 400 offerings from Fuji and Kodak rival the quality of much slower films of a few years ago. Ektar 1000 is even more remarkable, bringing unexpected sharpness to a film of this speed. Fujicolor Super G800 is another excellent high-speed film. Grain and sharpness are very good for its speed but exposure does need to be more accurate than with most colour negative films.

BRYCE CANYON,
UTAH
Kodachrome 25 is still
the standard against
which all other films are
judged. It is extremely
sharp, extremely fine
grained and of moderate
contrast with superior
reproduction of subtle
tonal values and colour
nuances.

Leica M6, 35/2 Summicron,
Kodachrome 25 Professional,
1/125, f5.6.

FALL COLOURS, NEW
ENGLAND
The ISO 100 versions of
Ektachrome Elite and its
professional equivalent,
Ektachrome Panther 100
and 100X, are very fine-
grained and sharp for
their speed. Colour is
very saturated and in the
case of 100X quite warm.
These attributes suited
this scene especially
well.

Leica M6, 50/2 Summicron,
Ektachrome Panther 100X, 1/250
sec, f8.

COLOUR TRANSPARENCY FILMS

Although the choice of a suitable colour negative film is important it has to be recognized that negative film is an intermediate step to a print. The final result is as much the result of the printing as the taking. This is not the case with colour transparencies, where the film that is exposed in the camera is the finished product. Not only the darkness and lightness but also the colour balance is governed at the taking stage by the type of film, any filters that are used, and the exposure that has been given. The choice of a transparency film is therefore very important. The experienced photographer will often have a 'palette' of different films that he has got to know so well that he can select one to be suitable for a particular subject or particular lighting conditions. He will have got to know these films and their attributes so that he can achieve, much more confidently, the style of image that he wishes, whatever the circumstances. As always, the sharpest, finest grained films with the best colour and smoothest gradation of tones are the slowest.

There are excellent films from all the leading manufacturers – Agfa, Fuji and Kodak. Within any given speed group quality from these suppliers is very close and the actual choice can often be based on subjective preferences for colour balance and contrast. For 35mm the slowest film available is Kodachrome 25 (ISO 25). This is the well established standard against which all others are

PHOTOKINA 92
This set was on one of
the video stands at
Photokina. Kodachrome
200 is unusually sharp
for such a high-speed
film and I was able to get
adequate exposure with
the Summilux at full
aperture.

Leica M6, 50/1.4 Summilux,
Kodachrome 200 Professional,
1/125 sec, f1.4.

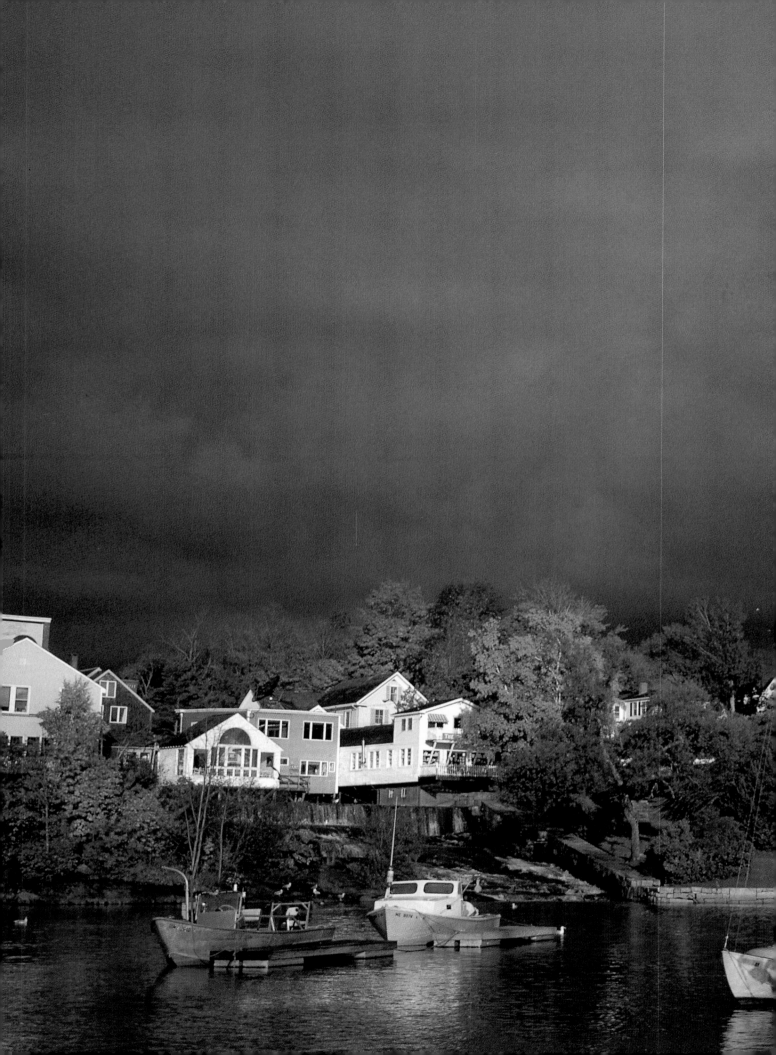

judged for quality. Not surprisingly, bearing in mind its speed, it is extremely sharp, has extremely fine grain, moderate contrast, clean, well saturated colours and very smooth tonal gradation. In good light the colour balance is fairly neutral but it does tend to be on the cool side in dull or rainy conditions. Most of the colour pictures in this book were taken on Kodachrome 25. Fuji Velvia (ISO 50) is another of the slower films noteworthy for its sharpness. At the time of writing it is undoubtedly the sharpest E6 process film (the Kodachrome process is different). It is also very fine grained and all the colours are highly saturated. Reds are very strong and blue skies never need a polarizer! The greens are very bright too, and for some are a little overpowering in the landscape at times. Other photographers like these greens, and the strong colours make it a useful film in dull lighting.

Fuji's Sensia/Provia range of transparency films includes an ISO 100 that is more neutral and less aggressive in colour saturation than Velvia and is still extremely sharp. Provia film is the professional version of Sensia and is sold without processing included. Kodak's Ektachrome Elite range also has a very good ISO 100 film that is especially fine grained and sharp, the professional equivalent being Panther (Lumiere in the USA). Kodak's Ektachrome 100 Professional EPN has always had a reputation for giving very natural colour rendering, whereas Elite and Panther have offered better sharpness and grain characteristics with greater colour saturation and contrast and a warmer colour balance. The EPN has recently been improved with benefits to grain and sharpness while retaining its characteristic natural colour.

Kodachrome 64 is another very popular film, mainly because of the extra speed it offers over Kodachrome 25. This is certainly helpful on occasions but the colours are not as 'clean' and accurate as 'K25' and the film is more contrasty, as well as having a tendency towards a more magenta colour balance. Sharpness and grain are not quite so good as in its slower cousin and are very much on a par with Velvia. My usual choice if I need a faster film than Kodachrome 25 is Kodachrome 200. This film is very sharp in spite of noticeably increased grain and has quite a pleasant colour balance, similar in many respects but somewhat warmer than Kodachrome 25. It handles high contrast and variations in lighting very well and has a nice 'documentary' quality that seems to go well with the Leica M style.

Agfa films now are all E6 process. They are notable for their excellent neutral colour rendering, with particularly clean whites and greys. Colours are somewhat less saturated than Fuji and most Kodak films but there are many situations when this can be advantageous.

With the possible exception of Kodachrome 200, I do not recommend a transparency film faster than ISO 100 if you wish to be sure of best detail, natural colours and good tonal rendering. The Leica, though, is *the* 'available light' camera and you may well wish to use it in conditions requiring one of the faster films.

THAI DANCER
A long lens was needed
to fill the frame
adequately and throw
the background out of
focus which meant that I
had to use a medium-
speed film.

Leica M4-P, 135/4 Tele-Elmar,
Kodachrome 64, 1/500 sec, f4.

AT THE WEDDING
RECEPTION
For candid portraits by
natural daylight indoors,
Kodachrome 200 is ideal.
Contrast is moderate and
sharpness is excellent.
The lens here was the
older model 90mm
Summicron used at full
aperture.

Leica M6, 90/2 Summicron,
Kodachrome 200 Professional,
1/125 sec, f2.

With the fast Leica lenses it is surprising how often Kodachrome 200 will cope but if you need more speed the current ISO 400 offerings from Fuji and Kodak are remarkably good. Even faster films are Agfachrome 1000RS, Fujichrome 1600, Kodak Ektachrome P800/1600 and Leica M – which has a splendidly individualistic coarse grain that can be exploited for special effects. It should be noted that the ultrafast Fuji and Kodak films are 'professional' films and are basically ISO 400 emulsions that have been specially designed for 'push' processing to ISO 800 or ISO 1600. You will need to use a professional lab and advise what 'push' you need in processing – ie one stop or two stop.

BLACK-AND-WHITE FILMS

Because it has particular strengths as a camera for photo-journalism and 'available light' work, a good deal of Leica M photography is on black-and-white film. Despite the increasing use of colour, a very high proportion of the most powerful images emerging from areas of conflict and disaster, as well as documents of the human condition, are in monochrome.

Aesthetically, too, the monochrome image can, if required, be a significant step away from the reality of a scene. This allows the photographer to impose his own vision more easily and use the original scene sometimes as no more than a starting point for his creative expression. Black-and-white also has the advantage that the processing is relatively simple and most photographers develop their own films and carry out the subsequent printing, ensuring that absolute control is exercised over the finished result and final impression. A first class black-and-white print has a unique quality of craftsmanship which can be appreciated in its own right – giving added value to a worthwhile image. Subtle toning processes can add a further dimension.

This continuing interest has ensured that there is still a wide choice of good quality, black-and-white films available. Some of the more popular ones and their recommended developers are discussed below.

GENERAL PURPOSE FILMS

The general rule is that the slower the film, the finer the grain, the better the sharpness and the smoother the tonal gradation.

For normal use, a medium-speed (ISO 100) film such as Ilford FP4 Plus or Kodak T Max 100 is ideal. Sharpness, grain and tonal quality are so good that the gain from using an even slower film is minimal. A plus point is that the slight extra speed will be a great help whenever filters are required. An orange filter, used to emphasize a dramatic sky for example, would reduce the effective speed of T Max 100 to ISO 25, but this is still adequate for hand-held exposures in reasonable light.

In bad weather or for low light photography an ISO 400 film will still provide good quality and is likely to handle the inevitable extremes in contrast more easily. With an F2 or faster lens, hand-held pictures can be made in reasonably lit areas at night but a tripod will be needed if you need to stop down for depth-of-field.

REBECCA
A snapshot by window light on a medium-speed film.

6 90/2 Summicron, Kodak T Max 100, 1/125 sec, f2.

For most low light work ISO 400 is usually fast enough and there are some excellent films in this group. Kodak's Tri X is a long-time favourite but is now slipping behind later introductions including its well regarded stablemate T Max 400. As well as Delta 400, Ilford have HP5 plus and the remarkable XP2 (see below), and Fuji offer Neopan 400. Most of these films can be 'push' processed to ISO 800 or even IOS 1600 if need be, but if you are really after a film for available darkness T Max 3200 must be the one. The speed is there and it is quite sharp but inevitably

grain is very obvious. Fuji Neopan 1600 will give you less grain but you lose a full stop in speed.

Two excellent new films from Ilford are Delta 100 and Delta 400. Both have exceptional grain and sharpness for their respective speeds. Delta 100 is even considered a serious alternative to earlier much slower emulsions from Ilford and other makers.

Ilford XP2 is a most unusual film. Its normal speed is ISO 400 but it can be rated anywhere between ISO 100 and ISO 800 with excellent results. It is a chromogenic film, drawing on colour negative emulsion technology. Processing is in C41 chemistry, the standard for colour negative. Home processing is not so easy as conventional black-and-white films but you can go to any High Street mini-lab and immediately get your film developed and a set of prints. Quick-service prints will be on colour paper and come out in a not unattractive sepia tone.

INFRARED

Kodak High Speed Infrared is a powerful tool for the creative photographer. As well as cutting through mist and haze – the purpose for which it was intended – the distortion of normal tonal values can be exploited to achieve some quite surreal effects. Their lack of infrared means that skies become black while, conversely, leaves on the trees, which have a high IR reflectance, become white. The film is very grainy, too, which enhances the other-worldly look.

This is not a particularly easy film to handle. Loading and unloading the camera must be carried out in the dark. Some plastic tanks can pass infrared wavelengths so that even the development may have to be done in the dark! The recommended developer is Kodak HC 110 for 6 minutes at 20 °C.

Exposures have to be made through a deep red filter (Wratten 25, 29, 70, 89B or equivalent) or special IR filters in order to exploit the film's special properties. Film speed is difficult to establish precisely because this is obviously dependent on the amount of infrared reflected from the scene. A useful starting point when using the Wratten 25 filter is to set the film speed to ISO 50. If metering in-camera, through the lens, remove the filter when taking your reading or set the film speed to ISO 400. An average scene in good daylight should read 1/125 at f11 and if you are not sure of your metering this is a good basic starting point. Whatever method you use, always bracket exposures +1, +2 and –1 and –2 stops.

Unless you are using an 'apo' (apochromatically corrected) lens you will need to correct the focus on your camera as infrared rays come to a focus at a different point to visible wavelengths of light. You will have to set the lens to a slightly nearer distance after you have focused normally. Some lenses have an IR mark on the scale and you should reset to this. Alternatively a useful rule of thumb that works with wide-angle and standard lenses is to reset the indicated focus to the f5.6 mark on the depth-of-field scale. Do not forget that this is to the mark that gives a *closer* focus!

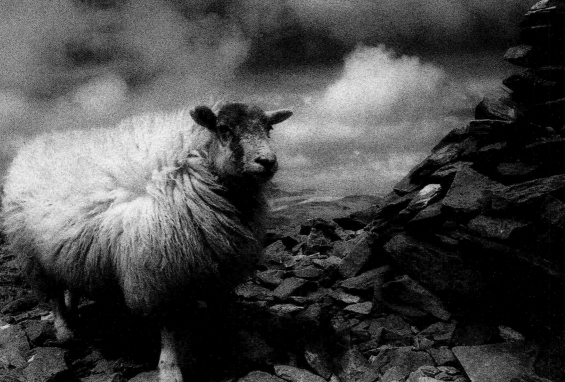

PROCESSING

Most black-and-white photographers enjoy doing their own processing. There are many excellent proprietary film developers available in addition to those offered by the film manufacturers themselves. This is a subject on its own, along with black-and-white printing techniques.

The majority of my black-and-white, technical illustrations for this book were taken on T Max 100, developed in T Max developer for the maker's recommended time. This gave fairly easy printing negatives for a Focomat V35. I have also used T Max developer satisfactorily for T Max 400 and Ilford Delta 100. I tend to use T Max developer because it is ready made up in convenient liquid form. However, if you are really into much black-and-white photography, Ilford ID II, which has to be made up into a stock solution from powder, is an old favourite and still very highly regarded by many photographers and technicians. For consistent reliable results it is best used as a 'one shot' developer, diluting the stock solution 1:1. Kodak D 76 is almost identical with ID II but also has to be made up from powder. Other liquid developers worth checking out are Agfa Rodinal and Kodak HC 110, mentioned above in connection with infrared film, but also a useful general purpose developer.

PROFESSIONAL FILMS

As we have already seen, some films, both in colour and in black-and-white, are designated as 'professional'. These are usually distributed through a separate stockist network that can provide both the controlled storage conditions usually required and also the detailed technical information and advice needed for specialized applications. Although in some cases the 'professional' and 'amateur' films may come from the same production, more often the professional film has been specifically designed to meet the particular needs of professionals. An example is Kodak Vericolor III. Because this film is particularly intended for use by professional wedding and portrait photographers the contrast is much lower and the colours more natural than the general purpose amateur print films, which aim for bright, saturated colours and relatively high contrast. Similarly the 'aim points' of the professional transparency films are much more specific, with different films of the same nominal speed but with slightly different characteristics being available. Kodak's recently introduced Ektachrome Panther series is an example – the regular 100 being intended for studio use with electronic flash and the 100X having a 'warmer' emulsion for location use. Kodak also offer Ektachrome Professional 100 (EPN) as giving the most accurate colour rendition of any of their films, while Ektachrome 100 Plus (EPP) is similar but has greater colour saturation.

Kodachrome professional film is in fact exactly the same production as the amateur film. The difference comes when batches are tested to ensure that they are within the very tight quality tolerances. Those with the absolute minimum deviation

MEDIEVAL HOUSE, HAMELIN, GERMANY It was important to record the fine detail of the carving on this building. Cross lighting plus a sharp, slow-speed professional film ensured reliable results. Kodachrome Professional is sold non-process-paid. In Europe it has to be sent to a Kodak laboratory for processing.

Leica M6, 35/2 Summicron, Kodachrome 25 Professional, 1/60 sec,f5.6.

from perfect speed and colour standards are selected and released into the controlled professional distribution chain when at their optimum. All films mature and slight changes occur even prior to the expiry date on the box. 'Amateur' films are released on the assumption that this maturing will continue to take place during storage on dealers' shelves. Where appropriate, professional distributors and dealers store at low temperatures to minimize these changes. All the special films – infrared, duplicating, high resolution and high contrast – are designated 'professional'.

PROCESSING

Professional colour transparency films are sold without processing and need to be handled by a high-standard professional lab if the quality chain is to be maintained. E6 is the now-universal process for all except Kodachrome, which because of its very complex procedure has to be returned to a Kodak laboratory. Most professional labs offer a two-hour service on E6. Professional Kodachrome is same day 'in-house', plus any time for posting or long-distance delivery.

Professional negative films such as Fuji Reala and Kodak Vericolor need special care in printing, as does Ektar. Although the film processing is the standard C41, the printing requires different filtration. The typical High Street mini-lab whose low prices are based on volume and fast throughput will rarely be able to achieve the quality of a professional lab. The cost of the latter will, of course, be much higher.

For the professional or any serious photographer, the advantages of professional films and processing by professional labs are reliability and consistency. Eliminating as many technical variables as possible allows the photographer to concentrate on the picture. It pays to get to know the characteristics of just a few films and a reliable processor so that you know the results to expect with different types of subject under different lighting conditions in order to achieve the effect that you require.

WINDERMERE, CUMBRIA
Fuji's Provia 100 is the professional version of Sensia 100. It is sold non-process-paid. Consistent results are best assured by using a reliable professional laboratory for processing.

Leica M6, 90/2 Summicron, Fuji Provia 100, 1/500 sec, f4.

CORRECT EXPOSURE

Correct exposure of the film is an essential step in the chain of quality that begins with a first class camera and lens, such as the Leica, and ends in the production of a superior print or transparency. For best results even today's relatively forgiving negative materials, colour and black-and-white, require exposures accurate to plus or minus half a stop, while the finest colour transparency films need to be accurate to within plus or minus a quarter stop.

Incorrect exposure not only affects overall density, tonal values and colour, but sharpness too is adversely affected. Underexposure loses detail in shadow areas while overexposure blocks up detail in the lighter areas. In both cases the colour rendition will be affected. With the negative/positive print process density and colour balance can be corrected to some extent at the printing stage, but the colour transparency is the finished article and it must be got right at the taking stage.

PRINCIPLES

All metering systems, whether built into the camera or a separate hand-held meter, and all film speed ratings are calibrated to a well established standard. It is accepted that with the majority of subjects with normal lighting, the overall reflectance of the varied tones averages 18% and this is the standard basis used. It is very important to remember this because this is the reflectance that your meter assumes it is reading. Thus if it is reading a non-standard subject, eg a white card, it assumes that it is in fact grey and will give an exposure to record it as grey. Equally if it is reading something that is entirely black it will give sufficient exposure to make that grey also!

To be used effectively the meter requires the application of intelligence to recognize those situations when the in-built assumptions are wrong. First of all this means knowing what area of the subject the meter is reading and then making a judgement as to whether any correction is required. You will find that with most normal situations, a straightforward reading can be relied upon, which is why the 18% reflectance was selected. However, the Leica M photographer, more than most, is likely to be pushing the limits of his photography in difficult lighting conditions and requires the skills to recognize and adjust for these situations quickly. In low light photography a relatively small but very bright highlight can have a disproportionate effect causing serious underexposure of the scene as a whole.

LEICA M METERING SYSTEMS

The M6 meter (see page 26 for description) is a particularly effective compromise between a narrow-angle spot system and one that takes in a much larger area of the image. The area that it reads can be most easily visualized as a circle occupying two thirds of the vertical height of the frame. This is narrow enough to allow for accurately aimed readings of significant parts of the subject when necessary, yet sufficiently wide for straightforward general readings to include, in the majority of instances, a good average spread of tones, thus enabling correct exposure to be achieved easily and quickly. The main point to remember is that with wide-angle lenses, especially the 28mm and 21mm Elmarits, outdoor scenes are likely to include an excessive amount of bright sky in the metering area and the camera should be tilted downwards to exclude most of this when making a reading.

Correct exposure is indicated when both the LEDs in the finder glow with equal brightness. Exposure is over by half a stop if the left-hand LED is only partially lit or under by half a stop if the right-hand LED is only partially lit.

The M6 meter is quite sensitive and capable of giving accurate readings at low levels of light. With ISO 100 film and an f1.4 lens it will read down to levels requiring an exposure of 1 sec at f1.4. For available-light photojournalism this translates to 1/4 second

BODIE GHOST TOWN, CALIFORNIA
This old mining town was still active in the 1930s. Its remote location and elevation have ensured the clean dry air that has helped preserve the buildings and other artifacts. Slow film and a sharp lens make the most of the clear light. A relatively straightforward exposure, the reading with an MR meter could be used without modification.

Leica M4, 21/3.4 Super Angulon, Kodachrome 25, 1/125 sec, f5.6.

at f1.4 with a film rated at ISO 400, or 1/15 sec at f1.4 for a film rated at ISO 1600. Rarely will this be inadequate! The meter gives a warning when light levels are too low for an accurate reading by a steady flashing of the left-hand LED. This also occurs if the lens cap has been left on or the lens is stopped down too far for the prevailing light level. Note that with earlier M6 cameras, instead of a flashing warning the LED does not light. Although any Leica M lens can be used on the M6, the projecting rear elements of some earlier wide-angles obstructs the field of view of the meter cell and will either prevent any reading or give an inaccurate one. These lenses are:

❑ 21mm f4 or f3.4 Super Angulon
❑ 28mm Elmarit, below serial no 2314921
❑ 15mm Hologon

LEICA M5

The M5 incorporated the first TTL (through-the-lens) metering system to be built into a Leica M Camera. Essentially it consists of a metering cell on an arm that swings up into the focal plane when the film is wound on and then springs out of the way when the shutter is released. The display in the finder is more sophisticated than that in the M6 as the shutter speed in use is also shown. Correct exposure is indicated by the intersection of the speed/stop setting needle and the light measuring needle on a bar. Despite its complexities the system is easy to use and quite reliable, albeit not as robust as the LED system in the M6. Because light from the lens is read directly by the metering cell, the M5 meter is actually twice as sensitive as that of the M6. However, there is one serious aspect of the swinging-arm meter cell that all M5 users must remember. Certain lenses whose rear mounts project into the camera body will foul the meter cell and must not be used. The same also applies to older type lenses that could be collapsed into the body to make the camera more pocketable. It is possible to modify the lenses to avoid this risk but the meter is then inoperative so that it is hardly worth the cost or trouble. The safest thing is not to use the following lenses on the M5:

❑ any collapsible lenses (eg 50mm Elmars, Summitars, etc)
❑ the 15mm Hologon
❑ the 21mm, f4 and f3.4 Super Angulons
❑ 28mm Elmarits, below serial no 2314921

The M5 metering area is a circle approximately half the diameter of that of the M6. When the 50mm lens is fitted, the illuminated frame includes four marks, just outside the rangefinder patch, that indicate this measuring area. With other lenses the best guide is to imagine a circle equal to one third the height of the frame in use. The narrower angle means that the meter is less likely to be influenced by bright sky than the M6 but care should be taken to ensure that a representative range of tones is included.

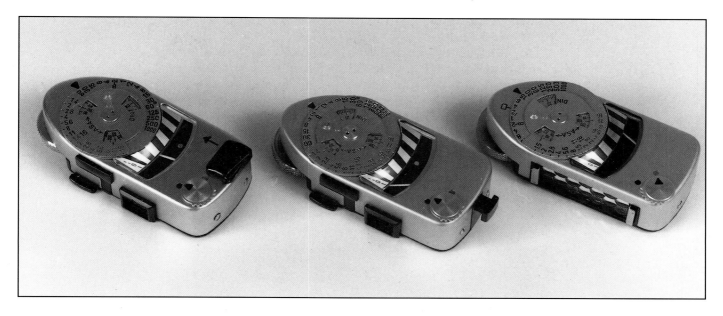

Three generations of clip-on meter for the M cameras. Left to right MR4, MR, MC.

LEICA CL

The meter system in the CL is virtually identical to that of the M5. The reading angle is similar but there are no aids to this such as you have with the 50mm and low light sensitivity is half that of the M5, similar in fact to the M6. The same warnings about not using certain lenses also applies to the CL as it uses the same swinging-arm system.

LEICA METER MR

No M camera prior to the M5 had a built-in exposure meter, but for many years Leica did provide a very neat and compact separate one that can be fitted into the accessory shoe and coupled to the shutter-speed dial so that appropriate aperture settings for the shutter speed set are indicated directly by the needle. Fitting it to the camera is straightforward:

❑ The camera shutter speed is set to 'B'
❑ The large knurled knob on the MR meter is first turned so that the shutter speed on the meter indicates 'B'. The knob can then be raised slightly and then turned to show a longer shutter speed of 2 seconds or more to lock it in that position
❑ The meter is slid into the accessory shoe. The meter speed setting is then returned to 'B' by moving the knurled knob, which will then drop back down and a small pin underneath it will locate in a groove in the camera's shutter-speed dial. A little wiggling may be needed to achieve this
❑ The camera shutter speeds are now set with the knurled knob on the MR meter

The MR meter was first made available for the M3 and M2 cameras and then for the M4, M4-2 and M4-P. Later models for the M4, etc, are sometimes unofficially known as MR-4 as they have a modified on/off switch, the earlier one being somewhat

vulnerable when rewinding film with the canted rewind knob of the M4 cameras.

The MR meter has a Cds cell and is powered by a PX625 battery or equivalent. Low light sensitivity is the same as an M6 when fitted with an f2 lens. As the MR meter is not reading through the lens, the sensitivity is unaffected by the lens fitted to the camera. The area read by the meter is the field of view of a 90mm lens so that accurately aimed readings can be achieved by using the frame selection lever to bring up the 90mm frame in the camera viewfinder, aiming this at the relevant part of the subject and taking a reading by pressing and then releasing the meter switch. This locks the reading, and the lens stop for any speed selected can be read off the meter scale. There are two light scales selected by a switch on the meter. For most daylight photography the

LAS VEGAS
The neon lights are very bright which can lead to serious underexposure of the rest of the scene, so it is best to take these pictures at dusk. Take a reading of an area of lights plus sky and a bit of the street area – and bracket.

Leica M6, 35/2 Summicron, Kodachrome 200 Professional, 1/60 sec, f2.8.

SAILPLANE
Aircraft are often photographed against a bright sky with white clouds. A direct meter reading will be such as to cause underexposure, with the aircraft in silhouette. Take a reading of an area of landscape plus a little sky beforehand and pre-set the camera.

Leica M6, 135/4 Tele-Elmar, Kodachrome 64 Professional, 1/500 sec, f5.6.

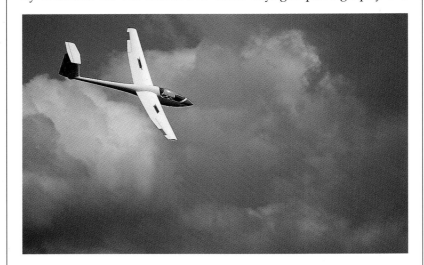

bright scale is used, but the meter should be switched to the low light scale if the needle is indicating within the bottom two segments.

The MR meter is reliable and accurate and, prior to the M6, I used one extensively with my M2 and M4 cameras. The ability to read clearly defined areas of the subject by using the 90mm frame is a considerable aid to accurate metering and in practice the meter is very convenient to use. The only disadvantages are the necessity to remove the meter if there is a need to use the accessory shoe (eg for a 21mm viewfinder or to fit a flash gun) or to fit a Visoflex, and the lack of exposure information in the camera viewfinder.

LEICA METER MC

This was the predecessor to the MR meter and is fitted to the accessory shoe and coupled to the shutter-speed dial in the same way. This meter operates with a selenium cell and thus requires no battery. Like the MR meter it has two light scales but the maximum sensitivity is very significantly lower. Even with the optional accessory booster, which is somewhat clumsy to use, maximum low light sensitivity is half that of the MR.

BLUE BOAR FARM, DERBYSHIRE PEAK DISTRICT
Snow scenes require careful exposure. A straight reading will lead to underexposure due to the overall whiteness. Either meter a shadow area or increase exposure by one to one-and-a-half stops.

Leica M6, 28/2.8 Elmarit, Kodachrome 25 Professional, 1/60 sec, f8.

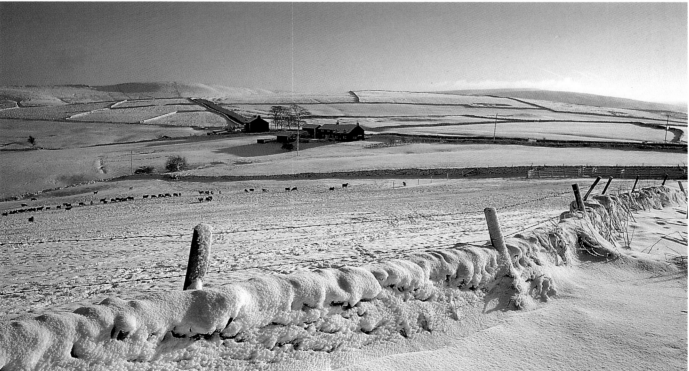

In practical use, the level of low light sensitivity may not always be important but a more serious disadvantage of the MC is the very wide reading angle common to all selenium cell meters including the redoubtable Weston. The 55° angle makes it very difficult to get accurately aimed readings from difficult or distant subjects.

SPECIAL SITUATIONS

Irrespective of the metering system used, certain types of subject and lighting will cause difficulties. The 'matrix' systems now incorporated in some of the highly automated and computerized modern SLRs are a sophisticated attempt to overcome the problems, but in practice still fall well short of the consistent results that can be achieved by intelligent application of a good conventional system.

The important thing always to keep in mind is that the meter thinks that the average reflectance that it is reading is the 18% referred to earlier. Any subject or lighting that is not reasonably close to that norm requires correction. Some typical situations are:

❏ Snow scenes. The preponderance of white will cause the meter to over-read the light and try to make the snow a dull grey. Either take a close-up reading off a darker area or increase exposure by around one to one-and-a-half stops.

❏ Very bright highlights in an otherwise low lit scene, eg a night scene with street lamps or an outdoor spectacle with floodlights directly in the field of view. If possible try to take a reading of part of the subject excluding the lights, or find a substitute part of the scene with a similar level of light. If this is not possible, try giving one to two stops extra exposure.

❏ Aircraft in flight. The very bright sky background will confuse the meter and cause underexposure with the aircraft coming out as a silhouette. This and other subjects with a lot of sky in the picture can be a real problem area for automatic cameras. With a manual camera like the M, the answer is simply to take a reading off a normal subject area, eg the runway, some grass, and a little bit of sky; adjust the camera for this, and use these settings for photographing the aircraft, etc.

❏ Spotlit performer on a darkened stage. Unless you have a very narrow angle spot-reading meter (the M6 and MR meters probably are not but the M5 *may* be narrow enough) the exposure will be unduly affected by the darker surrounding areas and the performer will be overexposed. It may be possible to get a better reading when the stage is fully lit earlier in this or another act. Alternatively try bracketing at –1, –1.5 and –2 stops.

❏ Small area of subject in bright sunlight with large area of background in shadow. Similar in many respects to stage shots but in many cases, eg portraits or relatively static subjects, it will be much easier to obtain a close-up reading of the main subject avoiding the dark background, or to make a substitute reading from a similarly lit area.

STAGE SHOW
The problem in this situation is that the meter will be including too much of the dark areas in its reading which will cause overexposure of the spotlit performers. Stage lighting constantly changes so sometimes the only answer is an educated guess at the adjustment required. Around one stop less exposure than the meter indicates would be correct here.

Leica M6, 90/2 Summicron, Kodachrome 200 Professional, 1/125 sec, f2.

SUNSET, RUNWAY 24, MANCHESTER AIRPORT

From an exposure point of view sunsets are relatively straightforward. Just take a reading from the sky, taking care not to include the sun itself. Foreground objects will record as silhouettes so you need to look for interesting shapes.

Leica M6, 35/1.4 Summilux Aspheric, Kodachrome 200 Professional, 1/500 sec, f2.8.

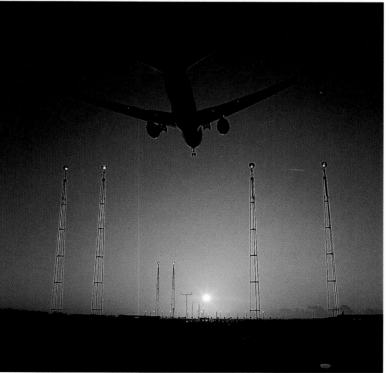

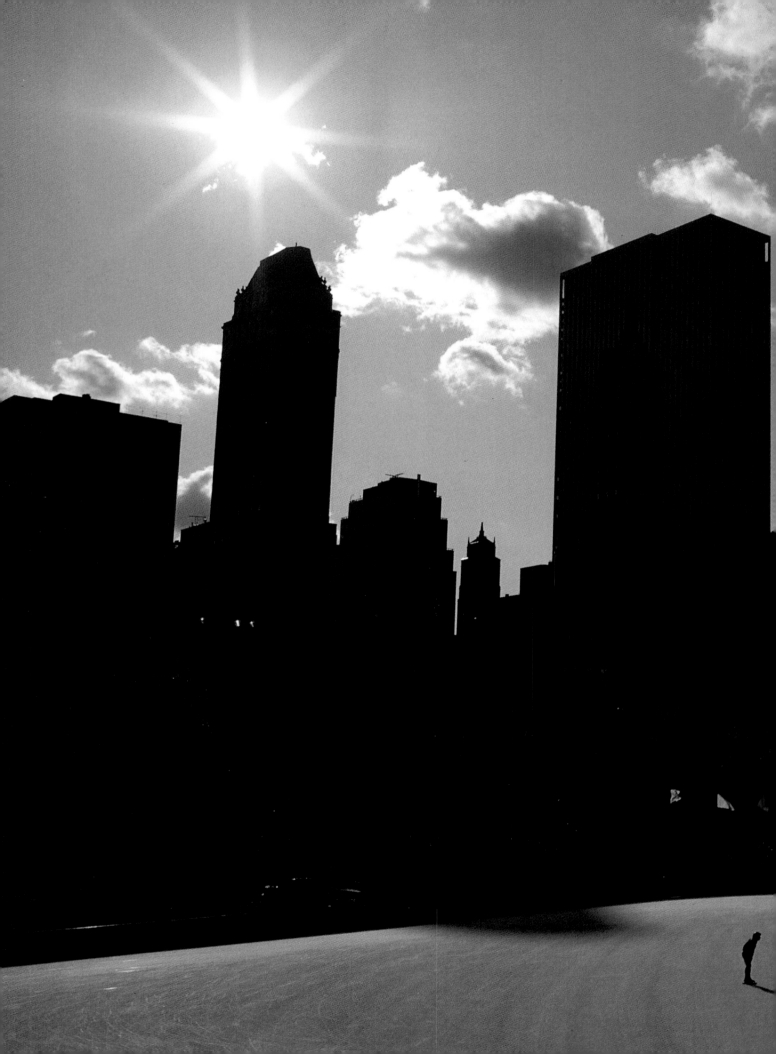

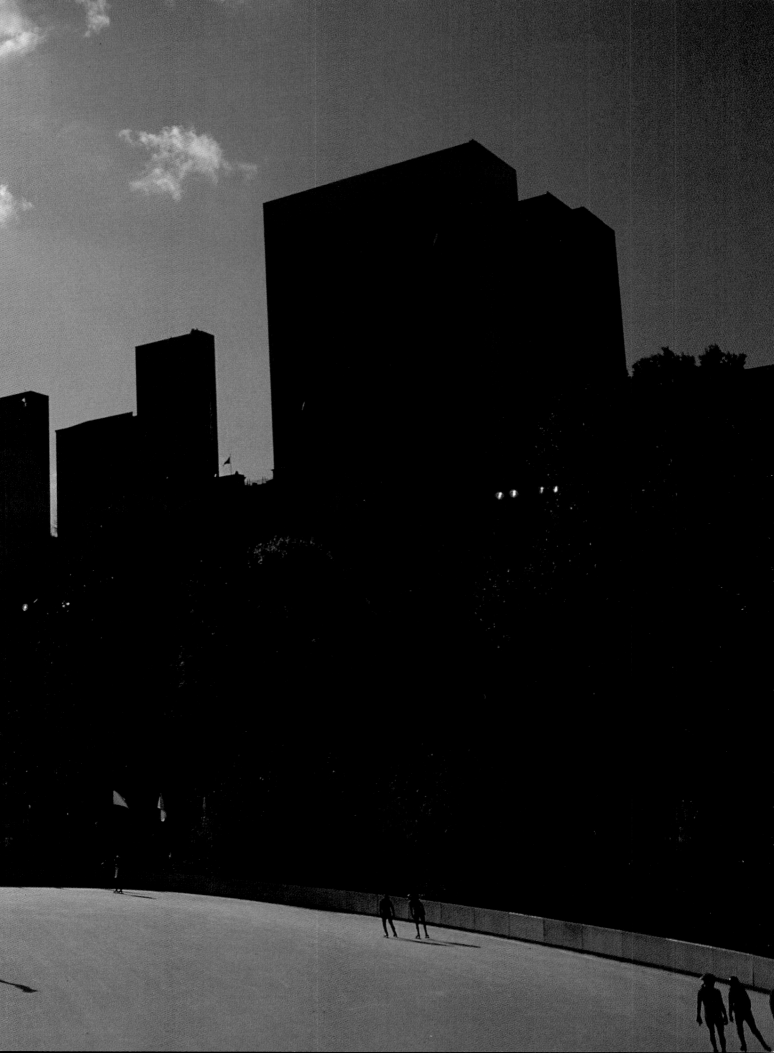

Technically this picture is
underexposed. I took
several shots using
21mm and 28mm lenses,
bracketing exposures
and looking for a good
arrangement of the
skaters. This strong
silhouette of the
buildings and skaters is
one of my favourites
from the series.

Leica M6, 21/2.8 Elmarit,
Kodachrome 25 Professional,
1/250 sec, f8.

❏ Shooting against the light. This can easily cause problems as the light source, generally the sun or its reflection, off water for instance, is very possibly directly within the metering area. It is important to take a reading ensuring that this situation is avoided if at all possible. If not, compensate by increasing exposure by one or two stops. The pictorial effect has to be considered. Distant scenes against the light can gain their charm from the sparkle of bright highlights and a semi-silhouette effect. They will need less compensation than, say, portraits against the light where detail in the face is important. Ideally in this latter case a close-up reading should be taken but this will only be possible in a formal situation. A wider spread of bracketed exposures (see opposite) is always worthwhile when shooting against the light.

❏ Close-up copying. It is often difficult to get a representative spread of tonal values as a single light or dark tone may dominate subjects for close-up or copying. This is not normally Leica M territory but the technique is worth knowing as it may have other applications. This kind of subject is usually static and my preferred solution is to take a reading off a Kodak grey card which is either temporarily substituted for the subject itself or placed in similar light to obtain an equivalent reading. The Kodak grey card is carefully produced: one side has the

FOGGY MORNING
Like snowscapes, mist
and fog scenes can easily
be underexposed as the
meter is misled by the
overall lightness of the
scene. Take a reading
from the darker areas
close to the camera or
increase exposure by a
half or one stop.

Leica M6, 135/4 Tele-Elmar,
Kodachrome 64 Professional,
1/250 sec, f4.

MANHATTAN FROM THE EMPIRE STATE BUILDING
Night shots are best taken at dusk. A meter reading including a little sky plus the main subject area will give correct exposure. The MR meter used here included the full frame in its area and was just sensitive enough to give a reading.

Leica M4, 90/2 Summicron, Kodachrome 64 Professional, 1/2 sec, f2.

correct 18% reflectance and the other side is white and has a known 90% reflectance. It has other useful applications in exposure determination and checking colour neutrality and is a most useful item to have around.

BRACKETING

Film relative to other photographic costs – equipment, travelling to a location, time if you are a professional – is cheap. On any important subject, bracketing the exposure is worthwhile and, in fact, standard practice with professionals whenever it is possible. Bracketing is the technique of shooting extra frames with the exposure adjusted by plus and minus half stop and sometimes even full stop increments. The most interesting subjects are often the most difficult, and sometimes the technically correct exposure is not always the most attractive in pictorial terms. Especially with the narrow tolerance of colour transparency film, bracketing is good insurance when you are faced with a never-to-be-repeated opportunity.

CHAPTER 13

RANGEFINDER SPECIALITIES

The special strengths of the M Leica in today's photography are the very same strengths that successfully established the Leica and early 35mm photography in the late 1920s and the 1930s. It is compact, it is portable, it is robust, and the precision of its build, together with exceptional lens optics, mean that it can be relied upon to produce images of outstanding quality.

It was the photojournalists, the travellers and the explorers who first seized upon the early Leica as the ideal tool for their needs. In spite of the enormous development that has gone into producing better and even more versatile 35mm single lens reflex cameras that successfully fits them for virtually any photographic requirement, the rangefinder M still has unique qualities in the self-same areas that brought it to prominence over sixty years ago.

Leading photojournalists, whether they work for major newspaper chains or top agencies like Magnum, or even as paparazzi, all revere the Leica M. They appreciate its robustness, its quietness and its low light capabilities. Its essential simplicity and its lack of dependence on battery power for anything other than metering, confer the reliability factor that photographers operating remote from base or in areas of conflict must have. In particularly difficult situations the way that the viewfinder gives the ability to see what is happening outside the field of view of the lens is an enormous advantage, allowing valuable anticipation of 'decisive moments', particularly in a fast-breaking situation. The photographer feels part of the action rather than a remote observer of the tiny screen and this lends an immediacy to his pictures that is especially noteworthy.

Many press and feature photographers, even though comprehensively equipped with professional quality SLR outfits by their newspapers or agencies, regularly use and often personally own a Leica M. Their preferred lenses are most often a high-speed wide-angle – a 35mm Summicron or Summilux, usually also with a 50mm Summicron or Summilux and perhaps a 90mm Summicron. Lens speed and wide aperture quality avoid the need for flash and allow direct low light photography.

Rangefinder focusing in such situations is more reliable than manual or auto-focusing in an SLR, and the lack of mirror slap or auto-diaphragm vibration ensures quietness and greater freedom from camera shake. Acceptably sharp pictures can be achieved at 1/8 second with the M when an SLR would need 1/30 second for equivalent quality results. An interesting observation, made by several photojournalists I have spoken to, is that the smallness and quietness of the M, especially when operating using available

EVE ARNOLD, Hon FRPS
This famous Magnum photographer was visiting the Royal Photographic Society in Bath and I was able to grab an informal picture of her in a corner of the dining room of the hotel where she had been invited to lunch. Although the light was nice it was very weak. The M with its fast lenses and accurate focusing is ideal for such situations.

Leica M6, 50/1.4 Summilux, Kodachrome 200 Professional, 1/60 sec, f2.

light and no flash, is quite disarming when they are faced with photographing well known personalities. Sometimes even the camera itself can be a talking point, which helps to get a natural picture!

EXPEDITION AND TRAVEL PHOTOGRAPHY

In the 1930s the Leica became essential equipment for any expedition, be it to the Sahara or the Arctic. The advantages of 35mm for such work were enormous. Compared with earlier cameras, the lightness of a complete outfit of camera and several lenses together with its large film load of 36 exposures made the arguments in its favour overwhelming.

In those days the Leica and later perhaps also the Contax were the only system cameras of the required precision. Now there are many SLRs available but it is still the Leica M that is chosen for the toughest assignments. In recent years M's have been to the top of Everest with a Canadian team, to the North Pole, the Antarctic and across Siberia where they were used at Omjykon, the coldest known place on earth ($-71.2°$C).

Compared with the early days of the Leica, when many parts of the world could be reached only by the dedicated and wealthy traveller with determination and time at their disposal, it is possible now to get to most places quickly, at reasonable cost and

(Previous page)
The soldier is firing a baton round. The M is a favourite of photojournalists, especially for difficult situations such as this.

M2, 35/1.4 Summilux, Ilford FP4.
Photo Denis Thorpe FRPS –
The Guardian

in reasonable comfort. Almost anybody can emulate, even in a small way, the journeys of the great explorers and travellers. The ease of travel however in no way eases the need for a robust, reliable and easily portable camera outfit for those who require a high quality record of their experiences. Unless you are a wildlife photographer when an SLR with specialist long telephoto lenses would be most appropriate, the Leica rangefinder M fulfils the travel requirement perfectly. Its lens range is entirely adequate for the purpose, it is an outfit comprehensive enough to meet almost any demands but is still small and portable, there is no doubt about its robustness and the quality of the results, and its quietness and inconspicuousness can be invaluable in many interesting photographic situations.

I particularly enjoy travel photography and one of my excuses for buying my first Leica, an M2 in 1967, was that it would give me total reliability when far from home. This camera was later supplemented with a pair of M4's which served me superbly for many years. In fact I still have these cameras. Although for a period I used the R system extensively, my travel photography over the last few years has been with the M6, which has proved ideal for my needs.

My normal outfit for a trip is two M6 bodies and the 21/2.8, 35/2, 50/1.4, 90/2, and 135/4 lenses. If you want to travel light, the 28/2.8 could replace the 21 and the 35, and the 50mm Summicron could replace the Summilux. You could also consider

ZAMBIA
The M is an ideal camera for the expedition photographer or traveller.

Leica M4, 35/2 Summicron, Kodachrome 25, 1/125 sec, f5.6.

CENTRAL PARK, NEW YORK
The M is compact and relatively inconspicuous – a considerable advantage when photographing in some parts of the world.

Leica M6, 28/2.8 Elmarit, Kodachrome 25 Professional, 1/60 sec, f5.6.

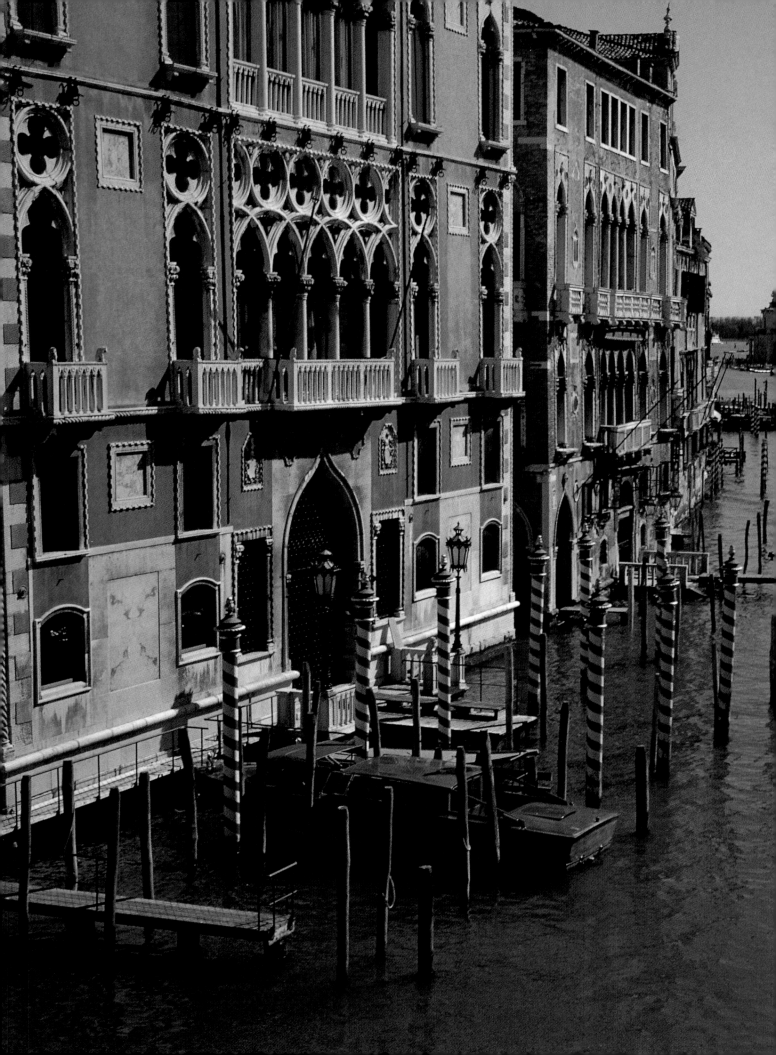

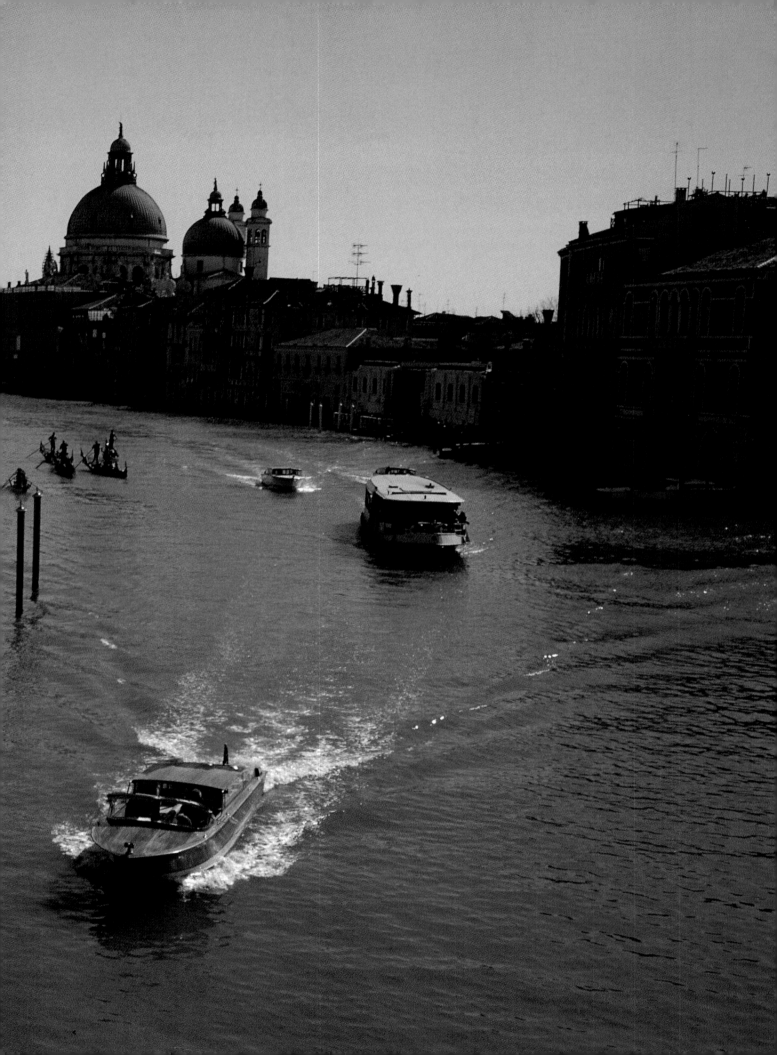

(Previous page)
THE GRAND CANAL,
VENICE
One of the classic views
of this beautiful city. The
low angle of the early
morning spring sunshine
gives solidity and shape
to the buildings. Travel
photographers need to
be up and about early.

Leica M6, 35/2 Summicron,
Kodachrome 25 Professional,
1/250 sec, f4/5.6.

the necessity for the 135mm. As described elsewhere, a small flash gun, the table tripod and a filter on each lens, mainly for protection, are the basic accessories needed. Spare batteries, a blower brush, one of the special micro-weave lens cleaning cloths, a miniature Swiss Army knife, together with plenty of film complete the package! It is most important that good maps and guides are included (the *Insight* series and Michelin *Green Guides* are recommended), to allow proper follow-up of previous planning and to get to the best locations at the right times.

PEOPLE

The M Leica is not a studio camera; this is very much the domain of the ubiquitous single lens reflex, whether 35mm or larger format, so its applications for picturing people are much more relevant in informal or candid situations or in 'location' portraits when the subject is set in a relevant environment. Even in such a relatively controlled situation the M photographer will be endeavouring to work with natural light, relying on the camera's low light capabilities to enable him, as far as possible, to retain the ambience of the location. Some fill-in light for heavy shadow areas may be necessary and this can be gained from reflectors or a touch of flash. It is important that any fill is not overdone or the lighting will look very unnatural.

The 90mm is the classic focal length for portraits, giving a pleasant perspective and allowing a reasonable working distance for head-and-shoulder compositions. 'Environmental' portraits will require a 50mm or, even more likely, a 35mm lens so that adequate background can be included to tell us something about the person.

The nicest lighting indoors comes from daylight – from a window facing North or with veiled sunlight. Out-of-doors, too, the best light is from a sun softened by a thin layer of cloud, or on a cloudy but bright day. With strong sunlight you are better off shooting against the light so that the subject(s) are not screwing

RUDOLPH NUREYEV
Newspaper
photographers often
have to make the most of
brief photo
opportunities. The Ms'
available-light qualities
are a real boon.

M2 35/1.4 Summilux, Ilford FP4.
Photo Denis Thorpe FRPS –
The Guardian

WILLIAM
The only camera to hand
had a slow film loaded.
This snapshot by natural
light was made possible
by the low light
capabilities of a quiet
camera and a fast lens.

Leica M6, 50/1 Noctilux, Fuji
Velvia, 1/60 sec, f1.

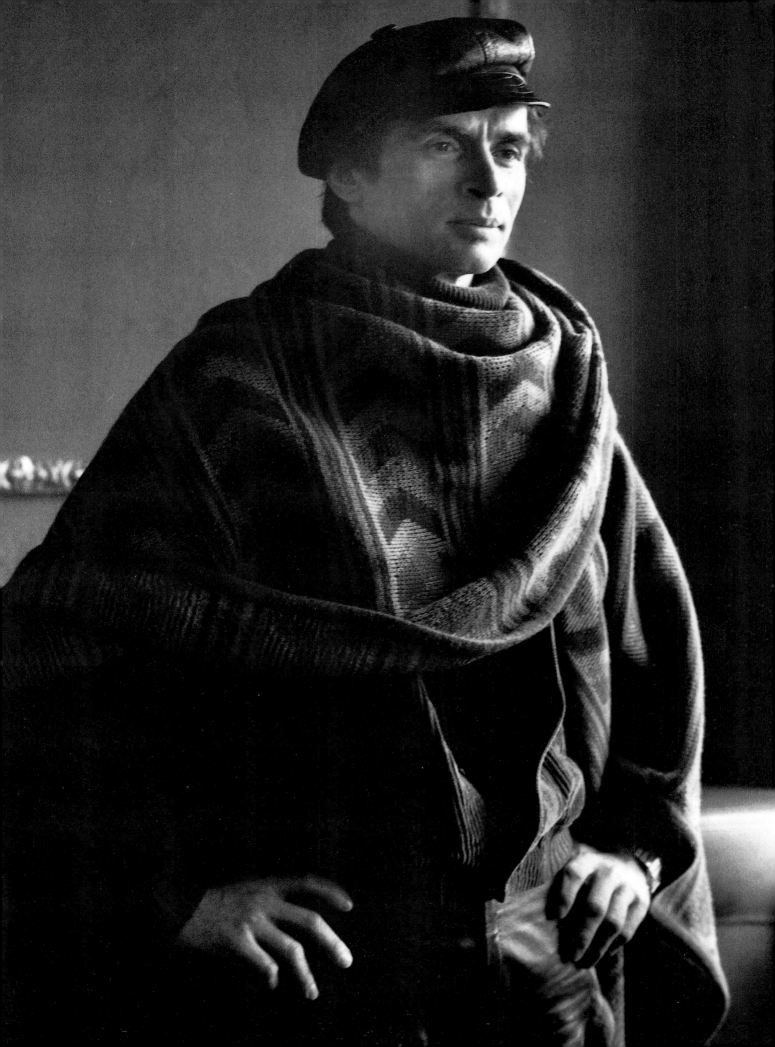

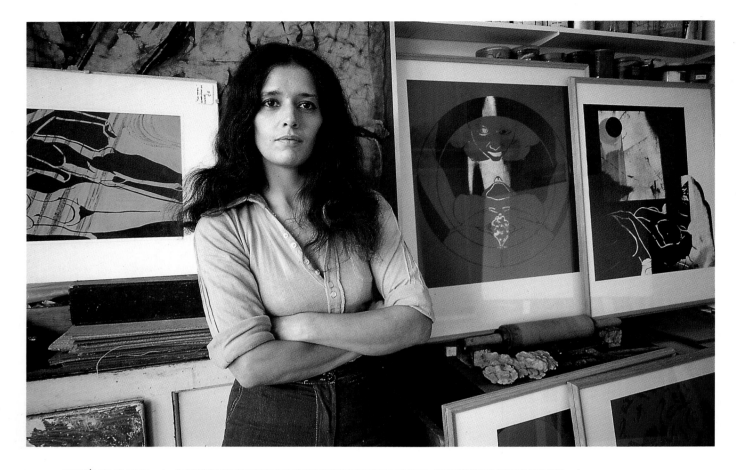

EUGÉNIE TYREE
These pictures show two approaches to a portrait of Eugénie, an artist. The lower picture is a conventional natural-light, head and shoulders with just a hint of her paintings in the background. The upper picture places her much more in her environment with a wide-angle approach. Daylight indoors, tripod.

Upper: Leica M4, 35/2 Summicron, Kodachrome 64, 1/8 sec, f4.

Lower: Leica M4, 90/2 Summicron, Kodachrome 64, 1/8 sec, f4.

MACAU
These children were
buying lunch-time
goodies from the
stallholder. Kodachrome
200 is a useful film for
this kind of subject.

Leica M6, 50/1.4 Summilux,
Kodachrome 200 Professional,
1/125 sec, f8.

up their eyes. You may need some reflected light from a nearby light-coloured wall to avoid too much contrast, or again the subtle use of fill-in flash can be tried. It is unfortunate however, that for synchro sunlight work the 1/50 sec, top synchronization speed of the M is restrictive.

For more candid work, the M fitted with a 35mm or 28mm lens – frequently acknowledged as the classic 'street photographer's' camera – is an ideal instrument. It is particularly quiet and inconspicuous, especially if you use a black camera, not a chrome one, and hide any shiny bits with masking tape, and the ability to see what is happening outside the viewing frame of the 35mm lens helps to avoid unexpected intrusions into the image area. As already discussed, compared with an SLR viewing screen the range-/viewfinder imparts a subtly different psychology whereby the photographer is less of a voyeur and more involved in a situation. Surprisingly subjects are often less concerned by a photographer working close to them with a wide-angle lens than one endeavouring to remain inconspicuous with a long telephoto.

LOW LIGHT
From time to time all the Leica M specialities mentioned above demand the remarkable low light capabilities of the camera and its lenses. Self-evidently the photojournalist never knows what he may have to contend with; for the traveller too, the most

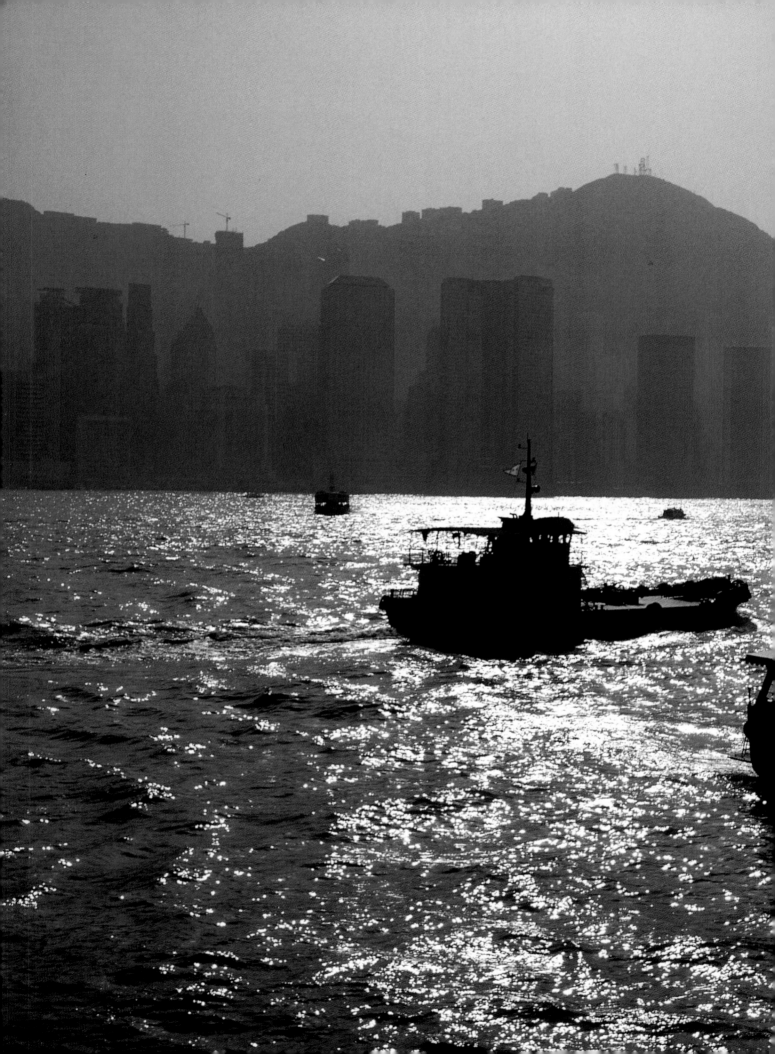

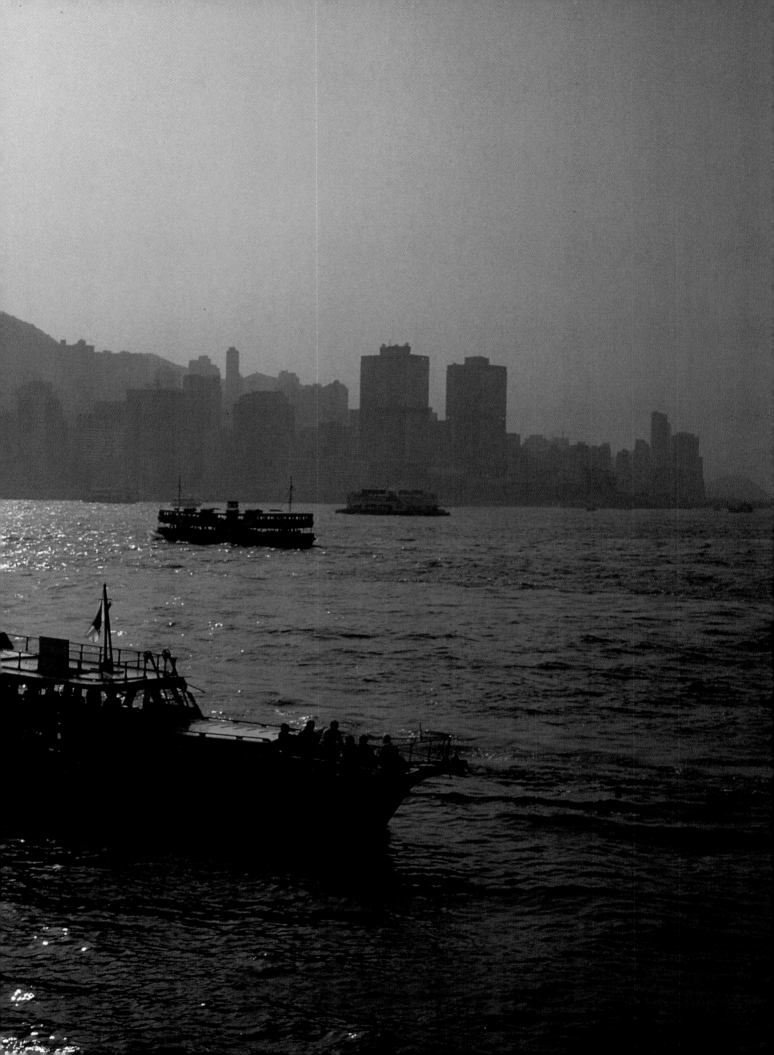

(Prervious page)
HONG KONG
An evening view across
to Hong Kong island and
Victoria Peak from
Kowloon. Another
demonstration of the
qualities of the M as a
traveller's camera. A
tricky exposure handled
most easily with a
manual camera.

Leica M6, 35/2 Summicron,
Kodachrome 25 Professional,
1/125 sec, f5.6.

interesting pictures often occur when light levels are low or even after dark. With portraits indoors, illumination by daylight through a window or existing light from artificial sources is generally very weak. All these situations demand a focusing system that is efficient at low light levels and fast lenses that deliver high image quality at their widest apertures.

The rangefinder focusing system and Leica lenses deliver in every respect. With a reflex viewing system both the human eye and the autofocus systems depend very much on the brightness and contrast of the image. The focal length of the lens also affects the accuracy of the focusing. This is not the case with the M; long base rangefinder accuracy is independent of focal length and the very positive operation of the coincident and split image methods is relatively independent of visual acuity and light levels. There is no question of judging best focus, it is either in or out.

Leica have always worked hard to ensure that their lenses provide first class image quality even at their maximum apertures. A Noctilux is fully usable at f1, a Summilux at f1.4, a Summicron at f2, and so on. Contrast, resolution and optical corrections are all to a standard that delivers first class images on film.

THUNDERHEADS
After a late evening take-
off from Chicago we had
to fly around a
thunderstorm. With
lightning playing in the
distance, the spectacle
was memorable and I
was glad I had my Leicas
to record the event.

Leica M4, 21/3.4 Super Angulon,
Kodachrome 64 Professional,
1/60, sec f4.

BUYING SECONDHAND

The secondhand market for Leica cameras and lenses is well established and there is an active private sales market through small ads in photographic magazines, the network of Leica users, and the various Leica societies. Much of this activity is centred on the collectors' market but outside the exotica, the special models and the 'mint' examples that interest them, there are plenty of 'cooking model' bodies and lenses around that are in good condition, very capable of yielding first class results and at prices more acceptable to a user. Leica build quality is such that a lens or camera that has had twenty-five years or more of normal use and reasonable servicing can still produce exemplary quality. My own Leica M2, purchased as an ex-demonstration model in 1967, falls into this category. It works just as well as my M6 but lacks some of the later camera's conveniences. I also still have my first lenses – a 35/2.8 Summaron, a 50/2 rigid chrome Summicron and a 90/2.8 Elmarit. Naturally these do not have the optical quality of their current equivalents, but in most situations, without a side-by-side comparison this would not be readily apparent. The main gains with newer lenses are better performance at wide apertures,

LEICA STORY
The recent M6 alongside the 27-year-old M2 shows the subtle development of the classic design over many years.

Leica M6, Visoflex, 65/3.5 Elmar, Kodachrome 200 Professional, 1/8 sec, f16.

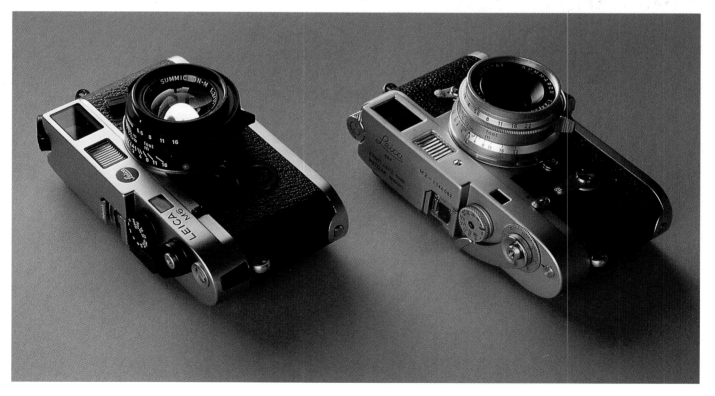

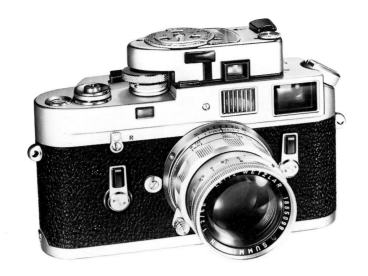

reduced tendency to diaphragm reflections when bright light sources such as the sun are included in the image, improved correction and quality in the near focus range, higher contrast and new coatings that improve light transmission, ensure consistent colour rendering and eliminate flare.

WHAT TO BUY

It is entirely practical to put together an effective Leica M outfit at a quite reasonable price by careful buying of used equipment. Demonstration-soiled equipment which usually comes with a full warranty also offers useful savings. My M2 referred to above was a demo model, bought very cheaply because the M4 had just been introduced, and my 90mm Elmarit was a secondhand purchase.

If you cannot stretch to an ex-demo or secondhand M6 my advice would be to look around for an M4-P or M4 in reasonable condition. You will probably pay little more than half the price of a used M6 but you will lose nothing in terms of build quality and performance. It may need a service (not cheap, if you do the right thing and go to Leica), which should be reflected in the price that you negotiate, and you should remember that neither of these cameras has an exposure meter so this might be an extra cost. The M4 also lacks bright-line frames for 28mm and 75mm lenses. The latter lens is not likely to be in the list of an economy buyer but for the more popular 28mm you will either need an accessory finder or you can assume, as many used to do before the M4-P and the M6 came along, that the full view from the finder represents the field of view of a 28mm lens. This assumption is pretty accurate and is effectively what the '28' frame on the M6 does.

So far as lenses go, a late model 50mm Summicron, a 35mm Summicron and a late model 90mm Elmarit or Tele-Elmarit will be enough to cover a very high proportion of M-style subjects. The whole outfit is compact, light and pocketable and will deliver impeccable quality.

An M2 would be less costly. Certainly there are fewer conveniences with this older body but if you are careful to avoid

one that has been seriously mistreated, you have no less potential than with a later body.

WHAT TO LOOK FOR

When buying a secondhand body, the first thing to check is whether there are any serious dents or knocks that could indicate possible internal damage – to the rangefinder or lens mount alignment for example. With a lens fitted and at the infinity setting, look at a clearly defined object at least 200 metres away and check that the rangefinder images are correctly aligned – both vertically and horizontally. If possible, check the closer focus accuracy of the rangefinder against a body that is known to be correct, using the same lens on both bodies. Ten metres and two metres are good distances to check. Wind on and fire the shutter at the 'B' setting. The wind-on should be smooth throughout; the shutter should make a similar sound as the first curtain opens, when you press the shutter on 'B'; and as the second curtain closes when you then release it. Fire the shutter on all the speeds. This is only a superficial test but any serious hesitation or 'stickiness' at the slower speeds will be apparent, and if you have tested a shutter on a camera that is known to be accurate you will quickly recognize the sound of the different speeds as you work through from 1 second to 1/1,000 second.

Any camera much over five years old is likely to need lubrication and/or adjustment but that should be all, unless the camera has had a very hard life indeed, and even this will be repairable.

With a secondhand M6 or M5, check that the exposure meter is working correctly. If there is a problem the first step is to check the condition of the battery and its contacts.

Lenses should also be checked first for external damage that might indicate internal problems. Next, make sure that the external lens elements are not chipped or scratched. Use a magnifier (a 50mm lens makes a good one!) but don't worry too much about the odd faint scratch, this is unlikely to affect performance to any noticeable extent. Check that there is no condensation or other deposits or fungous growth on internal elements – these are serious but a bit of dust is not. Oil on the diaphragm blades could be bad news and a possible indication of inexpert servicing at some stage.

The focusing action should be smooth and free from backlash. An older lens may be a little stiff from lack of use. It might free up with a little 'working' but lubrication at a Leica agency may be needed, and will cost.

Put the lens on a camera and do the infinity focus test, also a nearer distance if possible. If the lens coupling is correct at infinity it is unlikely to be 'out' at other distances. Make sure that there is a lens hood included (and a UV filter if possible). Hoods can be difficult to find for some lenses as well as being expensive.

Finally it can be worthwhile joining one of the many societies interested in Leica photography or collecting. There is much camaraderie and private dealing as well as exchange of information on useful contacts for secondhand buying.

THE LEICA COLLECTOR

LEICA IIIg OUTFIT
Collecting an outfit representative of a particular model period can be interesting and worthwhile. The IIIg is shown with several of the very last screw-mount lenses and its special ADVOO close-up device.

Leica M6, Visoflex, 65/3.5 Elmar, Kodachrome 25 Professional, 1 sec, f16.

This book is aimed mainly at users of Leica cameras rather than collectors but talk of buying secondhand naturally leads on to the subject if only because the Leica has become the most collected of all cameras. Given its place as the originator of the now universal 35mm format and also of the concept of a system camera, this was inevitable. Although those primarily interested in the Leica as a picture-making tool may find the collectors' absorption with seemingly irrelevant minutiae amusing, or even a cause for irritation with the attendant effect on the secondhand prices of useful items, there is no doubt that it has contributed to the continuing commercial viability of the marque, for which all must be grateful.

There can in fact be few users who do not become fascinated with the history of their favourite camera, and because of this become collectors to a greater or lesser degree. This may simply

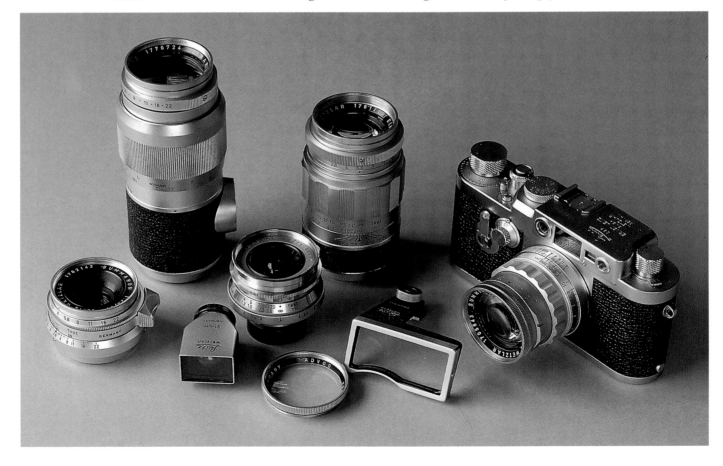

be by default because, like the author, they hate parting with older equipment that has become surplus to requirements and hold on to it just because it is so beautifully made and delightful to handle. It is quite interesting, and need not be expensive, to add to such a 'default' collection a few older interesting items that represent milestones in the history of the Leica – for example, a Leica I (Model A in USA) and a II (Model D in USA) and perhaps a IIIf or IIIg to represent the ultimate development of the screw-mount designs (the IIIg in my opinion is a hybrid and in any event has become too expensive for a casual collector!).

Serious collectors are looking for examples in the finest possible condition and for special models and rarities, not 'workhorse' items, and accordingly have to pay serious money. They are often looking at investment as much as interest so that there is still scope for the alert 'economy-class' enthusiast to acquire slightly less perfect items for a more modest collection.

A collection should have a purpose. Part of the fascination is in the hunt, and the purpose can be angled to the collector's pocket so that just as much pleasure can be gained from a modest outlay as from the enormous amount that would be necessary to gather together a major collection representing every camera model ever made by Leica. Examples of less expensive collectables would be a collection of Leica literature, say camera brochures or lens brochures, or of the many books that have over the years been

LEICA M6 PLATINUM This special edition to commemorate the 150th anniversary of photography and 75th anniversary of the UR Leica is one of a number of M6 'specials' that have been produced with collectors in mind.

Photo Leica Archiv

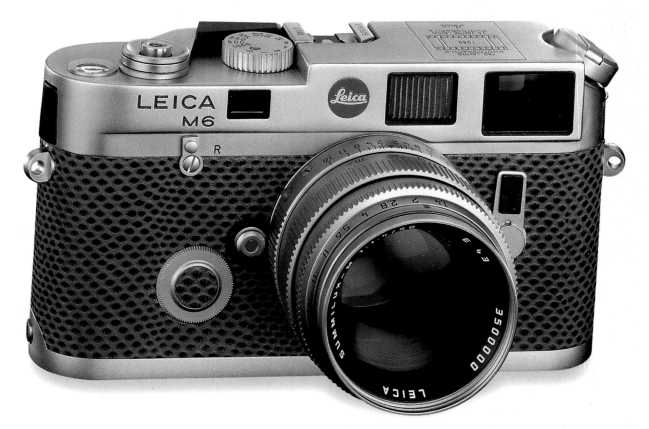

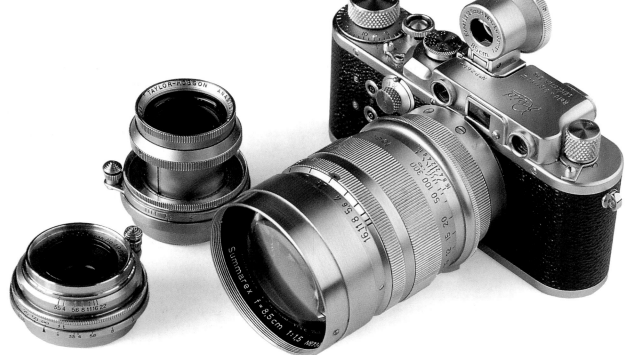

LEICA LITERATURE
Many Leica collectors
also find the literature
just as fascinating as the
cameras and lenses.

M6 16526 copying gauge 50/2.8
Elmar, Ektachrome Panther 100,
1/15 sec f11.

REID III AND LENSES
Leica copies are another
area of fascination to
collectors. The English-
built Reid is essentially a
copy of the Leica IIIb.
The Taylor Hobson
standard lens however
was ahead of the
contemporary Leitz
Summitar in
performance.

devoted to the Leica. Another idea would be to put together a usable outfit relevant to the period of a particular model of the Leica, for example the previously mentioned Leica II or the Leica IIIf; a collection of examples of the lenses made in a particular focal length might be interesting.

These are all relatively inexpensive areas that I have found quite fascinating to pursue both as a collector and user. In the case of equipment I have always looked for items in full working order that I have been able to go out and take pictures with whenever necessary. Actually using the older equipment is both challenging and enjoyable. Leica mechanical and optical quality is so good that a forty-year-old outfit will still yield first class results on modern films. You soon begin to realize just how high a level of performance was achieved by Leica equipment so many years ago.

Collectors naturally need to be thoroughly knowledgeable about their subject. Again, learning is part of the enjoyment and Leica collectors are especially well served by many good books. The bibliography on page 150 lists those that I have found particularly informative and /or helpful and can recommend for an interesting read as well as a valuable reference source.

ROYAL
PHOTOGRAPHIC
SOCIETY LEICA M6
The camera shown is the
prototype of the special
M6 produced at the
author's instigation to
commemorate the
centenary of the Royal
Photographic Society
being granted royal
patronage. Only 100
examples complete with
a special 50mm f2
Summicron were
manufactured.

APPENDICES

APPENDIX A

BATTERIES FOR THE LEICA M6

Manufacturer	Designation
Silver oxide button cells (2 required)	
Ucar	EPX 76
Ucar	S 76 E
Ucar	Nr. 357
Duracell	D 357 (10 L14)
Varta	V76 PX
Varta	V76 GS
Varta	V 357
Eveready	S 76 E
National	SR 44
National	SR 44 W
Ray-o-vac	RS 76 G
Ray-o-vac	RW 42
Maxell	SR 44 P
Maxell	SR 44
Maxell	SR 44 SW

Lithium battery (1 required)	
Duracell	DL 1/3 N
Varta	CR 1/3 N
Ucar	2 L 76
Panasonic	CR 123

BATTERIES FOR THE LEICA M5 AND THE LEICA METER MR AND M4

Manufacturer	Designation
Mercuric oxide button cell (1 required)	
Mallory	PX 625
Varta Petrix	7002

APPENDIX B

DEPTH-OF-FIELD IN CLOSE-UP PHOTOGRAPHY
for use with Visoflex and copying gauges 16526 and 16511

Reproduction scale on the film (decimal)	Exposure factor non-TTL metering	Depth-of-field (mm)			Object size (mm)
		f/8	f/11	f/16	
0.1 (1/10)	1.2	60	80	120	240 x 360
0.2 (1/5)	1.5	15	20	30	120 x 180
0.3	1.7	8	11	16	80 x 120
0.4	2	5	6	10	60 x 90
0.5 (1/2)	2.3	3	4	6	50 x 70
0.6	2.6	2.5	3.5	5	40 x 60
0.7	3	2	2.5	4	35 x 50
0.8	3.3	1.5	2	3	30 x 45
0.9	3.6	1.3	1.7	2.5	37 x 40
1 (1:1)	4	1	1.5	2	24 x 36
1.5 (1.5:1)	6	0.6	0.8	1.2	16 x 24

In this close-up range depth-of-field is approximately half in front and half behind the point of focus.

APPENDIX C
Which LEICA WINDER for which LEICA M

Winder type	Camera Type			
	LEICA M6	LEICA M 4-P	LEICA M 4-2	LEICA MD-2
LEICA WINDER M	yes	yes	yes	yes
LEICA WINDER M4-P	yes	yes	yes	yes
LEICA WINDER M 4-2 from Serial No 10350	yes	yes	yes	yes
LEICA WINDER M4-2 up to Serial No 10349	no	yes apart from Serial No 1522500* – 1552884* and 1563000 – 1588536 (can be adapted by Technical Service)	yes	yes

BIBLIOGRAPHY

LEICA PHOTOGRAPHY
Bower, Brian. *Leica Reflex Photography* (David & Charles)
Bower, Brian. *Lens, Light and Landscape* (David & Charles)
Eastland, Jonathan. *Leica M Compendium* (Hove Books)
Frey, Verena. *75 Years of Leica Photography* (Leica Camera GMBH)
*Haas, Ernst. *The Creation* (Michael Joseph)
*Kisselbach, Theo. *The Leica Book* (Heering Verlag)
 Laney, Dennis. *Leica Lens Practice* (Hove Books)
Leica Camera GMBH. *Handbook of the Leica System* (Leica Camera
 GMBH)
Matheson, Andrew. *Leica M6 Practice* (Hove Books)
*Matheson, Andrew. *The Leica Way* Various editions (Focal Press)
 Magnum. *In our Time* (Andre Deutsch)
*Morgan. *The Leica Manual* Various editions (Morgan & Morgan)
*Osterloh, Gunter. *Leica M* (Umschau Verlag)
 Salgado, Sebastiao. *Workers* (Phaidon)
*Scheerer, Theo. *The Leica and the Leica System* (Fountain Press)

LEICA COLLECTORS' GUIDES
Hasbroeck, Paul Henry. *Leica, a history illustrating every camera
 and accessory* (Sothebys)
*Lager, James. *Leica Illustrated Guide* I II III (Morgan & Morgan)
 Laney, Dennis. *Leica Collectors' Guide* (Hove Books)
 Laney, Dennis. *Leica Pocket Book* (Hove Books)
 Nakamura, Shinichi. *Leica Collection* (Asahi Sonorama)

*Although these books are out of print, some for many years,
 they are recommended as being particularly informative on
 older equipment and are worth seeking out privately or from
 second-hand bookshops and camera dealers.

ACKNOWLEDGEMENTS

Without the constant support and help of my wife Valerie this book would not have been possible. Not only has she always been amazingly tolerant of my obsession for photography and fascination with the Leica, but she 'word processed' the text, helped me with the editing and later the proof checking! Over the years many colleagues and friends, too numerous to mention individually, have also humoured my enthusiasm and been patient and helpful with my photographic activities. I am grateful to all of them.

The Leica organization has always given me unhesitating co-operation and assistance and I would particularly like to thank Nicole Rubbe, Hans Gunter von Zydowitz and Uli Hintner for their continuing help and encouragement. At David and Charles my special thanks go to Alison Elks my editor and Brenda Morrison the designer, my main points of contact, but I wish also to mention the entire team, editorial, production and marketing whose skills and effort are truly appreciated. Last but not least I am especially grateful to William Cheung FRPS and Denis Thorpe FRPS for the privilege of using their excellent photographs in this book.

INDEX

These spectacular deals are only available by calling 1-800-CALUMET (225-8638).

Available Nationwide

Stop in our retail location at:
1111 North Cherry Street
Chicago, Illinois

Mamiya Demo Equipment
Demos come with a one-year Mamiya warranty

Description	Cond.	Part No.	Sale
RZ 67 Pro II Package	Ex	MA0283U	$2,299.00
RZ II 220 Film Magazine	Ex	MA2506U	$479.00
RZ II Polaroid Back	Ex	MA2523U	$375.00
RZ 50mm f4.5 ULD Lens	Ex	MA1721U	$1,299.00
RZ 180mm f4.5 R Lens	Ex	MA1750U	$1,099.00

Mamiya 645

Description	Cond.	Part No.	Sale
SVX-II Value Pack	Ex	MA0272U	$1,759.00
645 55mm f2.8 Lens	Ex	MA1013U	$479.00
645 150mm f3.8 LS Lens	Ex	MA1218U	$995.00
645 Power Drive Grip	Ex	MA50245U	$345.00
645 Polaroid Back	Ex	MA2428U	$309.00
645 Pro 120 Magazine	Ex	MA2426U1	$319.00
Mamiya 645 Pro Body	Gd	MA0266U1	$795.00
Mamiya 645 Old Style 110mm f2.8	Gd	MA1201U	$245.00

Mamiya 7

Description	Cond.	Part No.	Sale
Mamiya 7 II Champagne Body(Demo)	Gd	MA0703U	$1,345.00
Mamiya 7 Camera Body	Gd	MA0700U	$795.00
Mamiya 7 Camera Body	Vg	MA0700U2	$745.00
Mamiya 7 43mm UW f4.5 w/Finder	Vg	MA0710U	$1,949.00
Mamiya 7 65mm W.A. f4	Ex	MA0715U1	$1,200.00
Mamiya 7 80mm f4	Ex	MA0705U	$945.00
Mamiya 7 80mm f4.0	Ex	MA0705U1	$899.00
Mamiya 7 150mm f4.5	Ex	MA0720U1	$1,150.00
35mm Panoramic Adapter	Ex	MA0730U	$145.00

RZ 67

Description	Cond.	Part No.	Sale
RZ67 Pro Body	Gd	MA0280U1	$1,095.00
RB/RZ PD Prism finder	Ex	MA2310U1	$849.00
RB/RZ Prism Finder II	Gd	MA2318U	$549.99
RZ 90mm f3.5Z	Ex	MA1737U1	$949.95
RZ 110mm f2.8 Lens		MA1740U	$995.00
RZ 150mm f3.5	Vg	MA1748U	$899.00
RZ Tilt-Shift Adapter	Ex	MA1707U	$1,199.99
RZ II 220 Roll Film Holder	Ex	MA2506U	$375.00
RZ II 6X4.5 120 Film Holder		MA25075U	$299.00
Beattie RZ67 Pro Horiz Split	Vg	BT0214U	$145.00

RB 67

Description	Cond.	Part No.	Sale
RB67 Pro SD Body	Gd	MA0285U	$549.00
RB Body (Body only, no Adr.)	Fr	MA0286U2	$350.00
RB Pro S Body	Gd	MA0286U4	$450.00
RB KL 65mm f4.0	Gd	MA1623U	$1,199.00
RB 127mm f3.5 Lens	Vg	MA1631U	$1,079.99
RB 150mm f4.0 Soft Focus	Gd	MA1640U1	$599.00
RB Lens 180 F4.5		MA1644U	$699.00
RB 65mm f4.6 Lens	Gd	MA1620U	$695.00
RB 90mm f3.8 C		MA1625U1	$300.00
RB KI 90mm f3.5	Ex	MA1628U	$1,149.99
RB KL 140mm f4.5	Ex	MA1634U	$1,399.99
RB 150mm f4.0 Soft Focus	Gd	MA1640U	$599.00
RB KL 250mm f4.5	Vg	MA1659U	$1,495.99
RB 360mm	Vg	MA1660U	$1,095.00
RB 500mm f8	Vg	MA1680U	$2,895.00
RB/SD 120 Film Back	Vg	MA2455U	$249.00
L Grip RZ Demo	Ex	MA2026U	$169.95
RB SD 6 x 4.5 120 Back		MA2445U	$395.00
RB SD Polaroid Back	Fr	MA2453U	$195.00
Module F/Metz Flash		MA2842U	$125.00

Mamiya 645 AF

Description	Cond.	Part No.	Sale
Af 80mm f2.8	Ex	MA0314U	$449.00
645Af 210mm f4	Vg	MA0318U	$995.00

Mamiya 645 AF *continued*
645 Manual Focus

Description	Cond.	Part No.	Sale
M645 SVX Pack II	Vg	MA0272U1	$1,599.00
645 Pro Body	Vg	MA0266U	$895.00
645 35mm f3.5 Lens	Gd	MA1005U	$695.00
645 35mm f3.5 Lens	Ex	MA1005U1	$799.00
645 55mm f2.8 w/Shutter	Vg	MA1015U1	$1,299.00
645 80mm f4.0 Macro	Gd	MA1118U	$699.00
645 100mm f2.8 Lens	Gd	MA1203U	$225.00
645 120mm f4.0 Macro (Demo)	Ex	MA1204U	$1,149.00
645 200mm f2.8 APO Lens	Vg	MA1219U	$1,699.00
645 300mm f5.6	Ex	MA1225U	$775.00
645 220 Film Insert	Gd	MA2425U	$75.99
645 Pro 120 Film Back	Gd	MA2426U	$279.00
645 220 Film Magazine	Vg	MA2427U	$279.00

Pentax 6x7 Equipment

Bodies

Description	Cond.	Part No.	Sale
67 Body		PX6702U	$575.00
67II Body	Ex	PX6705U	$1,375.00

Lenses and Accessories

Description	Cond.	Part No.	Sale
67 105mm f2.4 Lens	Gd	PX6710U	$379.00
67 135mm f4.0 SMC Macro Lens		PX6713U	$429.00
67 Smcp 165mm f2.8 Lens	Gd	PX6716U	$399.00
67 165mm f4.0 LS Lens		PX6717U	$499.00
67 Smcp 200mm f4.0 Lens	Gd	PX6720U	$250.00
67 Smcp 300mm f4.0 Lens	Gd	PX6730U	$595.00
67 Smcp 300mm f4.0 Lens	Vg	PX6730U1	$995.00
67 400mm f4.0 Ed-IF Lens	Vg	PX6741U	$3,599.00
67 Smcp 55mm f4.0 Lens	Vg	PX6755U	$495.00
6X7 75mm 4.5 Smc Lens	Vg	PX6775U	$349.00
67 Smcp 90mm f2.8 Lens	Gd	PX6790U	$395.00
67 Hand Grip	Vg	PX7204U	$99.00

Polaroid Back

Description	Cond.	Part No.	Sale
NPC Proback for Pentax 6X7	Gd	NP1200U	$449.00

Seagull 6x6 TLR

Description	Cond.	Part No.	Sale
6x6 WWSC-120 TLR	Ex	AA0120U	$159.99
6x6 GC-104 TLR	Ex	AA0124U	$129.99

Noblex Equipment

Description	Cond.	Part No.	Sale
6/150U+ 120 Panoramic Camera	Ex	NX1205U	$2,400.00
135S Basic 35mm Camera	Ex	NX1350U	$1,350.00
135U Ultra 35mm Camera	Ex	NX1355U	$1,475.00
Exposure Control Module for 120		NX1356U	$695.00

Passport and ID Cameras

Description	Cond.	Part No.	Sale
Cambo PP40 4-Lens Passport Camera		CB0602U	$749.00
Polaroid Minipassport 455	Ex	P03002U	$599.00
Polaroid Model 207 Miniportrait		P03005U	$329.00

35mm Equipment

Canon Equipment

Canon Collectible

Description	Cond.	Part No.	Sale
Limited Edition Gold Elph	Ex	CA7201U	$250.00

Manual Focus

Description	Cond.	Part No.	Sale
Canon 200Mm F/2.8 Fd	Gd	CA1235U	$325.00
Tokina 80-200 Canon Fd	Vg	TK0031U	$295.00

Auto Focus

Description	Cond.	Part No.	Sale
Sigma Af28-200 3.8-5.6	Vg	SM2145U	$179.99
Tamron Af20-40 2.7-3.5	Vg	TR2040U	$475.00
EOS 1V ES-E1 Link Software	Ex	CA40221U	$149.00
433Af Flash	Vg	SU8000U	$79.99

Contax Equipment

Description	Cond.	Part No.	Sale
AX Camera Body	Ex	CX1500U	$795.00
28-85mm f3.3-4.0 Vario Sonnar	Ex	CX2830U	$775.00

Leica Equipment

Leica M

Description	Cond.	Part No.	Sale
Black M-6 Body w/Box	Vg	LC5006U	$1,295.00
Chrome M-6 TTL In Box	Ex-	LC5006U	$1,395.00
35mm Can. Summ. F2.0 w/Hd	Gd	LC5030U	$499.00
50mm f2.0 Summ, w/ Hd."	Gd	LC5051U	$449.00
90mm Tele-Elmerit f2.8 w/hd	Gd	LC5070U	$449.00
Tri-Elmar 1st Gen	Vg	LC5082U	$1,195.00
Leica Grip M	Ex-	LC6170U	$49.00

Leica Point and Shoot

Description	Cond.	Part No.	Sale
Leica Z2X With Data Back	Ex	LC7012U	$249.99

Leica R System

Description	Cond.	Part No.	Sale
R4 Black	Gd	LC1015U	$345.00
R 24mm f2.8 Lens	Gd	LC1050U	$495.00
R 90mm f2.0 Lens		LC2015U	$695.00
R 135mm f2.8 Lens	Gd	LC2045U	$450.00
R 180mm f2.8 Lens		LC2050U	$1,375.00
R 2X Extender	Vg	LC3040U1	$299.00
Motor Winder R4	Gd	LC4006U1	$149.00

Minolta 35mm AF

Description	Cond.	Part No.	Sale
9X1 Body	Gd	MN7012U	$350.00
Af 35-70 3.5	Gd	MN7355U	$65.00
Minolta Af 28-80 F/4.0-5.6 Xi	Gd	MN7425U	$125.99
Af 2X M/A Converter	Vg	MN7320U	$189.00

Nikon Equipment

Description	Cond.	Part No.	Sale
Titanium F3HP	Gd	NT1000U95	$495.00
F3 HP Body w/Md4	Gd	NT1000/3000U	$650.00
F3 HP Body	Gd	NT1000U	$375.00
MD-4 Drive		NT3000U	$149.00
MD-15 Nikon		NT3007U	$75.00
MF-23 Multi-Control Back	Gd	NT1100U	$269.99
24mm f2.0 AIS Lens	Vg	NT2014U	$349.00
28mm f2.0 AIS Lens	Vg	NT2016U	$299.00
35mm f2.0 AI Lens	Vg	NT2021U	$199.00
300 f4.5 AI Lens		NT20415U1	$425.00
70-210mm f4.5-4.6 AIS Lens	Gd	NT2059U	$79.00
MB-100 Battery (2) w/Chgr for N 90		NT30815U	$149.00
MB-23 Battey w/Charger		NT3471U1	$299.00
MH-20 Batt Charger	Gd	NT3478U	$229.00
Nikon F5 Focus Screen EC-B	Ex	NT6970U	$80.00
Nikon Ps-6 Slide Copier	Ex	NT7902U	$199.00

NPC Pro Backs

Description	Cond.	Part No.	Sale
Proback II Nikon F3	Gd	NP1000U	$199.00
Pro BackCanon F-1 N	Vg	NP1030U	$325.00
Pro BackCanon F-1 N	Gd	NP1030U2	$350.00
Proback II for Canon F-1 N	Ex	NP1040U	$449.99
MF-1N Hasselblad Polaroid Back	EX	NP2000U1	$229.00

Novaflex Close up Equipment

Description	Cond.	Part No.	Sale
Macro S Copy Stand	Ex	NF1000U	$249.00
Macro Light Plus	Ex	NF1080U	$679.00
60mm f4.0 Noflexar for Nikon	Gd	NF2010U1	$125.00
Extension Bellows	Gd	NF2090U	$35.00
Nf Grip for Magicball Head	Ex	NF3312U	$32.95

Digital Cameras, Scanners and Accessories

Description	Cond.	Part No.	Sale
Canon Cameras			
Powershot PR070 Kit (Demo)	Ex	EC2700U	$849.99
Canon Scanners			
Canoscan FS2710 Scanner	Ex	EC3500U	$309.95
Epson Printers			
Stylus 2000 Printer	Ex	IM5015U1	$450.00
Stylus 2000 Printer	Gd	IM5015U	$400.00
Kodak Cameras			
DC260 Dig. Camera w/2-16Mb Cord	Ex	EK0260U	$999.99
DC265 Digital Camera	Ex	EK0265U	$705.99
DC265 Digital Camera	Ex	EK0265U1	$699.99
DCS330 Digital Camera	Ex	EK0330U	$1,950.00
Nikon DigitalCameras			
Coolpix 950 Millinium	Ex	NZ1955U	$699.00
Coolpix 990 Digital Camera	Ex	NZ1990U	$599.99
Coolscan III LS-30	Ex	NZ2100U	$699.00
Olympus DigitalCameras			
C2500L Digital Camera	Ex	OM1635U	$995.00
Minolta Digital Camera			
Dimage 7 Kit	Ex	MN2007U	$775.00
Minolta Film Scanners			
Scan Multi Film Scanner	Ex	MN2230U	$1,099.00
Polaroid Film Scanners			
Sprintscan 4000 for Windows	Ex	PO9071U	$999.00
Lenses for Digital Photography			
Rodenstock Apo Digital 90mm f5.6	Ex	RS3066U	$779.00
Monitors			
Saphir Ultra 2 Mac/Pc	Ec	IM4800U	$600.00
Linoscan 1400/Mac/Pc	Ex	IM4802U	$750.00
Saphir Ultra Mac	Ex	IM4805U	$500.00
Radius 17"" PressVIew Mon	Ex	IM3050U1	$1,650.00
Micro Drives			
IBM 1Gb Microdrive w/Adapter	Ex	IM4383U	$269.00

Studio Lighting Equipment

Description	Cond.	Part No.	Sale
Arri Hot Lights			
650w Fresnel Spot	Ex	AX2000U	$299.00
1000w Fresnel Spot	Ex	AX3000U	$379.00
Arrilite 1000/3 Compact Kit	Ex	AX7052U	$1,299.00
Arri HMI Lights			
575w Compact Hmi Head	Ex	AX8001U	$999.00
Balcar Power Packs			
Source 3200Ws Pack		BF10254U5	$2,200.00
Source 3200w/s 2-Head Asym. Pack	Ex	BF10253U	$800.00
Source 3200w/s 3-Headd Asym. Pack	Gd	BF10254U	$1,200.00
Source 6400w/s 4-Head Asym. Pack	Gd	BF10255U	$2,500.00
Jet 1600w/s Pack	Ex	BF10261U	$800.00
Jet 1600Ws Pack		BF10261U2	$1,100.00
Jet 3200Ws Pack Ex	Ex	BF10262U	$1,100.00
Jet 3200Ws		BF10262U1	$100.00
Jet 3200 #3908		BF10262U3	$900.00
1600w/s 2-Head Sym. Pack		BF10270U	$1,900.00
Nexus S3200 2-Head Pack		BF10271U	$2,200.00
Nexus A3200w/s 4-Head Asym. Pack		BF10273U	$2,500.00
Balcar Mono Lights			
Classic 1500 Monobloc	Ex	BF10358U	$400.00

Description	Cond.	Part No.	Sale
Balcar Light Kits			
Balcar Case Kit 3	Ex	BF10377U	$3,100.00
Balcar Flash Heads			
Bi-Tube Head	Ex	BF10505LHU	$600.00
Bi-Tube Head	Fr	BF10505LHU1	$200.00
Bi-Tube Head	Gd	BF10505LHU2	$400.00
Pencil Light 3200Ws Lstd		BF10567LSU1	$375.00
Power Z Head w/Long H.D. Tube		BF10651LHU2	$499.00
Power Z Head Long Std. Tube	Ex	BF10651LSU	$499.00
Power Z Head Long Std. Tube	Fr	BF10651LSU1	$300.00
Power Z Head Long Std. Tube		BF10651U	$499.00
Balcar Accessories			
Standard White Umbrella	Ex	BF20201U	$60.00
42" Metal Umbrella	Ex	BF20203U	$60.00
Jumbo White Umbrella	Ex	BF20205U	$129.00
3-7" Grid Set (20, 30, 40°)	Vg	BF20500U	$50.00
40° Grid for Opalite	Gd	BF20504U	$79.00
Opalite 2 (complete)		BF20611U	$199.00
LFX 20 Reflector w/Intensifier	Gd	BF20624U	$199.00
Diamond Box w/Yoke		BF20631U1	$500.00
Super Diamond Box		BF20632U	$850.00
Super Diamond Box		BF20632U1	$850.00
Opalite 3 Reflector	Fr	BF20711U1	$199.00
Prisma Lightbox VPLB-30	Gd	BF20815U	$99.00
Prisma Box V-LPB65	Vg	BF20816U	$159.00
Elite 4 Head Case	Fr	BW7260U	$89.00
Elite 4 Head Case	Ex	BW7260U1	$109.95
Balcar Fluorescent Lighting			
Fluxlite 300 Daylight	Gd	BF81106U	$899.00
Spotflux 2 Daylight	Gd	BF72100DU	$1,200.00
Powerflux 1 170W 120V	Ex	BF75100DU	$1,600.00
Powerflux 2 340W 120V	Ex	BF75200DU	$2,600.00
Duolite 100 Daylight	Gd	BF80115U	$725.00
Quadlite 200 Daylight	Gd	BF81126U	$995.00
Bowens Hotlight Equipment			
Hotlite 1000	Ex	BW3551U	$199.00
Bowens Mono-Lights			
Esprit 2 500w/s	Gd	BW8011U	$350.00
Esprit 1000w/s	Gd	BW8015U	$599.00
Calumet Light Control Panels			
PVC 42X78 Frame Only	Gd	CF3078U	$18.00
Calumet Light Stand Clamp		CF5000U	$9.00
Calumet Elite Equipment			
1200w/s Pack	Ex	BW7200U	$750.00
1200w/s Pack	Vg	BW7200U2	$750.00
2400w/s Pack	Ex	BW7210U	$999.00
2400w/s Pack		BW7210U1	$999.00
UV Head	Ex	BW7220U	$269.00
UV Head	Vg	BW7220U1	$269.00
UV Flash Head Kit	Ex	BW7223U	$299.00
Calumet PS Equipment			
PS 1250w/s Pack	Ex	CE12305U1	$799.00
PS4N Power Supply	Gd	CE12350U	$500.00
Calumet Travelite Equipment			
250w/s	Vg	BW0250U	$250.00
Light Specialty Kit (4-way b.d., snoot and 7" reflector)	Ex	BW1882U	$89.00
750w/s 1-Head Kit	Vg	CE1550U	$450.00
Calumet Traveller Equipment			
Traveller Plus 3000w/s Sym. Pck	Ex	CE2941U	$1,399.00

Description	Cond.	Part No.	Sale
Calumet Traveller Equipment *continued*			
Head Excellent	Ex	CE2990U1	$299.00
Linear Head	Gd	CE2912U	$299.00
IR Remote	Vg	CE2905U	$199.00
13' Head Ext Cord		CE2910U	$49.00
Chimera Lighting Equipment			
Super Pro Strip Lg White	Gd	CH1027U	$299.00
Super Pro Bank Med. Silver		CH1070U	$199.00
Dynalite Flash Equipment			
Usd M Ser Bitube Head/Blowr	Ex	DY4050U	$407.99
Soft Lite 18" 80 Deg White	Ex	DY4091U	$95.00
40° Long Throw Reflector	Vg	DY4097U	$75.00
Elinchrom Equipment			
El3000 AS Micro Pack	Ex	EL0056U	$2,999.00
El500C Flash System	Ex	EL0012U	$479.95
Scanlite 1000 W/Frost	Ex	EL0100U1	$299.99
Scanlite 1000 W/Frost	Vg	EL0100U4	$280.00
8-1/4" 55 Std Refl	Gd	EL0404U	$18.00
Elinchrom 6-1/2" Wide Ref	Ex	EL0406U	$29.00
81/4X6" 4 Way Brndr Set	Vg	EL0440U1	$32.00
Lowell Lighting Equipment			
Lowell 650W Spot Fresnel Lens	Ex	LM1150U	$54.99
Lowell Omni-Light	Ex	LW1005U	$129.95
Lowel Basically 3 Kit	Vg	LW4010U	$799.00
Metz Flash Equip			
60Ct1 W/Dryfit Battery	Gd	MZ1015U	$299.00
45CL-4 W/Cord	Ex	MZ1026U2	$260.00
45CL4NC w/Nicad & Chgr.	Ex	MZ1070U	$295.00
Metz 32 MZ-3 Flash		MZ1080U	$175.00
30CT7 TTL Flash	Vg	MZ1080U1	$50.00
50MZ-5 w/Cont.	Vg	MZ1084U	$300.00
P50 Battery Pack	Ex	MZ1105U	$294.95
54MZ-3 Nikon	Vg	MZ1154U	$299.00
Eos Adr F/32,36,45,60	Ex	MZ2050U	$75.00
Sca 300 Adr.VGT3/4	Vg	MZ2500U	$24.00
Norman Equipment			
P2000D Pack	Fr	NR1230U	$299.00
P2000D Power Pack	Gd	NR1230U1	$395.00
LH2000 W/Blower	Fr	NR1905U	$99.00
LH4000 Bi-Cord Head	Fr	NR2230U	$199.00
G-22 Grid for 5" Reflector	Ex	NR4440U	$139.99
Profoto Equipment			
Acute 24 Power Pack		PF0402U	$1,295.00
Profoto 7" Reflector	Vg	PF1158U	$899.00
Speedotron Equipment			
2403CX 2400w/s Power Pack	Ex	SB1025U	$1,399.00
8" Fresnel Focus Spot	Ex	SB1005U	$699.00
6" Vari Focus Zoom	Gd	SB1006U	$599.00
202VF/CC Head w/M.L.7"	Vg	SB1119U	$225.00
Hosemaster II Systems and Accessories			
System Complete		HM1000U	$2,999.00
5" Shutter w/Filter Cables	Gd	HM1224U	$799.00
8" Light Sword w/Grid	Gd	HM1302U	$95.00
Paddle		HM1303U	$150.00
Light Skimmer w/Hood		HM1304U	$139.00
Hosemaster Turbofilter Systems and Accessories			
Turbofilter System (Old Style)	Gd	HM5000U	$600.00
Turbofilter System (Old Style)		HM5500U	$699.00
Turbofilter System Complete	Vg	HM6000U	$899.00
Turbofilter System Complete	Ex	HM6000U1	$999.00

Specialty Cameras

Description	Cond.	Part No.	Sale
Noblex Equipment			
135U Camera	Ex	NX1355U	$1,499.00
Passport and ID Cameras			
Polaroid Mod 403 4-Lens Miniportrait	Gd	PO3004U	$395.00

35mm Equipment

Canon Equipment

Description	Cond.	Part No.	Sale
EOS-1 Body	Gd	CA4030U	$659.00
Power Drive Booster E1	Ex	CA4200U	$200.00
Wireless LC-4 Remote Control	Vg	CA4278U	$295.00

Leica M Equipment

Description	Cond.	Part No.	Sale
M6 Black Body	Ex	LC5006U	$1,395.00

Nikon Equipment

Nikon Auto Focus Equipment

Description	Cond.	Part No.	Sale
8008 Body	Fr	NT1011U2	$325.00
8008S Body	Vg	NT1011U3	$350.00
300 AF 2.8 ED-IF Lens	Vg	NT2103U	$2,399.00
35-70mm AF Lens	Gd	NT2125U	$455.00

Nikon Manual Focus Equipment

Description	Cond.	Part No.	Sale
F4 Body	Gd	NT1007U1	$775.00
F3 Body w/ MD-4 Motor Drive	Gd	NT1000U6	$695.00
F3 HP Body	Gd	NT1000U	$800.00
F3 HP Body	Gd	NT1000U14	$495.00
FM2 Chrome Body	Gd	NT1025U1	$400.00
MD-4 Motor Drive	Vg	NT3000U1	$250.00
MD-15 Motor Drive	Vg	NT3002U1	$195.00
SB-16A Speedlight	Gd	NT2506U	$250.00
55mm f3.5 Micro	Gd	NT2028U	$145.00
55mm f3.5 Micro	Gd	NT2028U1	$129.00
105mm f1.8 AIS	Gd	NT2032U3	$395.00
105mm f2.5	Gd	NT2032U4	$175.00
105mm f2.5 AIS	Vg	NT2033U	$140.00
300mm f2.8 Ed-IF AF	Vg	NT2103U	$2,995.00
MD-11 Motor Drive	Gd	NT3002U	$150.00
MF-21 Multi-Control Back	Vg	NT3222U	$75.00
105 Micro f2.8 lens	Vg	NT1455U	$425.00

Medium Format Equipment

Bronica 6x6 Equipment

Description	Cond.	Part No.	Sale
Sq-Ai Body w/Finder	Vg	BA0123U	$600.00
80mm f2.8 SQ-A Lens	Gd	BA0283U	$550.00

Bronica 6x4.5

Description	Cond.	Part No.	Sale
ETRSi Kit	Gd	BA0104U	$1,750.00
E Polaroid Film Back	Vg	BA0411U	$275.00

Fuji GX 680 Equipment

Description	Cond.	Part No.	Sale
GX680 II Body	Vg	FE6703U	$1,495.00
GX680 220 Back	Vg	FE6709U	$495.00
GX680 120	Vg	FE6900U	$595.00
GX Instant Holder II	Vg	FE6898U	$250.00
GX 680 WL Finder	Vg	FE6937U	$65.00
GX680 Battery	Vg	FE6905U	$35.00
GX680 Charger	Vg	FE6906U	$149.00

Hasselblad Equipment

Camera Bodies and Outfits

Description	Cond.	Part No.	Sale
Flex Body	Ex	HA1017U	$1,429.00
503 CW Body	Ex	HA1026U	$1,095.00
500CM Outfit w/80mm Lens & A12 Back	Vg	HA0055U4	$1,800.00
501CM Body	Vg	HA1005U	$1,050.00
500C w/A12 Back	Vg	HA0051U2	$695.00

Hasselblad Magazines

Description	Cond.	Part No.	Sale
A12 Chrome Magazine	Gd	HA2090U	$395.00
A12 Chrome Magazine	Gd	HA2060U	$295.00
A12 Chrome Magazine	Gd	HA2060U6	$400.00
A12 Chrome Magazine	Gd	HA2060U5	$225.00
A12 Chrome Magazine	Gd	HA2060U2	$350.00
A12 Black Magazine	Gd	HA2090U1	$375.00
A12 Chrome Magazine	Gd	HA2060U3	$350.00
A12 Chrome Magazine	Vg	HA2068U	$600.00
Polaroid Back	Vg	HA2076U	$295.00
NPC Pro Back for Hassleblad	Gd	NP2000U1	$165.00
NPC MF-2 Polaroid Back	Vg	NP2002U	$250.00

Lenses

Description	Cond.	Part No.	Sale
30mm C t* Distagon f3.5 Lens	Gd	HA1100U	$1,895.00
50mm Distagon f4.0 Lens	Ex	HA1114U	$2,100.00
60mm CB Distagon f3.5 Lens	Vg	HA1116	$2,099.00
120mm CF Makro-Planar f4.0 Lens	Vg	HA1135U	$1,895.00
150mm f4.0 Lens	Vg	HA1145U	$1,400.00
250 f5.6 Lens	Ex	HA1150U	$1,600.00
500mm f/8 Lens	Ex	HA1155U	$2,900.00

Misc. Hasselblad Equipment

Description	Cond.	Part No.	Sale
Pro Lens Shade 93mm	Ex	HA3056U	$345.00
Pro Lens Shade w/60 Bay Adr	Vg	HA3060U	$275.00
Acute-Matte Screen/Gri	Vg	HA3241U	$145.00
Acute-Matte D Screen	Vg	HA3244U	$179.00

Mamiya Equipment

Mamiya 7 Equipment

Description	Cond.	Part No.	Sale
Mamiya 7 Body Only	Ex	MA0700U	$1,995.00

Mamiya 6 Equipment

Description	Cond.	Part No.	Sale
Mamiya 6 150mm Lens	Ex	MA0630U	$950.00
Mamiya 6 35mm Adapter	Ex	MA0650U	$140.00

RB 67 Equipment

Description	Cond.	Part No.	Sale
RB67S w/Prism	Gd	MA0285U1	$800.00
RB67 Pro S Body	Gd	MA0286U5	$700.00
RB67 Body	Gd	MA0280U8	$1,100.00
RB Focus Hood	Gd	MA2280U	$175.00

RB Lenses and Accessories

Description	Cond.	Part No.	Sale
RB 65mm f4.0 Lens	Gd	MA1620U	$650.00
RB 75mm f4.5 Shift Lens	Vg	MA1735U1	$1,499.00
RB 90mm f3.5 Lens	Gd	US0613	$625.00
RB/SD 120 Magazine	Gd	MA2455U	$295.00
RB/SD 120 Magazine	Gd	MA2455U1	$295.00
RB220 Back	Gd	MA2505U4	$249.00

Mamiya 645 Equipment

645AF Equipment

Description	Cond.	Part No.	Sale
Mamiya 645AF Value Pack	Ex	MA0302U	$2,759.00

645 Equipment

Description	Cond.	Part No.	Sale
645 SVII Kit	Ex	MA0271U	$1,995.00
645 Pro-TL w/ Prism	Ex	MA0264U	$795.00
645E Outfit	Ex	MA0273U	$549.00
645 Body	Gd	MA0266U	$445.00
645 Pro 120 Magazine	Gd	MA2426U1	$275.00
645 Polaroid Magazine	Vg	MA2428U	$295.00
645 Pro HP401 Polaroid Magazine	Vg	MA2428U1	$295.00
645 Pro Prism Finder	Ex	MA2330U	$200.00
M645 500mm f5.6 Lens	Ex	MA1304U	$995.00

Pentax 67 Equipment

Description	Cond.	Part No.	Sale
67 Camera w/TTL Finder	Gd	PX6700U11	$750.00

Digital Equipment

Digital Cameras and Scanners

Description	Cond.	Part No.	Sale
Canon D30 w/Batt & Grip	Ex	EC2630U	$1,680.00
Fuji IX 4900 Zoom Digital Camea		FZ2407	$799.99
Kodak DC265 Camera	Ex	EK0265U	$200.00
Kodak RFS 3600 Film Scanner		EK3600U	$499.00
Nikon Coolpix 885	Ex	NZ1885U	$369.99

Large Format Cameras and Accessories

Cambo 4x5 Cameras and Accessories

Description	Cond.	Part No.	Sale
Ultima 4X5 Camera	Gd	CB4240U	$1,495.00
45NX w/Ext. Bellows & Stdf	Vg	CC4005U	$595.00
Legend 4x5 w/ Case	Ex	CB4115U	$899.99
Compendium Kit C-311		CB0512	$249.00

Calumet 4x5 Cameras

Description	Cond.	Part No.	Sale
Orbit 4X5 Camera w/ Case	Ex	CC4000U2	$295.00

Horseman Equipment

Description	Cond.	Part No.	Sale
8X10 w/ Case	Gd	HR0001U	$950.00
8X10 to 4X5 Reducing Back	Gd	HR8209U	$395.00

Polaroid Equipment

Description	Cond.	Part No.	Sale
8X10 Processor.	Vg+	PO6005U	$375.00

Sinar Equipment

Description	Cond.	Part No.	Sale
P2 8X10 w/Foba Mount	Vg+	US0010	$4,950.00
8X10 Bag Bellows	Vg+	US0013	$225.00
F1 4X5 w/210mm f6.3 Lens and case	Vg	SN0001U	$1,100.00
F 4X5 Camera w/Shade	Vg	US0007	$575.00
Alpina 4X5 Camera	Vg	SN0001U1	$600.00
18" Rail	Ex	US00103	$150.00
6" Rail Extensions	Ex	SN0019U	$90.00
Auto Aperture Shutter	Ex	US0027	$1,295.00
Binocular Viewer	Vg	SN0020U	$200.00
Long Bellows	Ex	SN0015U	$150.00
Short Bellows	Ex	SN0017U	$50.00
Bag Bellows	Ex	SN0018U	$195.00

Toyo Equipment

Description	Cond.	Part No.	Sale
Robos 4X5 Camera	Fr	TY4602U	$695.00
Robos 4X5 Camera w/ Case	Gd	TY0001U	$795.00

Zone VI Equipment

Description	Cond.	Part No.	Sale
4X5 Classic Mahagony Camera	Ex	ZN1001	$1,195.00
Wide Angle Bellows	Vg	ZN1020U1	$159.00

Meters

Description	Cond.	Part No.	Sale
Gossen Luna-Pro F Meter	Vg	GS4015U	$200.00
Gossen Luna-Star Light Meter	NEW	GS4029U	$345.00

Large Format Lenses

Normal Taking Lenses

Description	Cond.	Part No.	Sale
Caltar 210mm f6.8 E		CL4210U1	$295.00
Nikkor 150mm f5.6 Lens w/Board	Gd	NL8150U	$245.00
Schneider 210mm f5.6 Apo-Symmar Lens	Ex	SC7225U	$679.00
Nikkor 240mm f5.6 Lens	Ex	NL1860U	$949.00
Schneider 360mm f6.8 Lens on Sinar DB	Vg	US0004	$1,395.00
Schneider 480mm f9.0 Apo-Sinaron Lens	Vg	US0009	$995.00

Wide Angle Lenses

Description	Cond.	Part No.	Sale
Nikkor 65mm f4 SW Lens	Ex	NL1805U	$595.00
Nikkor 90mm f8.0 Lens	Ex	NL1815U1	$595.00
Nikkor SW 90mm f8.0 Lens (Copal)	Vg	NL1815U	$575.00
Topcor 90mm f6.3 Lens	Vg	US0003	$275.00
Schneider 90mm f8.0 Super Ang. Lens	Vg	SC6908U1	$495.00

Lighting Equipment

Dyna-Lite

Description	Cond.	Part No.	Sale
M1000XR Power Pack	Gd	DY4015U	$765.00
M1000XR Lighting Kit	Gd	DY5020	$2,245.00

Large Format Cameras and Accessories

Description	Cond.	Part No.	Sale
Cambo 8x10 Cameras and Accessories			
Legend 8X10 View Camera	Gd	CB4040U	$1,250.00
Horseman Equipment			
4X5 LB S/N	Gd	US1349	$1,200.00
Binocular Viewing Hood	Gd	US1422	$395.00
6X9 Roll Film Holder for 4x5	Vg	HR4634U	$325.00
Sinar Equipment			
8X10 to 4X5 Reducing Plate	Gd	US6810	$395.00
Toyo Equipment			
8X10 Back w/Cover	Gd	US7118	$139.99
Binocular Viewing Hood	Gd	US1449	$250.00
Zone VI Equipment			
Bag Bellows		ZN1020U	$150.00

Large Format Lenses

Description	Cond.	Part No.	Sale
Normal Taking Lenses			
Schneider 180mm f5.6 Comp. S In Shtr.		SC5180SU	$649.00
Schneider 180mm f5.6 Symmar-S Lens	Gd	US1533	$549.00
Schneider 210mm f5.6 Lens	Gd	US1450	$449.00
Rodenstock 240 f5.6 Sironar Lens	Gd	RS24056U	$895.00
Schneider 300mm f5.6 Lens (Compur Shtr).Gd		US1114	$949.00
Rodenstock 360mm f9.0 Apo-Ronar	Gd	RS4300U	$995.00
Fuji 360mm f6.3 W Lens	Gd	FU36063U	$995.00
Schneider 480mm Symmar S Mc Lens	Gd	SC7245U	$1,795.00
Wide Angle Lenses			
Schneider 47mm Super Angulon Lens	Vg	US1436	$749.00
Schneider 165mm f8.0 Sup. Angulon Lens	Vg	SC6165U	$1,900.00

Medium Format Equipment

Description	Cond.	Part No.	Sale
Contax 6x4.5 Equipment			
80mm f2.0 Lens	Vg	CX6470U	$995.00
Fuji GX 617 Equipment			
90mm f5.6 for GX-617	Vg	FE1053U	$2,299.00
Fuji GX680 Equipment			
GX680 220 Roll Film Holder	Gd	FE6901U4	$495.00

Hasselblad Equipment

Description	Cond.	Part No.	Sale
Camera Outfits (Body, Lens and Magazine)			
501CM Outfit 80mm CB lens and A12)	Ex	HA10071U	$2,299.00
501 Kit	Ex	HA10081U	$2,195.00
Camera Bodies			
500C Body	Vg	HA0055U1	$395.00
500C Body	Vg	HA0055U2	$450.00
500 CM Body	Vg	US1250	$595.00
500CM Chrome Body	Vg	HA0085U17	$695.00
553 ELX Body Demo	Ex	HA1050U3	$1,976.25
Magazines			
A12 Chrome Magazine (Old Style)	Gd	HA2060U	$475.00
A12 Chrome Magazine	New	HA2060U40	$700.00
A12 Chrome Magazine	Gd	US1427	$495.00
A12 Chrome Magazine	Gd	US1255	$425.00
A12 Chrome Magazine	Gd	HA2090U	$349.00
.E12 Chrome Magazine	Vg	HA2100U	$889.99
E24 Magazine (Demo)	Vg	HA2104U	$952.00
Hasselblad Polaroid Back	Gd	HA2077U	$279.00
Finders			
90 Degree Prism w/diopter	Gd	US1095	$495.00
PME-51 Prism	Gd	US1532	$895.00
Prism	Gd	US1565	$349.00
45 Prism	Gd	US1428	$495.00

Description	Cond.	Part No.	Sale
Hasselblad Finders *Continued*			
Magazine Hood	Gd	US1538	$189.00
Lenses			
50mm Cf f/4 Distagon Lens		US1457 "	$1,695.00
60mm Lens		HA1116U	$1,561.00
80mm Cf		US1539	$995.00
80mm Cf Lens		US1430	$1,195.00
80mm Planar Lens		US1420	$649.00
80mm T* F2.8 Lens		US1092	$695.00
80mm C f2.8 Lens		HA1120U	$949.00
120mm Macro Planer f4.0 Lens		US1562	$1,595.00
150 mm CF f4.0 Lens		US1541	$1,595.00
250mm C f5.6 Lens		US1448	$795.00
140-280mm CF f5.6 Zoom Variagon	Ex	HA1168U	$4,799.00
Misc. Hasselblad Equipment			
Flashgun Bkt		HA3306U	$145.00
500/553 Flash Bracket		HA3309U2	$250.00
SCA 390 Adaptor (Demo)		HA5705U	$176.00
PCP 80 Projector	Vg	HA8500U	$2,050.00
150 Projector Lens	Vg	HA8505U	$395.00

Mamiya Equipment

Description	Cond.	Part No.	Sale
Mamiya 6 Equipment			
50mm f4.0 Lens	Vg	MA0620U	$895.00
75mm f3.5L Lens	Vg	MA0610U	$695.00
150mm f4.5 Lens	Vg	MA0630U	$675.00
Mamiya 7 Equipment			
43mm f4.5 Lens	Vg	MA0710U	$1,899.00
RZ Bodies			
RZ67 Pro II Body	Gd	MA0282U	$999.00
RZ Body		MA0208U6	$565.00
RZ Body		US1266	$475.00
RZ Lenses			
RZ 50mm f4.5 Lens w/Hood		MA1720U	$1,021.00
RZ 90mm ff3.5 Lens		US1455	$895.00
RZ 110mm f2.8 R Lens		MA1740U	$995.00
RZ 127mm f/3.5 Lens		MA1744U	$650.00
RZ 140mm Macro		US1275	$1,095.00
Sekor Z 150mm f3.5		US1456	$900.00
RZ 180mm Lens		MA1750U11	$850.00
RZ 180mm f4.5W-N Lens		MA1750U10	$995.00
RZ 180mm f4.5 R Lens		MA1750U2	$925.00
RZ 250mm f4.5 Lens		MA1760U	$995.00
RZ Film Backs			
RZII 220 Back		MA2506U3	$375.00
RZ 220 Magazine		MA2505U2	$375.00
Mamiya 645 Equipment			
645 Pro		MA0266U7	$525.00
645 Pro Body		MA0264U	$850.00
645 Pro Body		MA0266U1	$600.00
645 Svx Prism Find (Demo)		US6740	$250.00
645 Pro Prism Finder		MA2330U	$350.00
NPC Back For Mamiya 645		NP2075U	$195.00
645 Lenses			
55mm f2.8N Lens		MA1013U	$450.00
80mm f1.9 Lens		US1134	$450.00
150mm f2.8 Lens		MA1212U1	$1,195.00
150mm f3.5 Lens		MA1214U1	$406.00
210mm f4.0		MA1220U	$379.00

Pentax Equipment

Description	Cond.	Part No.	Sale
Pentax 6x7 Equipment			
55mm f4.0 SMC Lens		PX6755U	$507.00
75mm Leaf Shutter Lens		US1126	$550.00
105mm f2.4 Lens		PX6710U	$250.00
150mm Lens		US1446	$549.00
165mm f2.8 Lens		PX6716U	$300.00
AE Prism		US1442	$299.00
Extension Tube		PX6971U	$125.00
Waist Level Finder		US1443	$125.00
645-6X7 Lens Adapter		PX8835U	$129.00
NPC Polaroid Back for Pentax 6x7		NP1200U	$675.00
Pentax 645 Equipment			
120mm AF Lens		US1125	$850.00
645 AF 45-85mm Zoom Lens		US1362	$1,095.00

Digital Equipment

Description	Cond.	Part No.	Sale
Digital Cameras			
Fuji S1 Pro Finepix Camera	Ex	FZ3000U "	$1,300.00
Nikon Coolpix 990 Camera	Vg	NZ1990U	$375.00

Specialty Cameras

Description	Cond.	Part No.	Sale
Noblex Equipment			
6/150U 120 Mode	Vg	NX1205U	$1,495.00
Panolux 135 Exp Control	Vg	NX1206U	$689.00
135U	Vg	NX1355U	$1,795.00

35mm Equipment

Description	Cond.	Part No.	Sale
Canon Manual Equipment			
28mm f2.8 Lens		CA4044U	$178.00
28mm f2.0 FD Lens		CA1040U	$425.00
200mm f2.8 FD Lens		CA4063U	$529.00
Canon AF Equipment			
EOS A2 w/Grip Vg 10	Ex	US1403	$495.00
EOS 5 Qd S/N 3101467		US1395	$395.00
20mm f2.8 EF Lens		CA4041U	$349.00
35 mm f2.0 EF Lens		CA4043U	$239.00
200mm f2.8 EF-L USM Lens		CA1235U3	$499.00
200mm f2.8 EF-L USM Lens		CA1235U	$599.00
500mm f4.5L EF Lens w/case		CA4059U	$5,000.00
20-35mm f2.8L EF Lens		CA4061U	$938.00
35-70mm f3.5-4.5 EF		CA4069U1	$109.00
Speedlite 540EZ		CA4104U	$260.00
Contax Equipment			
G2 Body	Vg	US1458	$695.00
G1 Body	Vg	CX1100U10	$495.00
28mm f2.8 Lens	Vg	CX1128U	$349.00
45mm f2.0 Lens	Vg	CX1145U	$225.00
45mm f2.0 Lens	Vg	US1375	$249.00
90mm f2.8 Lens	Vg	CX1190U	$349.00
90mm f2.8 w/ Filter 46mm	Vg	US1459	$349.00
Konica Equipment			
Hexar Body w/50mm f2.0 Lens	Vg	KH0500U	$950.00
Leica Rangefinder "M" System			
M6 Chrome Body	Ex	LC5001U	$1,395.00
Leica SLR "R" System			
R4 Body		US7358	$450.00
R4 Body		US7315	$600.00
R4S Body		US7097	$450.00
R4S Body		US7583	$395.00
R6 Body Black		US7515	$1,250.00
Motor Drive R		US9005	$245.00
R 35-70mm f3.5 Lens		US7565	$695.00

What Do You Have to Trade or Sell?

Calumet is actively looking for your used equipment.

Is your used gear worth money? Calumet is always on the lookout for the following types of used equipment:

- Clean large format cameras, lenses and accessories

- Current-model medium format gear such as Hasselblad, Mamiya RZ, Mamiya 645/645AF, Mamiya 7 and Contax 645

- Pre-owned Leica items are always in short supply

- Do not dismiss items such as used tripods, meters or film holders

- Panoramic, specialty items and high-quality vintage gear are also on our wish list

Please contact our Used Equipment Department by faxing us your list of items as well as their condition to: **Attn Used Equip. Dept, Fax #1-312-944-4270** or email us at **used.equip@calumetphoto.com.**

All quotes will be pending subject to actual inspection of the equipment. At the time of quotation we will instruct you on how and where to send the equipment for evaluation. Please do not send us any items until you have received a quote from us.

Serving the photographic community for over 60 years, Calumet Photographic is your source for professional photographic equipment, new and pre-owned.

CALUMET
PHOTOGRAPHIC

Savings Worth Straining Your Eyes Over!

Not All Merchandise is Available Nationwide!

PLEASE NOTE: Most merchandise listed here can be purchased by calling our toll-free order line, 1-800-CALUMET (225-8638). However, for your benefit we have also listed items that are only available by calling our New York (1-212-989-8500) and Los Angeles (1-323-466-1238) retail locations. On the top of each page we have listed the proper phone numbers that should be called for ordering. Call today — these items are limited in quantity.

Used Cameras, Lenses and Accessories

Take advantage of this great opportunity to save on quality used camera equipment and expand your shooting options at the same time. Our descriptions and abbreviations may be cryptic, but in our effort to bring you the most up-to-date listings possible, we have downloaded these files right before going to press. If you have any questions concerning an actual description, please call 1-800-CALUMET (225-8638) and one of our technical sales representatives will be happy to help you.

Calumet Used Equipment Ratings

All of the used equipment that we sell is in clean, serviceable and warranted condition. Whenever possible we have applied our rating system to each item. However, due to the volume of equipment that we sell, this is not always possible. If an item has no rating, please feel free to call us and will be glad to describe the condition to you. The guidelines we have developed for rating the condition of the used equipment we offer is as follows:

Excellent

The item is like new except for very minor cosmetic flaws. The item could simply be missing the warranty card or other items that would prevent the item from being sold as new. Shutters have been tested and found to be within the specifications for new equipment.

Very Good

The item is almost new but it has some minor cosmetic flaws. Shutters have been tested and found to be within specifications for new equipment.

Good

The item has been used and shows normal wear and tear. There could be very minor dents or noticeable cosmetic flaws. Shutters have been tested and found to be within the specifications for new equipment.

Fair

The item is well-used and has moderate wear and tear. Could have minor dents, brassing or other noticeable cosmetic flaws. Shutters have been tested but may not be within specifications for new equipment at all speeds.

Calumet Used Equipment Guarantee of Satisfaction

All equipment listed here comes with a 30-day Calumet Warranty.

Super Special Deals on Used Cambo Legend Cameras and Schneider 210mm Lenses!

See L.A. Used Equipment listings.

In our Nationwide listings you will find some very attractive deals on factory demo Mamiya and Contax equipment

What Do You Have to Trade or Sell?

We want your used equipment.
See back page for details.

Please Email us at
used.dept.@calumetphoto.com
or Fax us Attn: Used Equipment Department
(312) 944-4270
*All quotes will be pending;
subject to inspection.*

CALUMET
PHOTOGRAPHIC

These spectacular deals are only available by calling
1-800-CALUMET (225-8638).

Available Nationwide

Stop in our retail location at:
1111 North Cherry Street
Chicago, Illinois

Large Format Cameras and Accessories
Cambo and Calumet Photo Equipment

Description	Cond.	Part No.	Sale
Cambo 4x5 Cameras			
Cambo 45 Repro D Camera	Gd	CB6005U	$875.00
Cambo 4x5 Wide Front Panels			
Front Panel w/47mm f5.6 S.A. Lens	Gd	CB0810U	$1,795.00
Front Panel w/58mm f5.6 S.A. Lens	Gd	CB0815U	$2,129.00
Calumet 4x5 Cameras			
Cadet 4X5 Camera	Vg	CC3001U1	$275.00
Cadet Wide 4X5 Camera	Vg	CC3101U1	$379.00
Calumet 4X5 Economy Case	Fr	CZ4501U	$89.00
Calumet Lupes			
Calumet 4X Wa Lupe		CC1000U	$49.00
Cambo Monorails and Extensions			
Cambo 25.5" Starter Rail	Gd	CB4305U	$99.00
Cambo 10" SR Extension Rail	Gd	CB4310U1	$99.00
Cambo 7" Basic Monorail		CB4315U1	$89.00
Cambo 4x5 Standards and Bellows			
SC Bellows Coupling Standard		CB0525U	$229.00
SR Multi-Purpose 4x5 Standard	Vg	CB4500U1	$275.00
22" (56cm) Standard Bellows	Ex	CB0207U	$185.00
Cambo 8x10 Cameras and Accessories			
Legend 8X10 Camera	Vg	CB4040U	$1,100.00
8X10-4X5 Reducing Frame	Gd	CB0413U	$245.00
Cambo Accessories			
SC4 Compendium for 360mm Lens	Gd	CB0408U	$369.99
Deluxe Compendium w/Vignettes	Ex	CB05065U	$269.00
C2N 6X7 Roll Film Holder	Vg	CB5500U	$295.00
Cambo Sliding CCD-Back		CB0193U	$499.00
Compend Plate F/Cb0513	Vg	CB0511U	$234.99
Compend Maskr F/CB0511	Gd	CB0513U	$213.99
Cambo 10 SR Ext Rail		CB4310U	$39.99
SR Tripod Mntg Block Poor		CB4400U	$70.00
SR Dble Trpd Mount Block Old		CB4420U	$179.00
Cambo 4X5 Sliding Back	Ex	CB6050U	$1,085.00
Hass Adpt F/Cb6050/60		CB6070U2	$239.00

Horseman Equipment

Description	Cond.	Part No.	Sale
LS 4X5 VIew Camera	Vg	HR4514U	$1,800.00

Leonardo Pinhole

Description	Cond.	Part No.	Sale
4X5 Pinhole Camera	Vg	PY1300U	$89.00

Majestic Tripods

Description	Cond.	Part No.	Sale
Majestic 5007 2 Sec Sgl Leg Qklft	Vg	MJ2502U	$329.00

Polaroid

Description	Cond.	Part No.	Sale
545 Holder	Gd	PO5100U	$85.00
545 Back Cond	Gd	PO5100U1	$85.00
550 Film Hold	Vg	PO5500U	$95.00
8X10 Film Holder	Gd	PO6050U	$119.00
MP4 Sliding Camera Hd	Vg	PO7070U	$377.99
600 One Step Af Camera	Gd	PO3040U	$37.99
Daylab 3X4 Film Base	Ex	PO3108U	$59.00

Sinar Equipment

Description	Cond.	Part No.	Sale
F1 4X5 Camera Body	Vg	AA0118U1	$685.00
Norma 8X10 4X5 Reducing Plate	Gd	SN0011U	$175.00
Beattie Sinar Plus 4X5 With Grid	Vg	BT0077U	$149.00

Large Format Lenses
Normal Taking Lenses

Description	Cond.	Part No.	Sale
Caltar II-N 210mm f5.6 Lens	Gd	CL2210U	$525.00
Caltar II-E 210mm f6.8 Lens	Ex	CL4210U	$345.00

Normal Taking Lenses *continued*

Description	Cond.	Part No.	Sale
Schneider 210mm Conv. Symmar Lens	Vg	SC7226U	$375.00
Schneider Apo Symmar 360mm f6.8 Lens	Ex	SC7240U	$1,495.00

Wide Angle Lenses

Description	Cond.	Part No.	Sale
Schneider 90mm f8.0 S.A., Sync. Cpr	Gd	SC6900U	$300.00
Rodenstock 90mm f8.0 Geronar W.A.	Ex	RS0010U1	$275.00
Nikkor SW 150mm f8.0 Lens	VG	NL1817U	$1,275.00

Tele-Photo Lenses

Description	Cond.	Part No.	Sale
Nikkor 360mm T-ED Lens	Ex	NL1894U	$1,395.00

APO Lenses

Description	Cond.	Part No.	Sale
Schneider G-Claron 150mm f9 Bbl. Lens		SC7001U	$145.00

Meters

Description	Cond.	Part No.	Sale
Minolta Color Meter II	Vg	MN4017U	$375.00
Seconic L-328/318 5° Spot Attachment		SE4136U	$82.00
Seconic L-608 Super Zoom Light Meter		SE4094U	$575.00
Seconic L-718 Digi Master Meter	Ex	SE4101U	$219.00
Seconic L-778 Spot Flash Meter (Demo)	Ex	SE4200U	$599.00
Polaris Digital Flash Meter	Vg	SO2100U	$179.99

Medium Format Equipment
Bronica Equipment

Bronica 6x7

Description	Cond.	Part No.	Sale
G Prism Finder Good		BA0262U	$225.00

Bronica 6x6 Used Equipment

Description	Cond.	Part No.	Sale
SQ-B Kit (Body,Ps-B 80 Lens and120)		BA0425U	$1,495.00
SQ-B Body Only		BA0123U1	$695.00
SQ-AI Body Only	Gd	BA0123U	$495.00
SQ-I Motor Drive Grip	Vg	BA0125U	$399.00
AE Prism Finder SQ-I		BA0235U	$650.00
S TTL ME Prism	Gd	BA0234U	$349.00
6x4.5 120 Film Back for SQ-Ai		BA0413U	$199.00
6x6 120 Film Back for SQ-Ai		BA0431U	$199.00
6x6 220 Film Back for SQ-Ai		BA0433U	$199.00
Polaroid Back for SQ-I		BA0443U	$185.00
135mm f3.5 PS for SQ	Ex	BA0287U	$995.00
150mm f4.0 PS for SQ		BA0285U	$695.00
SCA 386 Flash Adpter for Etrs I Sq-Ai		BA0210U	$149.00

Bronica 6x4.5 Used Equipment

Description	Cond.	Part No.	Sale
E Rotary Finder		BA0204U1	$245.00
E Meter Prism AE-III	Ex	BA0207U	$449.00
E Meter Prism AE-II	Gd	BA0207U1	$245.00
PE 50mm f2.8 for E		BA0301U	$395.00
PE 75mm f2.8 for E	Ex	BA0303U	$449.00
PE 75mm f2.8 for E (Demo)		BA0303U1	$399.00
PE 105mm f4.5 Macro		BA0308U	$1,275.00
E 105mm f3.5	Gd	BA0308U1	$395.00
6x4.5 120 Back for ETRSi	Ex	BA0403U	$249.00
Polaroid Back for ETRSi	Ex	BA0411U	$279.00
E Speed Grip		BA1220U1	$149.00
Motor EI-II Etr Series (Demo)		BA1225U	$625.00
E Motor Winder		BA1223U	$295.00

Contax Demo Equipment
Demos come with a one-year Contax warranty

Description	Part No.	Sale
Contax 645 Outfit	CX6450	$2,900.00
45mm f2.8 Distagon t* lens (72Ø)	CX6465	$1,750.00
140mm f2.8 Sonnar t* lens (72Ø)	CX6475	$1,750.00
645 Back MFB-1 w/120/220 Insert	CX6502	$425.00
645 Polaroid Back MFB-2	CX6508	$449.00
AA Battery Holder/Grip for 645	CX6800	$395.00
Quick Shoe Adapter	CX6804	$79.00
Cable Switch Adapter	CX6802	$39.00

Contax Equipment

Description	Cond.	Part No.	Sale
G1 Leather System Bag	Ex	CX1280U	$150.00
Contax Hassbld Lens Adapt	Ex	CX2900U	$160.00
645 Dlx Med Form Case	Ex	CX6838U	$169.00

Fuji Equipment
Fuji GX 617 & G-617 Equipment

Description	Cond.	Part No.	Sale
G-617 Camera	Vg	FE1050U	$1,795.00
GX-617 90mm f5.6 Lens	Ex	FE1053U	$1,895.00

Fuji GX 680 Equipment

Description	Cond.	Part No.	Sale
GX 680 120 Holder	Ex	FE6690U	$649.99
GX 680 120 Insert	Gd	FE6942U	$69.99

Fuji 645 Equipment

Description	Cond.	Part No.	Sale
Ga645Wi Camera w/case & hood	Ex	FE1021U	$1,195.00

Hasselblad Equipment
X-Pan Equipment

Description	Cond.	Part No.	Sale
Xpan 35mm Body Only	Vg	HA0035U	$1,399.00
Xpan 30mm f5.6 Lens	Ex	HA0043U	$2,175.00
Xpan 45mm f4 Lens	Ex	HA0045U	$395.00

Camera Bodies

Description	Cond.	Part No.	Sale
903 SWC Chrome Body	Ex	HA1070U	$3,495.00
503CX Hasselblad Body	Vg	HA1019U1	$795.00
503CW Black Body	Ex	HA1027U	$1,395.00
500CM Body	Vg	HA1001U	$495.00
500CM Body	Gd	HA1005U2	$395.00
500 Cm Body	Gd	HA1005U6	$475.00
500Cm Blk Body	Gd	HA1012U	$525.00
500Cm Chrome	Gd	HA1014U	$395.00
555 ELD Black Body	Ex	HA1052U	$2,485.00
500 ELX Black Body		HA1065U	$995.00
553 ELX Chrome Body	Gd	HA1050U	$1,395.00
500EL/M Chrome Body	Gd	HA1021U	$695.00
500 EL Body Chrome		HA10685U1	$395.00

Finders

Description	Cond.	Part No.	Sale
PM-90 Prism Finder		HA2250U	$445.00
PME 90 Meter Prism	Ex	HA2252U	$945.00
PME-51 Meter Prism	Ex	HA22595U1	$995.00
Chimney Finder	Gd	HA2254U	$129.00

Lenses

Description	Cond.	Part No.	Sale
40mm Distagon Ct* Lens	Gd	HA1105U	$1,395.00
60mm f3.5 Distagon CB Lens	Ex	HA1116U	$1,395.00
100mm f3.5 Planar CF Lens		HA1125U	$1,195.00
100mm f3.5 Planar CFi Lens	Vg	HA1126U	$1,895.00
150mm f4.0 Sonnar CF Lens	Fr	HA1145U	$975.00
180mm f4.0 Sonnar CF Lens	Gd	HA1148U	$1,375.00
350mm CFE Tele-Superachromat	Ex	HA1161U	$6,295.00
1.4XE Teleconverter	Ex	HA1174U1	$695.00

FE Lenses

Description	Cond.	Part No.	Sale
250mm f4.0 Tele-Tessar FE w/Hood	Ex	HA1077U	$1,899.00

Magazines

Description	Cond.	Part No.	Sale
C-12 Back		HA2059U	$145.00
A-12 Back	Fr	HA20605U	$195.00

Miscellaneous Accessories

Description	Cond.	Part No.	Sale
Hasselblad 70Mm Back	Gd	HA2069U	$195.00
Hass Collapsible Pro Shade		HA3060U	$199.00
Mount Ring 93 F/6093	Ex	HA3074U	$65.00
8Mm Extension Tube	Gd	HA4056U	$175.00
16Mm Ext Tube	Vg	HA4060U	$175.00
56Mm Extension Tube	Vg	HA4068U	$175.00